Female Ascetics in Hinduism

SUNY series in Hindu Studies
Wendy Doniger, editor

Female Ascetics
in Hinduism

Lynn Teskey Denton

STATE UNIVERSITY OF NEW YORK PRESS

Back cover photo by Emily Lynn Denton.

Published by
State University of New York Press, Albany

© 2004 State University of New York

All rights reserved

Printed in the United States of America

For information, address State University of New York Press,
90 State Street, Suite 700, Albany, NY 12207

Production by Marilyn P. Semerad
Marketing by Anne M. Valentine

Library of Congress Cataloging-in-Publication Data

Denton, Lynn Tesky, 1949–1995.
 Female ascetics in Hinduism / Lynn Teskey Denton ; [edited by Steven Collins].
 p. cm. — (SUNY series in Hindu studies)
 Includes bibliographical references and index.
 ISBN 0-7914-6179-3 (alk. paper)—ISBN 0-7914-6180-7 (pbk. : alk. paper)
 1. Hindu women—Religious life—India—Varanasi (Uttar Pradesh) 2.
Asceticism—Hinduism. 3. Ascetics—India—Varanasi (Uttar Pradesh) 4. Monastic
and religious life (Hinduism)—India—Varanasi (Uttar Pradesh) I. Collins, Steven,
1951– II. Title. III. Series.

BL1237.46.D46 2004
294.5'447082—dc22 2004045335

10 9 8 7 6 5 4 3 2 1

Contents

Foreword

Lynn Shirley Teskey Denton was born on January 7 1949 in Vernon, British Columbia, and grew up in Ontario on a farm in Prince Edward County, the eldest of seven children. She completed a BA in Religious Studies (1972) and an MA in Anthropology (1973) at McMaster University. At the Institute of Social Anthropology at Oxford University, she was awarded a BLitt (1974) and an MLitt (1975), and completed all requirements for a DPhil except the dissertation. Between 1976 and 1981 she spent over two years in India, mainly in Benares, conducting fieldwork on female ascetics. During this time she also taught several sessions at McMaster University. She was Assistant Professor in the Department of Religion, Concordia University, from 1984 to 1989, when she resigned for reasons of health. She married Frank Denton in 1986 and in 1990 gave birth to Emily Lynn Denton. After many years of struggling with ill health, she died of leukemia in 1995.

During her life she published only one article, (Denton 1991). After her death Frank Denton and a number of scholars who knew her work wanted to see as much of it published as could be salvaged from the papers she left. It has taken an unfortunately long time to see this project through to fruition. In late 1997 the Committee on Southern Asian Studies at the University of Chicago kindly agreed to provide funds to proceed with the task. Sandra K. Mulholland did most of the typing, working from computer disks, manuscripts, and typescripts. She was able to use her own fieldwork knowledge of Nāth ascetics in North India, and of the Hindi language, to do so. The format of the book is my responsibility. It was the understandable feeling at State University of New York Press

that the remaining materials contained too much overlap to be made immediately into a publishable book, and so I have had to do more rewriting than was foreseen or wanted. I have tried to represent Lynn's ideas as faithfully as I am able. Nothing in this book is, intentionally, my own. Since we cannot know what the final drafts of Lynn's work would have looked like, we cannot know whether she would have approved of their being published in this form. There is, however, a clear consistency in a number of themes running through this book which suggests that the main ideas are presented here in something like the way she might have wanted them. The Introduction, chapter 1, and much of chapter 2 seem to have been in fairly final form for presentation as the DPhil thesis: they were revised in 1992. Chapters 2 and 3 combine a computer disk version dated 1987 with a handwritten revision of 1992. Chapter 4 seems much the same as chapter 4 of the thesis was intended to be; this version was prepared as a separate typewritten paper for a conference on "Ascetics and Asceticism in India" at the Department of Religion, University of Florida, in 1988. Chapter 5 was probably given in Oxford in 1987, although this is not certain. The appendix to this chapter is taken from a paper delivered in 1987 to the Department of Religion, Concordia University. Chapter 6 was also delivered to that department, in 1984. What is missing is much of the empirical data (some of which exists in manuscript and/or typescript form, but which is not comprehensible to anyone who did not gather it), and the life histories of individual female ascetics to which the book refers, but which Lynn was not granted the time to write. It is also to be regretted that the large number of slides she took, the importance of which is discussed in the Introduction, has proved impossible to reproduce here. Meena Khandelwal has generously compiled an annotated bibliography of relevant work that has appeared since Lynn's illness and death.

Given the nature of Lynn's work as she left it, there is perforce a certain amount of repetition across the chapters of this book. But given the originality of her research, its extraordinary sense of nuance and attention to detail, it is useful to be reminded now and again of the main outlines of her analytical model. Although the fieldwork was done some twenty years ago, aside from Meena Khandelwal's recent (2003) book, there is still nothing comparable to Lynn's work in the empirical study of female ascetics in Hinduism, nor indeed in the sociological analysis of Hindu asceticism in general. It is hoped that this book retains something of the vivacity of her writing, the acuity of her analysis, and the sympathetic humanity she brought to all her scholarly work.

In a number of places Lynn thanked those who helped her in her research (research assistants, named and unnamed, are discussed in the Introduction). In chapter 5 she wrote: "This [book] is based on the results of twenty-five months of fieldwork undertaken in Varanasi between 1976 and 1981, funded, in part, by the Canada Council. I wish to thank Professor Baidyanath Saraswati for his initial encouragement and advice, and Swami Sadānanda Giri for some major historical and sociological insights. For invaluable research assistance and access to the *akhārā* subculture, I am indebted to Bhairav Muni Udāsī."

<div style="text-align: right">Steven Collins</div>

Introduction

This book is about female asceticism in the Hindu tradition and, more particularly, about the female ascetic community in the North Indian city of Benares (Varanasi).

In Hinduism asceticism is believed to be both morally and ritually efficacious; it is a value that permeates the ideology, affecting the spiritual status and daily religious activities of all members of society. Practices such as fasting and celibacy are required elements of a wide range of religious rituals, from the ancient sacrificial rites performed by the priestly elite on behalf of their wealthy sponsors to the multitude of popular rites performed by members of all classes of society today. In the course of a lifetime the average householder will thus have undertaken, on more than one occasion and for varying durations, time-honored acts of self-denial and abstention, but they remain householders first and foremost, ordinary members of society whose asceticism is periodic and circumscribed; their primary identity is not ascetic.

This book examines institutionalized asceticism. It deals with specialist, professional ascetics, who by virtue of a recognized ritual of initiation have acquired an identity that is first and foremost ascetic; who lead lifestyles that in some dramatic way evince a rejection by renunciation of the values of the householder and a real or symbolic separation from householder society; who claim affiliation with a spiritual lineage founded by one of the many preceptors who have emerged over the centuries; and who recognize as their primary home one of the thousands of ascetic establishments that are to be found throughout the country.

1

Forms of institutionalized asceticism have long been a feature of religious life in India. Passages in the early Indian texts and records of Greek travelers to the subcontinent between the sixth and third centuries BCE testify to well-established ascetic personages and practices during the first millennium. The often astonished accounts of Chinese Buddhist pilgrims between the fifth and seventh centuries of our era and of a wide range of European traders, adventurers, and missionaries from at least the seventeenth century onward testify to the proliferation of asceticism. And today, even the casual observer is impressed by its persistence, for one cannot enter a major Hindu center—the sacred city of Benares is perhaps the foremost instance—without seeing ascetics in great numbers and of a remarkable variety. Although women and girls constitute only a small proportion of the total, there are and probably always have been female ascetics, pursuing an asceticism which is indistinguishable from that of their male peers and fully integrated within the larger ascetic community. In contrast with Christianity, for example, there are no exclusively female orders: What we find is an asceticism with male and female practitioners, and it is those female practitioners who primarily concern us here.

There is more than one way of being ascetic, but the best known and most influential expression is renunciation, in Hindi called *sannyās* (Skt. *saṃnyāsa*). In becoming a renouncer a person renounces the duties, especially the ritual duties, which orthodoxy makes incumbent on the properly married householder. The faithful performance of these duties can lead to a good rebirth, but it is generally thought that only by renunciation can one escape rebirth and achieve salvation. Salvation is spiritual release or liberation, *mokṣa*; it is release from the bondage of one's deeds or actions, including ritual actions, and the results of those actions (*karma*), which tie a person to an endless cycle of birth-life-death-and-rebirth (*sansār*; Skt. *saṃsāra*). In the minds of householder and ascetic alike, spiritual liberation is inextricably associated with renunciation.

Linking renunciation, a way of life, with spiritual liberation, a religious goal, is an example of the characteristic tendency in orthodox, priestly Brahminical thought to construct overarching schemas which systematize as many elements of social and religious life as possible. The widely used term *varṇāśramadharma*, for example, expresses the view that to establish the ideal world order—as both social and ritual construct—the duties of *dharma*, of *varṇa* (status, class), and *āśrama* (stage of life) must be upheld. Society coheres when its members are divided naturally into four

status classes, each of which performs a different essential func-
tion, and when the privileged members of society pass through four
natural life stages on the way from cradle to grave. Closely asso-
ciated is the notion of *puruṣārtha*, the four legitimate ends or goals
(*artha*) to which a human being (*puruṣa*) might devote himself or
herself in life. The last and highest of these goals is spiritual lib-
eration. In this idealized view of social and religious life, some-
times presented as the quintessence of "Hinduism" itself, one should
renounce at the end of one's life and seek the ultimate goal, *mokṣa*,
then. In reality, however, there are very few fourth-stage-of-life
renouncers in the ascetic community. By far the majority have
entered renunciation in youth or middle age, and it is quite likely
that this has always been the case. To clarify the status of renun-
ciation, and of another important ascetic expression, life-long celi-
bacy, we must turn to the textual tradition, even with, or perhaps
because of its ambiguities, for the corpus of sacred texts is an
essential reference point for ascetics themselves, and, hence, for
those of us who study them.

The most significant element of the *varṇāśramadharma* theory
is the Four Stages of Life schema, the *caturāśrama* (*catur*, four),
the prescriptions for which are contained in the sacred texts
that treat specifically of *dharma*, religious duty. Two texts are of
particular importance: an early compilation known as the
Dharmasūtras, composed between 600 and 300 BCE, and a later
compilation from the early centuries of our era, the *Dharmaśāstras*
or *Smṛtis*.[1] More systematic and thorough, the latter are often
referred to as the classical texts on religious duty. These religio-
legal texts were all composed by Brahmins and thus reflect the
perspective of an orthodox, priestly, male elite. According to the
caturāśrama schema, the ideal Brahmin male—in this context the
texts address only men[2]—should pass through four life stages of
which, significantly, three are in various degrees ascetic. Sometime
in late childhood or adolescence (the precise age varies with local
tradition), he should be formally initiated as a student, a
brahmacārin. In this, the first *āśrama*, he is to study the Veda (the
most ancient of the sacred texts) and lead a chaste life; the term
for this religious studentship, *brahmacarya*, is also a term for celi-
bacy. Then he becomes a householder (*gṛhasthin*) by marrying and
setting up the domestic fire, which is of crucial significance to or-
thodox ritual practice. When he becomes a grandfather, or as the
lawgiver, Manu, writes when he sees "the children of his children,"
and he himself is "wrinkled and gray," he enters the third stage of

life by becoming a *vanaprastha*, "one who sets out for the forest" (*Manusmṛti* VI). At this stage he renounces sensual pleasures but continues to live with his wife and perform his ritual duties. Only when he has formally entered the fourth and final stage, renunciation or *saṃnyāsa*, does he take up a solitary and mendicant life, withdrawing from all social and ritual obligations.

The theory of the *āśramas* as four life stages through which an individual passes sequentially is known as the Cumulation (*samuccaya*) view. It is the best known and the one to which the orthodox most often refer, but it is not the oldest. In the earliest Brahminical texts we find the *āśramas* portrayed as competing ways of life: all four are equally valid and optional lifestyles rather than ordered life stages (Olivelle 1974, 27–8). In this latter, Option (*vikalpa*) view, after completing the period of studentship one may become a householder, or a forest ascetic, or a renouncer. Or, one may remain within the student *āśrama*, in which case one becomes a special type of student, a lifelong celibate (*naiṣṭhika brahmacārin*). In contrast to the Cumulation view, the option view holds that it is appropriate to renounce at any stage of life, provided that one is sufficiently detached from worldly pleasures. The data presented in this book will suggest that the ancient Option position corresponds more closely to modern social reality than does its better known rival. Furthermore, the first *āśrama* as lifelong celibate studentship occupies a position equal in importance to renunciation as a mode of asceticism for women.

Competing views about the *āśrama* system explain not only the existence of two lifelong modes of asceticism, celibate studentship and renunciation, but also the presence of women, and, as we shall see, girls too, in the ascetic community. For the lawgivers offered an ambiguous response to another important question: To whom does the *āśrama* system apply? The life of a traditional Hindu is largely governed by ritual considerations, and each *āśrama* is a ritual status. Entry into any ritual status is defined by initiation. Most initiations are given by a spiritual master or preceptor, *guru*, but to receive them one has to have the entitlement, *adhikāra*. As encoded in orthodox tradition, women do not have the entitlement to enter any life stage but that of the householder. Even studentship is denied to them. For men and women alike marriage is the rite that initiates householdership and marks the distinctive break between being a child and being a member of society with responsibilities. However, while for the male marriage requires a previous formal ritual of entry into studentship,

the same does not hold for a female. Initiation into studentship has a special name, *upanayana*, and certain lawbooks state that for women marriage itself is equivalent to the *upanayana* (*Manu* II.67). This means that in theory there can be no female celibate students (*brahmacariṇīs*).

Closely related to gender is the question of status or class (*varṇa*). An orthodox and thus restrictive reading of the *dharma* texts allows initiation into studentship to male members of only the top three status classes—*brahmin, kṣatriya,* and *vaiśya,* the priestly, warrior, and merchant classes—while excluding the fourth class, the servile *śūdra*. In practice, it seems that if *kṣatriya* and *vaiśya* classes observe the custom at all it is only as a preparatory ritual immediately before marriage; they do not become *brahmacārin* students. Since only someone who has received Vedic training and learned how to perform the rituals can subsequently renounce them, it follows that according to orthodox tradition only a male Brahmin can be a renouncer. Again, however, the ascetic tradition and its lay apologists have consistently sought out exceptions, drawing upon the ambiguities in the *dharma* literature. A first line of argument relies on the well established fact that for the purposes of most ritual activities women are allocated to the *śūdra* class; that whenever a lawmaker argues for the admission of *śūdra* to a given status, women are, by extension, permitted as well. A second line of argument attempts to remove the issue of women's participation in ascetic life right out of the religio-legal textual sphere entirely, by asserting that there is a body of religious texts whose authority supersedes that of those texts and which sanctions, among other things, female asceticism. This body of texts is the Veda, the most ancient and sacrosanct of all. And, indeed, Vedic literature does provide irrefutable evidence for the existence of both female celibate students and female renouncers in ancient India.

While this should lead us to consider the nature of texts in the tradition and the role they can play in anthropological investigations of religious life, there are at least two good reasons why an anthropologist should begin with an account of old Sanskrit texts. First, they affect popular perceptions and thus the status that ascetics, male or female, occupy in the social and religious life of the community. Shortly after arriving in Benares I called on a renowned scholar, a Brahmin historian of religion. I told him that I wished to study *sannyāsinīs*, female renouncers, and that I had learned that there was a small group of them living near to his residence. He told me that such a thing did not exist, by which he

meant, of course, that in *Dharmaśāstrik* terms they could not, and therefore should not exist. I was to hear similar views from others during my fieldwork. The traditional view, which lays down what may exist and sees the world according to its rules, is male and Brahmin. This view of the world is often called *śāstrik*, textual (from *śāstra*, sacred text), a word which applies to both the view and the practices it sanctions. Most Hindus with even a minimal acquaintance with the textual tradition would cite the *Dharmaśāstras* as a collectivity, and the *Manusmṛti*, in particular, as the foundational texts of *dharma*, right action or duty, and thus the quintessential embodiment of the *śāstrik* worldview. The antonym of *śāstrik* is *laukik*, literally, "worldly," but more accurately, "popular." As in all great civilizations, many elements of folk or popular belief have been incorporated into the elite textual tradition and have thus acquired the authority of the written word. Even then, not all practices are considered equally orthodox. People commonly maintain a distinction between those they think are *śāstrik* and those they believe to be *laukik*, but in the process they are often expressing their evaluation of a practice rather than a scholarly fact.

There are objective criteria by which one may assess a given practice to determine the degree to which it conforms to textual prescriptions, but our primary concern is with the state of affairs as perceived and articulated by the subjects themselves. During the course of this research I was often confronted by the contrast between the *śāstrik* and *laukik* worldviews. In trying to see the world from the perspective of the woman ascetic, a person who in orthodox *śāstrik* ideology has no right to exist, I had necessarily to adopt a *laukik* perspective myself. The distinction between an orthopraxy based on the *dharma* texts and customary or popular tradition represents only two points of reference, and these pertain largely to nonascetic, householder, or lay discourse. For, as just noted, among ascetics a third source of religious authority is found in the Vedas, ancient texts anterior to the classical *Dharmaśāstras*. The word for this tradition and the practices that tradition sanctions is *vaidik*, "of the Vedas." *Vaidik* (Vedic) sources, it is believed, stretch back to the beginning of time; scholarly assessments locate the corpus of Vedic texts between roughly 1000 and 500 BCE indicating that they may reflect religious and social life as lived before the *dharmaśāstrik* period and the codification of what we now speak of as the orthodox, Brahminical, *śāstrik*, worldview. It is partly because the latest works of this Vedic corpus, the

Upaniṣads, contain discussion of the profound spiritual mysteries which still preoccupy many ascetics today that they so often elevate the *vaidik* above the *śāstrik*. These texts are also honored because they contain graphic descriptions of individuals who appear to be the precursors of many types of contemporary practitioners: celibate ascetics, both male and female, antinomian ascetics of the sort that today are often called *sādhus* or *yogis*, and even both male and female renouncers, at a time before they were officially recognized and incorporated into the Brahminical schema.

This leads directly to a second and more important reason for starting with a discussion of ancient and classical Sanskrit texts: they are important to the construction of ascetic society. Of particular importance to the anthropologist, they have played a crucial role in the development and diversification of practice and, hence, the proliferation of distinctive communities, often with forms of social organization that are radically different than those found in the larger society. It is a consistent feature of history that as the core value of asceticism has been translated into practice, numerous ways of life have emerged, and these different ways of being ascetic commonly result in the formation of independent communities. Thus, not only elements of practice and belief but also features of social organization derive their legitimacy—or so it is argued—from the texts.

It is not at all surprising, given the ambiguities within the *Dharmaśāstra* literature on such fundamental issues for asceticism as the Option versus Cumulation views of the four *āśramas*, the existence of at least two, not entirely congruent sources of textual authority (for example, do *śāstrik* injunctions supersede *vaidik* practice?), the tremendous potential for popular (*laukik*) tradition to both diverge from and gain acceptance by the official *śāstrik* view of things, and the tendency to translate varying interpretations of ascetic values into distinctive lifestyles, that we should find among ascetics numerous socio-religious groupings of the sort I will call sects, or orders. The great proliferation of such groups may often be traced to what are sometimes minute variations in interpretation of the textual sources on topics such as: the fundamental meaning or purpose of asceticism itself (e.g., is it a means to spiritual liberation or an expression of that state?), the proper relationship ascetics should maintain with the larger society (e.g., is the settled, monastic life as valid as that of the itinerant beggar or cave-dwelling hermit?), the key requirements of practice (e.g., are ascetics permitted to use fire or to accept money; ought they to

pursue severe penances and meditation, or study and teaching?), and, as just noted, the degree of social exclusivity (e.g., are women permitted entry, and what of foreigners and untouchables?). Disagreement in any one of these areas can result in a split within a sectarian tradition, or even the birth of an entirely new sect. The texts are clearly important, then, but it bears repeating that the anthropologist is not so much concerned with their actual content as with what the ascetics themselves believe to be their content and function. Vaidik and śāstrik values are frequently appealed to by ascetics in general, as also by women ascetics and their supporters in particular. No comprehensive study of asceticism can proceed without adequate attention to both the scholarly rendition of history, as reconstructed from the texts, and the ascetics' own version of their history, a large measure of which has been orally preserved and transmitted but which, nonetheless, describes itself as rooted in *vaidik* and *śāstrik* authority.

NOTES ON FIELDWORK

The Subjects

The material presented here is a product of four periods of field research in Benares, between 1976 and 1981, amounting to twenty-four months in all.[3] In the total ascetic population few are female, and many of these are mistaken for men, since at first glance they do not look like women. Not many Indians are familiar with the proper term for a female renouncer, *sannyāsinī* (Skt. *saṃnyāsinī*), nor with other words that refer to female ascetics (*brahmacāriṇī*, *bairāginī*, *sādhinī*). There is no common expression to convey the idea of institutionalized female asceticism. Those who are aware that female ascetics exist often use titles that are appropriate for males, or else refer to them by terms which indicate that they are good and spiritual women, but not—at least not directly—that they are ascetics.

During the course of my research in Benares, I located 134 female ascetics. Two of these women do not count Benares as their home base or spiritual home, but they make frequent pilgrimages to the city and have ties to other ascetics there. The 132 women and girls who identify Benares as their home are dispersed between twenty recognized, that is, legally incorporated religious establishments, the majority of which are residences specifically for

ascetics. Four of them are not primarily ascetic residences, but are temples in which an ascetic just happens to reside. Only two of the twenty-six establishments are exclusively female; the remainder are coresidential, both males and females being permitted under the same roof. An additional six residences sheltering female ascetics are not religious establishments *per se*, but rather, rooms in or attached to a householder's dwelling; nonetheless, some of these places have acquired a religious identity because of their occupant's presence and clearly ascetic daily round of activities. I visited all but three of the total of twenty-six places that shelter females. Additionally, my research took me to eight exclusively male establishments, thus allowing for some significant comparisons. Frequent interaction with male ascetics was not only valuable for the overall project, but also inevitable, given the nature of the community, with its coresidential emphasis. In all, I conversed with approximately two dozen male ascetics. Frequent contact was sustained with three of these who, for a variety of reasons, are knowledgeable about the female community and who thus became, along with three sophisticated, English-speaking females, key informants.

The twenty-six residences in which the female ascetics of Benares live vary greatly in type, size, wealth, number of residents, internal organization, status within the householder community and, of course, ascetic affiliation. Additionally, and not necessarily congruent with place of residence, the 132 female ascetics (and two pilgrims who count Benares as a second home) are distributed among eleven sectarian traditions and another three traditions or communities that reject sectarian identity. As well as gathering the life stories of as many of the female ascetics of Benares as possible and describing their practice and belief, this research has sought to locate the women within the larger ascetic fold as members of residential communities, however infrequent the daily interaction of these often peripatetic people might be, and as members of spiritual communities or lineages defined by sectarian affiliation.

The female ascetics considered in this study have all undergone some type of ritual which separates them from ordinary society; they have been initiated by a recognized preceptor into one of the many sectarian traditions of asceticism. In their religious belief and practice they differ little from the males among whom they live, but in their behavior and manner of dress, and in the way in which they think about themselves, they are strikingly different from the majority of women in Hindu society. As a class, these

women lead lives that are fully religious; they are members of a community whose raison d'etre is the attainment of salvation, *mokṣa*, and for this reason alone they stand apart from the larger society of Hindu women.

The Place: Kāśi (Benares)[4]

Benares, known officially as Vāraṇāsi, is perhaps the premier place to study asceticism because, among other things, it is believed to be the earthly abode of the god Śiva in his form as Yogeśvar, the greatest ascetic of all. Its ancient name is Kāśi, "City of Light." It is, in fact, the holiest pilgrimage site (*tīrtha*) of Hinduism and appears to have held this status for a very long time. Benarsis are still apt to call it Kāśi out of respect for its antiquity and sanctity. Within its boundaries lies concentrated the entire sacred geography of India. The city sits on the great and busy Ganges river, which many people lovingly call *Gaṅgā Mā*, Mother Ganges, in recognition of its practical and spiritual beneficence, for this river over the millennia has enriched the soil of the Gangetic plain and purified the souls of those who have come to bathe in its waters. There is a popular Hindi rhymed couplet (*doha*) which runs

> *Raṇḍ sāṇr sīḍhī sanpāsi*
> *Inse bace to seve Kāśi*

Loosely translated, this means, "Widows (*raṇḍ*), bulls (*sāṇr*), stone steps (*sīḍhī*), and renouncers (*sanpāsi*). If you manage to escape these, then you can enjoy the [spiritual] benefits that Kāśi has to offer." This sardonic representation of life in Benares derives its sense from the well-known and generally accepted belief that to live and, especially, to die in Kāśi assures a person the greatest benefit of all, *mukti* or *mokṣa*, liberation from rebirth (Parry 1981). Since nothing of worth is got without cost, to enjoy the fruits of living in Benares, one must put up with its vexations; foremost of these, according to the rhyme, are widows, bulls, the stone steps (of the bathing sites, i.e., the *ghāṭs*), and ascetics.

There are many widows in Benares, some of whom have been tragically reduced to begging; daily they line the streets and stone steps of the major bathing sites to solicit alms from those who come to bathe there. While others have become servants or have been forced into prostitution, a more fortunate few join singing circles specifically for widows, attached to certain temples, where they sit in rows clanging finger cymbals and singing devotional songs all

day long. As a reward for their continuous worship, temple admin-
istrators provide the widows with a daily meal. Kāśi is preemi-
nently the city of Śiva, whose animal mount is the bull. To mark
a special occasion such as the fulfillment of a vow, a young calf may
be released into the city in Śiva's honor. These calves forage from
refuse heaps in the lanes, and the stronger ones grow into huge
impressive bulls who everyone takes care not to irritate. Benarsi
people know well the temperament and preferences of the illustri-
ous bulls that roam in their district and proudly boast of their
virility. While it is always said, and patiently explained to foreign-
ers, that every foraging cow in Benares belongs to someone or
other, in fact none of these bulls belong to anyone. Like the great
god Śiva himself, they are undomesticated. The stone steps, the
ghāṭs, are central to the life of the city. They lead down into the
Gaṅgā and even though some *ghāṭs*, such as Assi, are not made of
stone at all but the raw clay of the river bank, they are nonetheless
a central attraction for pilgrims and all those residents whose re-
ligious commitments require a special or daily ritual bath. All the
most ancient and populous ascetic residences in the city are con-
centrated along the river's edge, especially in the area that lies
adjacent to and between the two cremation grounds, Maṇikārṇikā
and Hariścandra Ghāṭ. At two *ghāṭs* in particular one meets the
sanpāsis (derived from *sannyāsi*) referred to in the rhyme. All
renouncers are members of one order, the Daśanāmis, but they are
divided into several subgroups. Ascetics belonging to the two most
distinctive subgroups congregate at different *ghāṭs*: the Daṇḍis,
orthodox Brahmin fourth-stage renouncers, fastidiously perform
their ablutions on ancient Assi Ghāṭ; and the Nāgas, many of whom
care little for ritual or conventional religious propriety, spend the
larger part of their day lolling about on Hanuman Ghāṭ. It is these
sanpāsis that the couplet refers to as the last of the vexations the
visitor to Kāśi must avoid.

The Field: Encounter with Asceticism and Ascetics

On my first visit to Benares in 1973 I had noticed that many of the
beggars were widows, and the few references to the topic in the
literature suggested a relationship between female asceticism and
widowhood. I had also been told that there were women mystics
living in Benares, among them Anandamayī Mā, whom many people
honored as the greatest living saint in India. No one had indicated
that there might be communities of female ascetics, so when I

stumbled on one such group several months into my research, I was both surprised and encouraged. How could they have escaped notice? I decided to learn about their daily life and practice, and to determine how they fit into the entire field of asceticism so that I might describe the organization of female asceticism in Benares. I soon discovered that the ascetic style of life is highly individualistic, and that it was not entirely fruitful to pursue any sort of self-conscious organizational schema among the ascetics themselves. It is almost impossible to describe precisely bounded social structures until a great deal of data has been collected and a large number of historical and sociological studies have been consulted. Additionally, there is quite a bewildering variety of practices and beliefs. But these initial frustrations were balanced during fieldwork by the richness of the personal histories that the women offered me. At least half of the more than thirty adult women whom I met talked with me at some length. I discovered that the majority have an unusual background, a personalized and often idiosyncratic practice, and that they consider themselves somehow exceptional and set apart, not really women, yet certainly not men either. This active participation in the creation of their own destiny and awareness of themselves as individually unique contrasted with the householder women of my acquaintance. In addition to pursuing my interest in belief and organization, I ended by recording the life histories and even the dreams and visions which they spontaneously described, and so another dimension was introduced to the study: the women's experience and interpretation of their own asceticism.

The image and assessment of a woman in India, as in most places, is affected by her style of dress, and this was important to the way in which I presented myself. I wore the comfortable costume called *sālvār kamīz*, popular among young women at the nearby university. Liberal ascetics were not offended by this Islamic style, but in orthodox communities the proper garb of a Hindu woman, the *sārī*, was expected, as, indeed, it is in any situation where conventional Hindu values are honored, such as when visiting a temple. In this I complied. Styles of clothing are central both to feminine and to ascetic preoccupations and it is necessary for anyone, but women in particular, to consider this when living in such a complex sociocultural milieu. I was careful to conform to the expectations of a diligent student. All the women reacted positively when I indicated that I wished to study *dharma*, by which I meant "the Hindu way of life." But when I explained further my

interest in *sādhudharma*, the way of the ascetic, their responses were varied. A few stated emphatically that I must cultivate dispassion (*vairāgya*) and be sincerely motivated to undertake asceticism myself, or I would understand nothing at all. However, in the long run even the most cautious of the women enjoyed discussing their lives, not without insisting on their own virtues and reiterating the great merits of asceticism. Indeed, they were valiant defenders of asceticism in general, and of renunciation (*sannyāsa*) and celibacy (*brahmacarya*) in particular, as the highest and most desirable way of life. The majority were equally curious about me and my interest in their life, even though, ideally, they ought not to concern themselves with worldly (*sansārik*) matters. In theory, at least, ascetics have left their past behind together with its memories: "all has been abandoned," *sab kuch chora diyā*. Society judges them quite harshly and so they often feel the need to present an image of themselves in conformity with its highest expectations. But with familiarity and trust, this anxiety gradually eased. As I answered their questions about my mother, sisters, and brothers, and my unmarried status, they answered mine. It became obvious that those who were lonely and constrained enjoyed the chance to explore their lives and indulge in conversation.

Research in what is essentially an esoteric community poses specific problems, as do the conditions of Benares itself. There are severe stresses, both physical and emotional. The city is notoriously dangerous for someone not immune to the various sources of disease; though the Ganges spiritually purifies those who bathe in its waters, it also carries some very persistent parasites, and on two occasions I fell seriously ill. But perhaps more debilitating than the physical weakness which living there can induce is the confrontation with both psychological and social aberrance, against which I had no ready defense. To live closely with and study ascetics, many of whose excesses are sanctioned by tradition, presents a challenge. I found exposure to some of those who are recognized as adepts in magico-religious discipline quite disturbing. Few pursue the interiorized, obsessively fixed practices of occultism, but those who do are, by the standards of any culture whatsoever, exceptional and disconcerting people. Moreover they occupy a prominent place in the imaginations, and often lives, of all ascetics, so that their personages and accomplishments are never far from mind and are frequent topics of discussion.

In the end I was even more distressed by the suffering that I saw and was particularly affected when it touched the lives of

those I knew. When I last returned to the field, one of my ascetic acquaintances was in such a dangerously weak condition after badly performed surgery that she could neither take alms nor join a singing circle; she was in danger of dying. Several others suffered from chronic illnesses or repeated attacks of malaria and hepatitis. The great majority had, moreover, experienced much personal tragedy in their lives, the painfulness of which came to the surface in the retelling. This city, whose sacredness powerfully attracts the devout pilgrim, the impoverished beggar, the hardy ascetic, the weak and dying, and the religious eccentric, is a world of extremes. In studying the society of asceticism and female ascetics in Benares, one is forced to confront much more besides.

PROBLEMS ENCOUNTERED IN RESEARCH

Certain contingent factors affected this research, among them the outbreak of serious communal riots in the fall of 1977. An incident during a Durgā Pūjā procession in the ward adjacent to mine precipitated the riots, and for a period of several weeks my very productive visits to one of the largest communities of Bengali female ascetics were interrupted. Other problems arose from the character of asceticism itself. The community is socially deviant. I had not anticipated how difficult it might be to maintain the interest of a research assistant. The work seemed suitable for a young woman student, but in my first assistant's apprehensive and sometimes hysterical responses to certain of the ascetics she met while accompanying me, I saw, perhaps exaggerated, the disdain and fear that this life can provoke in the householder; though alert and intelligent, neither she nor any of her educated and very able friends could tolerate the, to them, aberrant world of female asceticism.

I soon realized that the subculture intrigues only those who are socially marginal or who for some reason are curious about the society in which they live. Individual ascetics as preceptors attract, of course, the devoted attention of many lay people. But fascination for a particular ascetic-as-guru seldom translates into a keen interest in ascetics as a class, or in the subculture as a whole. The two assistants who most enjoyed this research were both socially peripheral and nonconformist. One, a talented Bengali artist, unmarried even though in her late twenties, often sat alone sketching the life on the *ghāṭs*, inspired by the activity she saw there. The other, a young man who became my primary assistant, had been fully

initiated into an ascetic order in his adolescence. When I met him he lived outside the organized community but still followed many of its practices; toward the end of my research he formally rejoined the ascetic fold to lead a life guided exclusively by the values and codes of his order. As an ascetic himself, he knew the appropriate greetings, the secret language, and had much otherwise esoteric information that greatly facilitated my entry into certain communities. This was not the case, however, for three of the largest, female-led and, coincidentally, most orthodox of the communities, who were distressed or irritated by the presence of a youthful male; all sheltered young women or girls. Amongst them I made my own way with ease, occasionally aided by elderly and respected male ascetics who were also teachers of the girls or, more importantly, devotees of the female ascetic "mothers" who head the three communities.

Ultimately, of course, to acquire comprehensive knowledge of ascetic ideology or social life, a person must join that community by undergoing a formal initiation.[5] But one can still learn much without such a commitment. Although elements of its practice are indeed esoteric, the community is not socially exclusive; it freely tolerates, and in some sects even encourages the participation of lay folk in aspects of its life. (The truth is that the majority of householders are little inclined to involvement in the affairs of ascetics.) Given that traditional ascetic lifestyles attract fewer and fewer people, more studies, whether by initiated or uninitiated researchers, are urgently needed. Several other difficulties beset this study. It is not always easy to locate or keep track of ascetics. Their dispersed pattern of residence, the practice of itinerancy, and considerations of sex and gender each affected the research in different ways.

The female ascetics in Benares are not members of a single recognized or named social group. Some know only one or two others and there is no specific occasion on which they all congregate. The majority aim to attend, if at all possible, the Prayāg Kumbha Melā, but here they camp with the male sections of their particular order or sect. A few women ascetics live unobtrusively alone in the rooms of householders, dispersed throughout the city, and are not always identified as ascetics; they may be seen as a special type of widow. During the first months of research I spent a good deal of time simply trying to find female ascetics, following the vague leads that people gave me, observations such as, "A woman of ascetic appearance often passes through this lane," or, "I

have seen one who carries a trident and has wild eyes." These reports were of course heartening, but in the end it was often chance rather than direct inquiry that lead to their confirmation. Many female ascetics undertake pilgrimage and with some of them I could not sustain regular contact. In the city I observed their daily life and interaction with others, but they might well be at their home base one day and gone without warning the next. Other ascetic women, of course, come to Benares on pilgrimage. In this research I have included two female pilgrims who frequently visit the city. Though I observed them as transients, their very presence here is significant and indicates the geographical range of female asceticism. We see a central value of the renunciatory tradition, itinerancy, in practice and we also note how individuals are integrated into this rather fluid social universe.

Finally, considerations of sex and gender entered the research in an unusual way. A problem arose when the "female" ascetics I met were in fact male transsexuals or transvestites. All respectable forms of transsexuality and transvestitism in India are sanctified by religious tradition. In the course of this study, acquaintances who understood my research to be about female ascetics introduced me to several *hijrās*, transsexuals, popularly known as eunuchs.[6] In assuming that transsexuals are part of the community, these acquaintances had perhaps responded to the fact that, quite like some female ascetics, they are ostensibly dedicated to a religious way of life, yet are sexually ambiguous and socially disreputable. *Hijrās* are legitimate members of sectarian Hinduism: they undergo a lengthy apprenticeship and elaborate initiation rites, and they are largely itinerant. But they are not ascetic, and so I do not include them in the study. My informants' misidentifications do indicate, however, the company with which female ascetics may, in the popular mind, be associated. Transvestitism is a different matter because it is a well-established ritual component of ascetic Hinduism. These fully initiated and well-respected males participate in all public and private activities as women, but their order and practice are premised on the fact that as *men* they identify themselves with a female deity or her friend. They are thus female ascetics by gender and ritual practice, though not by sex. Both of those whom I met were uncomfortable in the presence of householders, but quite at ease with my male coresearcher.[7] Because they are members of distinctive subdivisions in some major sects, they are included in the outline of sectarian Hinduism presented in chapter 4.

RESEARCH METHODS

To discover the features of personal history and elements of ascetic life essential to sociological analysis, I designed a questionnaire with two sections. The first part focused on matters such as age, caste, education, marital status, circumstances of initiation, and the second on organizational details and the types and meaning of various practices. I rarely administered this in a structured situation, using it rather as a guideline for the essential facts I needed to gather in the course of conversation and observation. As a rule I first introduced myself to an individual or community and then made frequent visits, collecting information over a period of weeks or months. I also participated in a variety of private and public rituals, attending deity worship services and two communal feasts. In addition, I treated and was treated by ascetic women for various afflictions; while they employed magico-religious techniques, mine were more mundane, though I must admit that both methods appeared equally effective.

The only recording device I used was a camera. Visual markings are of great importance to ascetic identity: patterns painted on the forehead or arms, the colors of clothes, and the various items of ritual paraphernalia all have specific meanings which facilitate social interaction and provide clues to the doctrines underlying practice. The women are no less aware of the ascetic persona than their male counterparts, and this is encouraged by the general tendency to treat photographic representations of revered saints or gurus as icons to be worshiped, quite like the ubiquitous, brightly colored lithographs of the Hindu deities. (These lithos are popularly thought of and customarily called photos.) Many of the women requested that I take their photograph. Invariably, and without prompting, they carefully arranged their ritual items around them and then assumed a conventional pose of yogic piety.

Finally, a note on working with research assistants: Shortly after starting fieldwork it became clear that I would need an assistant, for at least two reasons. First, in the course of my research I had often to pass through or spend time in neighborhoods that are not entirely safe for a young single woman. (In truth, the average Benarsi considers it both foolhardy and improper for a woman to travel about alone anywhere in the city.) It soon became apparent that my work was both safer and more respectable when I arrived at a religious establishment in the company of at least one other person. Second, it also became evident quite early on that

this field research would require competence in languages other than Hindi and English. The Bengali and Nepali ascetic population is large, and while most Nepalis converse easily in Hindi, not all Bengalis do. The better-educated ascetics are also fond of Sanskrit terms, phrases and, of course, *mantras*. More than a few women and girl members of the relatively modern, postindependence institutions speak English, as do most of the older ascetic women from well-to-do Bengali families. We used this language interspersed with Hindi and, where relevant, discussed important Sanskrit terms in both Hindi and English. But Hindi was sometimes difficult when talking to Bengalis, who make up the majority of female ascetics in Benares, and for this reason I employed two Bengali-speaking research assistants, one male and the other female. As noted earlier, I had not anticipated how difficult it would be to locate and retain the services of a research assistant. In retrospect, I think that this was only partly because of the difficult nature of the research itself; of more importance, I had mistakenly believed at the commencement of the research that a female research assistant was absolutely essential and that no male could adequately do the job. As it turned out, though the two women who worked with me did manage to elicit some very emotional and intimate life stories, the two men who were my assistants proved equally, if not more, valuable because both had strong ties to the ascetic community.

Over the course of my several stints of fieldwork, I employed four research assistants, two men and two women. Both of the men had strong ascetic affiliations. One, Ravi Khanna, had been the lay disciple and personal attendant of a socially radical North Indian saint (now deceased), Nīm Karoli Bābā. The second, Bhairav Muni (Ravi S. Miśra), is a member of the Udāsin order, into which he was initiated as a young child. He reentered the order by taking full ascetic vows in 1983 and became the head of an Udāsi 'monastery' (*maṭh*) in Benares. Of the two women, one was a young Benares Hindu University student pursuing a sociology degree; and the other, an artist and university graduate in Fine Arts. As it turned out, by and large the various females we visited cared less about the gender of my research assistants than about their familiarity with asceticism. Once the young men had established their credentials by using customary modes of address followed by questions that quickly identified their preceptor (*guru*), lineage, spiritual home, et cetera, most female ascetics were far more at ease with them, and certainly more voluble about ascetic life in

general, than they were with my female assistants. In fact, a number of the older established ascetics were positively truculent in the presence of the young women, whom they regarded as weak and frivolous. However, most of the younger, gentler ascetics were kind to my two female assistants, genuinely flattered by our interest in their activities and beliefs. Some spoke candidly about their past and present lives, to the extent of discussing such varied and difficult topics as menstruation and spousal violence. As noted above, in the establishments that shelter young women and girls, the attention of male persons is, in general, unwelcome unless those men have an established relationship, spiritual or familial, with the senior "mother" of that establishment.

WHAT IS AN ASCETIC?

For the purposes of this study, an ascetic is a person who has been initiated into a tradition of asceticism by a recognized preceptor. This includes those accredited mystics and saints who have initiated themselves. In general, and with the attainment of maturity, entry into asceticism entitles a person to initiate others in turn, thus perpetuating a lineage. With this definition I exclude many people in India who pursue asceticism as part of their ordinary life. Asceticism is a virtue highly respected in householder life, and few people think of it solely with reference to the formally initiated community. On several occasions traditional, high-caste acquaintances who understood that my research was about female ascetics referred me to their grandmothers or aunts, with comments such as, "She lives a life of true ascetic discipline." Indeed, asceticism is appropriate to and expected of elderly members of orthodox families in general, and high-caste widows in particular. Both lead lives governed by dietary restrictions and celibacy, often devoting themselves exclusively to religious pursuits. Typically, they alter their style of dress to look distinctly ascetic by wearing only a single piece of cloth.

The regulations governing widowhood quite specifically dictate a lifestyle characterized by deprivation and austerity. One of the most oppressive features of the widow's enforced asceticism is the severely ascetical appearance she must cultivate: her head should be kept shaven and she is no longer entitled to wear a colorful *sārī*, but must tie a plain white *dhoti*, a much shorter length of cloth, over her body.[8] It is not surprising, then, that many people

mistakenly assume that certain sectarian female ascetics, such as the Vaiṣṇavas who also wear a white cloth and keep their hair shorn, are simply widows. Further confusion stems from the fact that widows and family elders often take a *mantra* for meditation from a guru, who may well be ascetic, and demonstrate their increased religiosity by prominently displaying sectarian bodily markings. Altogether, their style of life may conform in many ways to that of an ascetic. But, as the term is used in this study, these elderly or widowed persons, though ascetic in behavior, are not ascetic in identity. The crucial point to note is this: The entry of either a woman or man into asceticism is marked by a ritual rejection of the status of householder. For those who are not yet householders, it is a refusal; for those who are, it is an abandonment. In rejecting householdership, the initiate enters a society that is by no means homogeneous. Solitary ascetics apart, thousands of others are members of communities that are distinguished according to sectarian affiliation. The distinctions I speak of as sectarian are based on differences in doctrine and practice and, sometimes, on peculiarities of style or custom. Yet despite this great diversity, there is no systematic sex-based differentiation and thus there are no exclusively female sects or orders. The differences that exist between any two sectarian traditions are invariably greater than the differences that might exist between a male and female within the same tradition. In short, it is true to say that in the majority of traditions, being female is no impediment to ascetic discipline.

In the larger society, a woman's place is in the home, and her life is, ideally, governed by the body of religious law known as *strīdharma*, the way of life (*dharma*) appropriate to a woman (*strī*). Although the tradition identifies no body of *dharma* as specific to men, women's *dharma* is very different. *Strīdharma* presupposes that householdership is the only mode of life for a woman: to be a proper woman is to be a housewife. By contrast no distinctive *dharma* is prescribed for women in ascetic society. There is thus a disjunction between a woman's status in ascetic society and her status in the householder community. To understand the peculiarities of the female ascetic's status we must examine the *dharma* of woman-as-householder and then turn to the *dharma* of the ascetic.

In this book the first chapter outlines important features of the religious life of woman-as-householder. It looks at the textual definition of women's duties (*strīdharma)* and essential nature *strīsvabhāva*). These are placed in ethnographic context to demonstrate the importance of popular notions of women's duties and

nature. Both textual and popular traditions are relevant to women's pursuit and practice of asceticism. In the second chapter I discuss the life of those women who for various reasons fall outside the realm of householdership. Female ascetics come largely from their ranks and so we must note their special circumstances. But we must also know what it is that a female affirms in turning away from householdership, and so the remaining chapters focus on ascetic *dharma*. There is a textual notion of *yatidharma*, popularly known as *sādhudharma*, the way of life of the ascetic. It has influenced both renunciation (*sannyāsa*) and other developments within Hinduism subsequent to the Brahmanical definition of renunciation as the most acceptable form of asceticism. Today there are a great many sectarian traditions and a variety of religious or spiritual paths that, taken together with the underlying modes of asceticism, serve to define each person's particular discipline. These chapters, then, approach the study of female asceticism by focusing on features of two *dharmas*, two religiously defined ways of life: that of woman-as-householder and that of the ascetic, because female ascetics are women who have abandoned the former for the latter.

1

The Religious Life of
Woman-as-householder

Traditional textual sources that specifically forbid asceticism to women are few.[1] They occur in the religious lawbooks and focus on only one type, orthodox Brahmanical fourth-stage-of-life renunciation (*sannyāsa*). Often where the textual tradition does not directly prohibit, it nonetheless discourages, and conventional sentiment regards formal ascetic vows as inappropriate to women. As I. J. Leslie notes, "the concept 'female ascetic' is in itself an anomaly. For women are so identified with both family life and sexual pleasure that the idea of a woman renouncing these things is (from the orthodox male point of view) a contradiction in terms" (1989, 139). There is no known account of women's duties in any such text which suggests that asceticism is a viable, let alone desirable, alternative for a woman. Nonetheless, not only do female ascetics exist today, but there are enough descriptions of and indirect references to them in both classical texts and popular lore to suggest that women leading a wide variety of ascetic lifestyles have always been part of the Indian scene.[2]

Perhaps in no instance is the relationship between textual and popular tradition, the *śāstrik* and the *laukik*, more complex than when women are the subject of discussion. Indeed, the peculiar tension in the *śāstrik-laukik* relationship is implicated in the glaring contradictions and pronounced ambivalence that characterize the attitudes of both women and men toward the very fact of femaleness (Srinivas 1978, 28). While the lawbooks contain the Brahmanical statement of the duties in life appropriate to women, the average woman ignores, neglects, or otherwise considers irrel-

evant many of its injunctions. Her daily life is more likely to com-
bine certain textually defined prescriptions with many that are not;
so, in a sense, the ordinary woman's idea of her role contains both
more and less than the textual view. Simultaneously, many of the
most persistent and popular notions about women and femaleness,
notions that might typify the worldview of any ancient, complex
agricultural society, are well enshrined in the orthodox textual
assessment of women. Appreciating the interplay between official
and popular perceptions helps clarify the ambiguous status of the
female ascetic in Hinduism and of women in general in that tradi-
tion. Furthermore, it allows us to make some sense of the fact that
female ascetics exist at all.

THE TEXTUAL DEFINITION OF
WOMEN'S ESSENTIAL NATURE AND DUTIES

In regard to women, the lawgivers confront two separate but di-
rectly related issues. They have to establish and describe the inher-
ent nature of woman (strīsvabhāva), but also to determine her
appropriate duties in life (strīdharma). A distinction between no-
tions of nature and duty appears also at less formalized levels of
culture, often with contradictory implications. Thus, for example,
in the course of casual conversations about female ascetics, I noted
that those people who consider asceticism legitimate for women
often rest their case on an appreciation of strīsvabhāva, appealing
to features of what is perceived as woman's basic temperament or
essential nature, stressing that they have an innate capacity for
asceticism and for attaining spiritual release. Their opponents more
commonly appeal to strīdharma, insisting that various features of
asceticism violate the duties in life required of a woman.

As we shall see, the classical authorities express opinions
about the nature of women that are contradictory, although their
duties are quite carefully described throughout the literature,
usually as part of more general discussions of dharma. There is
only one extant text devoted specifically to the topic, the late
medieval Strīdharmapaddhati (Sdhp).[3] Although there are dif-
ferences between religio-legal texts, composed over a period of
more than a thousand years, taken together with other major
religio-legal texts such as the Manusmṛti this text serves well to
illustrate certain basic features of the śāstrik conception of
strīsvabhāva and strīdharma.

One section of the *Strīdharmapaddhati* takes *strīsvabhāva* as its topic (*Sdhp* 21r.3–22r.8; Leslie 1989, 246–72). From this text we learn that, owing to the processes of menstruation and childbirth, woman is innately impure. Moreover, she is inherently sinful (*adharmik*), that is, she has no natural inclination to *dharma*. Woman is thus not an appropriate candidate for sacred knowledge: she is "without a *mantra*" (*amantravat*). That is, she is unfit to hear and pronounce the sacred Sanskrit formulae (*mantra*) essential to orthodox religious practice. Being sinful and without a *mantra* poses an insoluble dilemma: "being sinful, a woman is *amantravat*; being *amantravat* she cannot purify herself of sin; she therefore remains sinful all her life" (Leslie 1989, 246). From these three features of *strīsvabhāva*, viz. that a woman is impure, sinful, and prohibited from having a *mantra*, certain rules for behavior inevitably follow. Tryambaka, the author of the *Strīdharmapaddhati*, quite carefully delineates the duties of women so as to accommodate their faults.[4] Of the many specifications of *strīdharma*, we will consider those that have special implications for female asceticism.

First, because of her impurity a woman's daily life requires a great number of ritual acts designed to remove or contain this special impurity and to maintain achieved states of purity. In fact, in this text as in others, women are assimilated into the fourth and lowest status class, that of the *śūdra* (e.g., Manu V.139; cf. Orenstein 1968, 122–23).[5] The allocation of women to *śūdra* status is important in the question of women's right to undertake formal asceticism. In the classic debate over who might become renouncers, those who permit *śūdra*s to enter *sannyāsa* recognize, by extension, the right of women also to undertake that form of asceticism (Chakraborti 1973, 93; Olivelle 1977, 33–34). So consistently were women identified with the lowest *varṇa* that the issue became significant in the development of sectarian movements: both historically and today the liberality of a sect is measured by noting whether it grants admission to "women and *śūdra*s." Further, in a reversal of values, the notion that women are essentially impure gains a special positive significance in those sectarian traditions that adopt a radical *tantrik* ideology. We shall return to these themes. For the moment, the important point to note is that from the perspective of orthodoxy, women's inherent impurity places strict limitations on their participation in certain religious rituals and statuses.

Second, because women are sinful, having no natural inclination to *dharma*, they need to be continually goaded and reminded

of their duties, and so remain perpetually dependent. As stated by the renowned lawgiver, Manu, in her progression through life a woman should always be under the authority of some male person: first father, then husband, and finally, in old age, son (Manu V.148, IX.2–3). They alone can protect her from her own sinful nature and her wanton passion. Women are inherently sinful, and the *dharma* of both male and female householders is designed to accommodate this fact. In certain sectors of orthodox asceticism, many notions based in householder ideology are maintained and so, as just noted, some people would argue that a woman's impurity, like that of a *śūdra*, renders her unfit for Brahmanical asceticism in particular. We can now see that women's sinfulness poses an equally important obstacle, especially to those forms of asceticism that assure their practitioners freedom and independence. Impurity and sinfulness are not inextricable: We will see that in some sects, conventional criteria for purity are ignored and women and *śūdras* are welcomed with open arms. But while these sects assume that asceticism itself purifies one's qualities, they nonetheless recognize sinfulness as a major problem, and so the majority of their ascetics live in a dependent status under the authority of a guru. Girls and women are found in disproportionately high numbers in these traditions, a fact which poses few problems for the average householder. Given a theory about women's inherent nature which stresses that she should be always controlled, this type of asceticism is entirely appropriate to her.

Third, the fact that women are entitled to neither hear nor speak a *mantra* has certain far-reaching implications. Orthodox rituals are accompanied and rendered efficacious by the uttering of these sacred verbal formulae, so the fact that a woman is *amantravat* prevents her performing major religious roles. For example, she should not conduct any form of ritual deity worship requiring the use of classical Sanskrit *mantras*, whether in a public temple or a domestic shrine. Women may in fact spend a good deal of time each day in the household shrine but, as Leslie notes, "their worship is strictly devotional. For unless a woman has been initiated, taught the *mantras* and what to do, she may not offer *pūjā* [worship] herself; her husband or a priest must do it for her" (Leslie 1989, 180).[6] The historical process whereby women became—in the eyes of the lawgivers—unfit to hear or recite sacred formulae is not entirely clear, but it is correlated with the exclusion of girls from the first of the four stages of life, Vedic studentship. As noted in the Introduction, the life-transition rite that marks entry into

studentship is called *upanayana*. During the *upanayana* ceremony, a sacred thread is bestowed on the initiate, who thus formally undertakes the life of a Vedic student and simultaneously enters the so-called "twice-born" (*dvija*) community. This consists of the top three status classes, who, by this ritual of "second birth," are distinct from and superior to the lowest and, theoretically most impure class, the *śūdra*. This first stage of life, *brahmacarya*, is to prepare the student for ritual and social adulthood as a twice-born member of society; under the careful guidance of the preceptor-*guru* in whose house the student resides, he or she studies the Veda and learns to perform Vedic ritual, most notably maintenance of the sacred fire with its accompanying *mantras*. There is good evidence that in ancient times girls underwent the sacred thread investiture and were educated together with boys (Kane 1941a, 293–95, 365–368; Altekar 1973, 13–16, 200–04), which would of necessity make them conversant with Vedic *mantras*. By 500 BCE, however, the *upanayana* had become for girls a symbolic rite performed just before marriage (Altekar 1973, 203). A few centuries later, prescriptions in the *Manusmṛti* indicate that the initiation of girls continued, but without the recitation of the sacred formulae. Leslie rightly observes (1989, 37) "the lack of Vedic training for girls made nonsense of their use of mantras." Finally, by the time of the lawgiver Yājñavalkya, 100 BCE–300 CE, women had lost the right to the *upanayana* initiation and subsequent Vedic studentship altogether (Olivelle 1977, 22 n.5); in the process they had been relegated to *śūdra* status and effectively excluded from all the classical stages of life but one, householdership. Householdership is entered by the ritual of marriage, as studentship is entered by the ritual of *upanayana*, investiture with the sacred thread. By the early centuries of this era, the Brahmanical lawgivers had established a direct parallel between the sacred thread investiture (for boys) and marriage (for girls); and thus, between Vedic studentship (for boys) and householdership (for girls). In this way provision was made for a girl's "education": While a young man should become a student and study at the feet of his *guru*, a young woman should marry and become a householder, taking her husband as *guru*, the house of her in-laws as her school of learning, and the dutiful performance of all the tasks of wife and daughter-in-law as her special education. In short, for a girl the ritual of marriage actually replaces the *upanayana* (*Sdhp* 2r.8–9). As the Manusmṛti (II.67) succinctly puts it: "The nuptial ceremony is stated to be the Vedic sacrament for women (and to be equal to the initiation), serving

the husband (equivalent to) the residence in (the house of the) teacher, and the household duties (the same) as the (daily) worship of the sacred fire." We can now more clearly see why Hindu thought conceives of the ideal woman in terms of marriage and family life. Marriage provides for her proper education, and is the sphere within which her spirituality should flourish.

Like many other religiously defined lifestyles, that of the ideal Hindu woman involves self-denial and self-sacrifice. Its truly striking feature is the pivotal role played by the husband. A reading of the texts shows that of all the specifications of *strīdharma*, those that focus on the husband are perhaps the most dramatic. Out of the wide range of customary religious practices the one that most typifies a wife's religiosity is the vow (*vrata*), of which one stands above all others: *pativrata*, self-abnegating love for and devotional service to the husband (*pati*). The *Strīdharmapaddhati* contains a lengthy section in praise of the *pativrata*, the woman who excels in all the virtues of wifely devotion (*Sdhp* 27r.4–33v.8). The entire range of a woman's duties is conceived of as a vow which takes the husband as its focal deity. This imperative continues even after his death so that the virtuous widow worships her deceased husband using his portrait or an image of him in clay (*Sdhp* 45v.9–10). Indeed, according to this text, religious acts other than devotional service to the husband are superfluous and to be avoided (*Sdhp* 22r.1–6). Tryambaka opens and closes his treatise with the bold assertion that obedient service to one's husband is the primary religious duty of a wife (*Sdhp* iv.2; 48v.7–8).

ENABLING FEATURES OF WOMEN'S *DHARMA* AND NATURE

If this were all that textual tradition had to say, women's social and religious lives would appear to be almost impossibly constrained. But there is more. In prescribing certain elements of *strīdharma*, they insist on the complementarity of woman and man, an idea especially conveyed in the notion of woman as *ardhāṅginī*. The word is compounded of *ardha* (half) and *aṅga* (limbs of the body) and refers to a woman as being half of her husband. (When used by a man in a place such as Benares, it usually contains the same touch of self-mockery as the Englishman's calling his wife "my better half.") Today, as in the past no doubt, people often illustrate the notion of *ardhāṅginī* by pointing out that a man's wife is his necessary partner in the performance of sacrificial rites centered

on the domestic fire.[7] The *Strīdharmapaddhati* states quite clearly that her presence is essential (*Sdhp* I.14). Moreover, all the prescribed domestic *pūjā*s, whether for gods or guests, require that a man's wife be in attendance and assist. A woman's *amantravat* status remains, however: At the rituals of the domestic fire, the formulas are spoken by the husband and other nontechnical performances are done by the wife.[8]

It is difficult to assess the significance of this ideal male-female complementarity. Text-historical studies demonstrate that the erosion of women's ritual participation has been a long-standing fact, though the process was probably gradual: By reading between the lines of even very early Vedic texts, we can see "an increasing isolation and exclusion of women by men from 'their' rituals" (Smith 1991, 22). Certainly, the contemporary feminist appraisal of women's social and religious status in Hinduism dismisses the notion of *ardhāṅganī* as having any real benefit for women.[9] If it is not true to say that women were religiously disenfranchised (Altekar 1973, 204, 206), it is still the case that within the sphere of orthodox Brahmanical ritual their religious activity was narrowly circumscribed.

CONTEMPORARY HINDU WOMEN'S RELIGIOUS LIFE: THE ETHNOGRAPHIC EVIDENCE

Until recently, very few studies focused on the everyday religion of women in Hindu India. Women's religious life was, by and large, subsumed under the more general sociological study of marriage and family life. The paucity of studies is quite remarkable given the fact that as early as 1920 M. S. Stevenson introduced us to the body of religious belief and practice that is the property of women exclusively, and which some people, only half in jest, refer to as "the Fifth Veda" (Stevenson 1971, xiii). The idea that women have their own religion is common enough; indeed, this religion has a name: *strī-ācār*, the tradition (*ācār*) of women (*strī*). What has been rarely noted is that this women's religion, though not entirely *śāstrik*, is nonetheless compelling and essential to the welfare of all members of society.

For example, all the major textually defined initiation rites are effective only when the women of the family participate. They perform many exacting and often colorful rituals as part of rites such as the *upanayana* and marriage, which are officially conducted

by the family priest. Knowledge about these women's ritual tradi-
tions is transmitted orally and a significant portion of it has no
textual correlate. On the whole, neither women nor men consider
these rituals frivolous or optional; their fastidious performance is
as necessary to the progress of the rite as the priest's correct pro-
nunciation of his *mantras*. I have heard men declare that it is the
women of the family who are genuinely knowledgeable in religious
matters, including details of the rituals that men themselves must
perform as part of their caste duties on important occasions.[10]

In recent years our knowledge of women's religion in Hindu-
ism has greatly increased. With the publication of major studies
by anthropologists such as Susan Wadley (1975, 1977a, 1977b,
1980a, 1980b), Doranne Jacobson (1977, 1980), Veena Das (1979),
Sylvia Vatuk (1980), Lina Fruzetti (1981, 1982), and Lynn Bennett
(1983), we now have much more information about the everyday
religious life of women in several sectors of society. Some of these
observers vividly convey how the women they studied perceive
their own religion. We come to know from Sylvia Vatuk, for ex-
ample, that women, who as noted earlier are excluded from the
classical four stages of life scheme, have their own notion of life
stages. Among the Rajput women she has studied, renunciation of
householdership has little virtue at all; on the contrary, for a
well-established woman who has worked her way up through the
entrenched hierarchy of the extended family, from humble daugh-
ter-in-law to head lady of the household, the taking of *sannyāsa*
would amount to a complete capitulation to her own daughter-in-
law (Vatuk 1980, 304). Another anthropologist suggests that
women have an alternative myth structure so that, for example,
the aspects of the goddess honored by men and the myths conven-
tionally represented as the goddess myths of Hinduism, have little
personal significance for women. Thus, while men honor Durgā,
women prefer Parvatī and her myth cycle; women tell myths about
classical goddesses that men do not report; and, even more inter-
esting, women often have an entirely different way of telling the
same myth a man might proffer as the explanation for a particu-
lar ritual (Bennett 1983, 236ff).

A thorough reading of the anthropological and sociological lit-
erature would allow us to see if and how the specifications of
classical *strīdharma* are worked out in everyday life. In addition,
it would amplify our understanding of *strī-ācār*, women's tradi-
tion, so that we could better ascertain the relationship between

the body of customary practice and textually defined duties that together constitute women's religious life. However, at this point I wish to consider only three topics, topics that I have noted briefly above and that are important to the study of female asceticism. They are: women's religious vows, women's rituals of worship, and the notion of a uniquely female purity. Even a cursory treatment of *vratas* and *pūjās* (which I will consider together) will serve to highlight the ways in which the religion of the average housewife differs from that of her ascetic counterpart; and a brief discussion of why popular sentiment supports the notion of the unique purity of women will enable us to clarify how, textual prescriptions notwithstanding, many people consider asceticism appropriate for women.

WOMEN'S RELIGIOUS VOWS AND WORSHIP RITUALS

The Importance of *Vratas*

Ethnographic evidence overwhelmingly supports the textual portrayal of women's religious life as centered on the family and defined by the roles of sister, wife, daughter-in-law, and mother. Nearly all of the very many regular and periodic rituals the average woman performs are intended to ensure the survival of infants, the health of brothers, children and husbands, and the general welfare—especially the economic good fortune—of the extended family and lineage (Wadley 1977a, 1977b, 1980a; Jacobson 1977, 1980; Bennett 1983). Of all the duties specified in classical *strīdharma*, the one that is perhaps most important today is the religious observance or vow. In part, people's assessment of a woman is based on the number and severity of her ritual acts of self-denial, and of these the *vrata* is the most common.

The *vrata* is a type of religious observance that has fasting as its central feature. It is a "votive rite" in that it commences with a statement of intent to undertake the observance for the achievement of a specific goal.[11] A *vrata* may last for one or two days, or for several weeks; its timing is determined by the lunar cycle and other planetary configurations (in the case of regular calendrical ones), or by consultation with an astrologer (in the case of optional or supernumerary ones). Elements of some *vratas* are quite social affairs that involve group singing or chanting, recitation of

religious stories, and the construction of intricate, symbolic floor patterns out of powdered or colored rice. But the most character- istic feature of the *vrata* is the fast, so much so that the word *vrata* is popularly translated as "fast" (Tewari 1982, 43). Certain *vratas* invite the participation of other family members and friends, and include a *pūjā* that entails the ritual worship of diagrams, imple- ments, animals, people, or deities that figure in the overall struc- ture and intended purpose of the *vrata*.

The vast majority of *vratas* are pursued for the benefit of hus- bands and sons. In addition to undertaking any or all of the vows from the annual cycle of *vratas* followed in a given region (the cycles appear to vary from one area to another [Wadley 1980a, Logan 1980, and Tewari 1982]), a woman may spontaneously de- cide to undertake a vow at any time. A woman decides to observe a vow because she has heard about it from a friend or female relative, or because she has been so advised by a *guru* or teacher and because she perceives it to be the best solution to a problem. So central is the vow to the lives of ordinary Indian women that it may be taken as tantamount to female householder religiosity it- self. As I discovered through general conversation, in Benares at least, should one wish to learn whether or not a woman is "reli- gious," the question to ask her is, "What *vratas* do you keep?". Close relatives are always aware of a woman's pledge to keep a fast; indeed, some women keep so many *vratas* so often that family members become alarmed for their health, and sometimes even irritated at their performance.

As noted earlier, the *dharma* literature elevates one feature of *strīdharma* above all others as the criterion of a woman's worth: *pativrata*, the worshipful service of one's husband.[12] Some sociolo- gists describe the compelling force exerted by society's expectation that all young girls should mature into paragons of *pativrata* (e.g., Gough 1956, 841–42; Srinivas 1978, 18; P. Mukherji 1978, 17, 50– 51). Others focus on a young woman's acquiescence to her husband's authority, or, if Veena Das's observations are correct (1979, 97), the projection of acquiescence, as the most characteristic feature of a woman's relationship with her husband. It is my observation that precisely because the submissiveness of *pativrata* is so formalized and routinized, conformity to this ideal serves far less as a crite- rion for measuring a woman's devotion to her husband and her religiosity as a whole, than does the performance of religious vows or ritual observances like the *vratas*. Unlike *pativrata*, the reli- gious vow demonstrates a woman's active and often spontaneous

decision to take a difficult problem into her own hands, to command the attention and respect of men and gods, and to effectively coerce them both.

Women's Rituals of Worship

Vratas often entail a ritual of worship, a *pūjā*, but women's *pūjās* must not be confused with orthodox forms of worship, which require both the use of Sanskrit *mantras* and a high level of sustained purity. Women are forbidden *mantras*, menstruate, and give birth to children, so they cannot, in theory at least, be priestesses in orthodox temples. But women may and do, especially in the south of India, act as oracles or priestesses at small shrines to non-Sanskritic deities. They may even act as priestesses in larger temples, especially to the goddess, provided they have received a sectarian initiation into the proper performance of worship rituals. But the *pūjās* performed on the occasion of *vratas* and as part of exclusively female festivals are quite different from all of the above.[13] Whether done alone or in groups, women's *pūjās* employ no *mantras* at all. They require no special initiation, though they are complex and must be learned from older women. Tewari notes that there is room for elaboration and creativity in the performance of these *pūjās* and that "the womens' memory for ritual detail is astounding" (1982, 43). In the *pūjās* I have observed, the images of the deities are fashioned by the women, out of clay or the like. They make simple offerings of flower petals and rice, enact playful dramatic performances, and invariably sing popular songs and tell stories. Interestingly, on certain occasions the womens' husbands may preside over or participate in the worship ritual associated with a *vrata*, but, as Tewari points out, "women tell them what to do at each moment of the ritual" (1982, 43).

I have touched on these two elements of *strī-ācār*—religious vows such as the *vrata* and deity worship—in order to highlight, by comparison, several points pertinent to the topic of female ascetic religiosity. First of all, the religious life of the average woman, that is, the woman who is wife, mother, and householder, is almost exclusively concerned with the well-being, the fertility, health, and prosperity, of persons other than herself; even those rituals designed to assure or increase her own fertility are ultimately for the promotion of the lineage. Second, it is, in the main, self-effacing and requires the conscientious submersion of her individuality. Third, it is exclusive, that is, the large body of practice and belief

characteristic of women's religious life is theirs alone; it is orally transmitted from one woman to another and, though we do find in it certain textually based prescriptions, the greater portion of it is nonetheless popularly conceived and sustained. In short, the married woman householder has a religion that is practical or "this-worldly,"[14] essentially altruistic, and almost exclusively feminine. By contrast, we shall see that the religion of the woman who becomes an ascetic differs from that of the woman householder both in its specific practices and general orientation. She joins a community whose religiosity is not sex-differentiated, and whose goals are distinctly other-worldly. Rather than the welfare of others, she seeks the goal of spiritual liberation, and the liberation she seeks is her own.

WOMEN'S INHERENT NATURE AND THE LEGITIMATION OF FEMALE ASCETICISM

Some of the most interesting discussions in the course of this research turned on the question, "Are women entitled to become ascetics?" I was particularly keen to learn how nonascetics might respond to this question. Though the major part of my work was conducted among ascetics, I lived and interacted with householders who were often well aware that the greater part of my day was spent with women ascetics. So even without directly raising the issue, acquaintances often volunteered their opinions. In Benares many people affirm women's right to asceticism, or assert that formal asceticism is an appropriate way of life for a woman, should she wish to undertake it. By and large, the arguments advanced in support of female asceticism appeal to various features of women's personality, to characteristics that are believed to be inherently female. And though some of these features find explicit expression in the textual assessment of women's inherent nature, others are only vaguely represented or else not mentioned at all. There is a wide variety of popular notions about the inherent nature of women, some of which amplify, while others contradict, *śāstrik* textual formulations.

Only certain elements of the *laukik* list of women's innate characteristics are directly relevant to female asceticism. The suggestions, observations, and arguments that my question elicited frequently explored dimensions of womanhood rooted in a large and seemingly nebulous concept: the auspicious (*maṅgal*). The concept of auspiciousness raises issues that go far beyond the limits of

this study, but it merits some attention here both because it informs popular perceptions of womanhood, and so understanding its essential features will amplify the textual formulation of *strīsvabhāva*, and more specifically because certain ideas Benarsis raise in their discussions of women and asceticism prove, on closer examination, to be special and particularized expressions of it.

AUSPICIOUSNESS AS A VALUE IN THE ASSESSMENT OF A WOMAN

I noted earlier that an inconsistency in the textual assessment of *strīsvabhāva* might be resolved by reference to popular sentiments. The *Strīdharmapaddhati* poses a problem: it states that women are impure and yet, simultaneously, that they are possessed of a purity that men do not have. How can this be? In addition to the pure-impure axis defined by orthodox concerns for the avoidance of pollution, auspiciousness sees a qualitative difference between those things, places, times, animals, and persons that are auspicious and those that are not. Such notions appear to be highly developed in popular tradition, particularly as they apply to women.[15] This is a largely unexplored topic, but as far as I can tell it is woman's auspiciousness, her being *manglik*, that accounts for her being pure in a way that man is not. Auspiciousness or inauspiciousness can invert a person's status as defined by conventional pure-impure criteria. Thus, for example, the highly impure prostitute is an auspicious figure, yet a widow, even if she is chaste, circumspect, and meticulous in matters of ritual purity, is nonetheless an embodiment of inauspiciousness.

Not every individual woman is *manglik*, but both woman and femaleness as notions, and women as a class are. Auspiciousness rests on two principles, fertility and nurturance, the power to give and maintain life, and it thus pertains to females of all species. Its relationship to fertility and nurturance is translated into various socially recognized forms, from the honor accorded a woman who bears many sons to the abhorrence felt for those who are intimately associated with death. The young bride is often called *grhalakṣmī*, literally, "the Good Fortune of the household." Lakṣmī is the divine personification of good luck and wealth, and the phrase indicates that the bride's very presence—inasmuch as it presages children—foretells wealth for the family. By giving birth to sons, she strengthens the lineage, and a family with many sons is bound to prosper. For a girl to prove barren is a most awful curse, which renders her, as does widowhood, supremely inauspicious. Nurturance

and maintenance of life are evident physically in a mother's giving of milk, and emotionally in her selfless love and tender devotion to her children. Woman thus appears as an active, life-engendering, and powerful being. These capacities are generalized and her ability to effect increase is transformed into the notion that her very presence in the household is Good Fortune.[16]

THE SPIRITUAL VALUES OF FEMALENESS

How does this provide a basis to legitimate female asceticism? All the values implicit in auspiciousness would appear to discourage rather than promote asceticism as a way of life for women. In the act of elevating and glorifying certain dimensions of femaleness, Hindu tradition takes what we view as fundamentally biological and social facts and transubstantiates them, so to speak, assigning them a supreme spiritual value. The auspicious character of femaleness bears with it two related spiritual powers: nurturance presupposes an especially expansive repertoire of emotions that are powerful enough to change the ordinary course of *sansārik* existence; and parturition, as an expression of ultimate power, suggests that women are somehow closer to the very source of life itself. Anyone who takes formal initiation does so with only one goal in mind, spiritual liberation. To this end the spiritual implications of woman's emotionalism and reproductivity can be her greatest asset. Both these facts of femaleness, nurturance and parturition, figure in ordinary discourse and support the assertion that, for some women at least, asceticism is an entirely appropriate and legitimate enterprise.

WOMEN'S NURTURANT EMOTIONALISM AND PASSION AS A SPIRITUAL FORCE

The first point—that women are expansively and uncontrollably emotional—is one of the most common observations made about women. It is noteworthy that in discussions with even learned men and women on the topic of women's right to asceticism, no one ever made reference to the decidedly negative, textually based observations about *strīsvabhāva* such as that discussed above, which sees women as impure, sinful, and without a *mantra*, and thus ineligible to take *sannyāsa*. Rather, many pointed to a feature that they themselves consider woman's greatest strength, her capacity for strong emotions of love, nurturance, and passion. Educated Benarsis,

both ascetic and householder, told me that women are emotional in the extreme. Some, largely men, went further with statements in English and Hindi to the effect that "women have too great a capacity for *vāsanā* [passion]." (*Vāsanā* means enjoyment in a general sense, but it always carries with it the notion of sexual enjoyment, carnal pleasure.)

These factors would seem to contradict the fundamental prerequisite of asceticism, dispassion, *vairāgya*. Yet it is generally acknowledged, even by these same men, that, although it may not be altogether appropriate for a woman to become an ascetic, when she has entered that life, it is *easier* for her to attain liberation. And people admit that those women who follow their discipline well do become liberated. Indeed, as both householders and ascetics frequently reminded me, among the greatest women of India are Andal, Mirabai, and Mā Anandamāi: all three are renowned for their asceticism, and all three are saints, that is, *jīvanmuktas* (liberated souls). Perhaps a direct link between women's emotionalism and liberation is forged only in popular imagination, expressed as a part of the informal, unofficial, and, largely oral folk tradition. The issue appears to turn on certain differences in the assessment of the content of the highest spiritual state. Both popular and textual tradition hold that the visible evidence that a person has attained liberation is that she or he easily enters into a state of meditative trance (*samādhi*). While philosophers disagree about the ontological status of *samādhi*, most ordinary people, including many of the women I met, conceive of it more simply: in their view, it is an extraordinarily refined, yet nonetheless emotional state of bliss, a state in which, as one English-speaking female ascetic told me, "you get union with God." On this account it can be seen that women's passion and capacity for intense emotion serve her well. Ideally, of course, both of these should be converted into acceptable expressions of devotionalism or bliss. Formal asceticism allows for some rather dramatic acting out of intense passion; most disciplines recognize that emotional outbursts may be a legitimate means to the attainment of release and conclusive evidence that one has indeed achieved such a state.

ŚAKTI AS A SPIRITUALLY SUPERIOR, FEMALE POWER

The second "fact" of woman's auspiciousness, parturition or reproductivity, also figures in informal discussions of female asceticism, but in a more subtle way. It is perhaps the main source of the

insight contained in the textual assertion that woman has a unique purity. Both men and women—but predominantly men—state that from the perspective of the ultimate goal of human existence, that is, the eventual attainment of spiritual liberation, woman's greatness lies in this fact: without her, humankind could never attain release, no one would ever escape *sansār*, the transient world, at all. It is woman who, by giving birth to us all, provides the opportunity for *mokṣa* in the first place. She gives us *mokṣadān*, the gift of liberation, and must therefore be the superior form of sentient being. Dimensions of this cosmological argument are evident in nearly all religio-philosophical systems (*darśanas*), and the idea figures prominently in the official philosophy and folk theology of all *śāktabhaktas*, those who are devoted to the goddess (*devī*), or the feminine principle (*śakti*), as the supreme expression of divinity. The majority of Bengalis are *śāktas* and, on the whole, they accord greater respect to women ascetics and saints than do other Hindus. As said earlier, there is a disproportionate number of Bengalis among both the female ascetic community in Benares and the householder clientele of those women who are recognized as preceptors, whether or not these female *gurus* are themselves Bengali. The *śākta* mode of thought typically gives spiritual expression to the fertile, reproductive dimension of auspiciousness. Here, the potency or power (*śakti*) attributed to woman is in recognition of her life-generating capacities.[17] Even though for a female ascetic the salvation that this power provides is primarily her own, people still assume that the power is available to them also, because that is how things are with women in the world at large.

Having introduced the notion of *śakti* it is appropriate at this point to note that this concept has another, more controversial implication. Those who see women as the incarnation of *śakti* may well emphasize sexuality rather than reproduction as the foremost feature of this embodiment. Such an interpretation has legitimate roots in both textual and popular notions about woman's inherent nature, but to articulate it fully presupposes more than a passing acquaintance with *tantrik* ideology. Thus, though many sectors of the ascetic population have appropriated the idea of *śakti* as female sexual power, householders are rarely familiar with it. Translating the doctrine of yoga and the Sāṃkhya tradition of philosophy into practice, certain *tantrik* disciplines require that male and female practitioners engage in ritualized sexual intercourse. In this manner, the union of the feminine and masculine principles, Śakti and Śiva, is effected. Ritualized sexual intercourse is, in its most elabo-

rate forms, confined to only a minority of sects, but members of that minority most certainly condone female asceticism. Although in fact few female ascetics act as ritual partners to a male ascetic or householder, or aspire to the *tantrik* path, because *tantra* so effectively pervades asceticism as a whole, the status of all female ascetics is affected by *tantrik* formulations. Textual sources are always written by men, and so portray the matter in androcentric terms: in such rituals, woman is primarily the agent of man's salvation, but oral traditions among female *tantriks* do not present it this way. There are even more extreme *tantrik* sects which require their practitioners to indulge in many polluting acts, from necrophagy to sexual intercourse (for men) with a woman who is, ideally, both a prostitute and menstruating. These sects attribute the power of the sexual ritual less to the inherent virtues of woman as the embodiment of *śakti* than to the dramatic effect of immersing oneself in impurity. In this case, power is rooted in the specifically female impurity of menstruation and childbirth, and arises out of a complete inversion of the normal order of things.

In examining the practice of a given sectarian tradition, it is not always possible to determine at first glance whether its assessment of women is based on a valuation of *śakti*, feminine power in its auspicious form, or on the reversal of conventional criteria, the efficacy of impurity, women's uniquely dangerous power. I return to the specifically tantric codifications of Śaktism in the discussion of sectarianism in chapters 3 and 4. For now, it is important to note that from the perspective of women themselves, whether householder or ascetic, and from the perspective of the populace at large, the notion of power that is central to women's religiosity is one linked with auspiciousness rather than impurity.

In this chapter I have focused on the religious life of woman-as-householder, noting how despite the careful definition of a woman's duties and the specificity of her religious rituals, there is still a complex and rather ambiguous range of notions about the inherent nature of woman, and how some of these can provide justification for a woman's becoming ascetic. But few do: The dominant model of womanhood locates her squarely in the domain of householdership. Values such as auspiciousness, ritual purity, and chaste obedience are crucial primarily in the definition of ordinary womanhood. Nonetheless, for a variety of reasons, girls and women can and often do slip outside the sphere of householdership to find themselves inauspicious, economically insecure, and suspected of sexual impropriety. If we look closely at the high-caste women who

suffer most from such disabilities, we can see that nearly all belong to a category defined by involuntary exclusion from precisely the way of life we have just outlined, householdership. Since such women figure prominently in asceticism, we need to explore their predicament, and so in the next chapter I turn to an examination of the woman who is not a householder.

2

The Woman Who
Is Not a Householder

Widowhood, Unmarriageability,
and Female Asceticism

Having considered the religious life of the ideal woman as properly married householder, I turn to those women who, through no choice of their own, are not householders, those who are involuntarily women-without-husbands. This category consists of three types: widows, girls and women who for various reasons are unmarriageable, and women who have rejected marriage. In this chapter I discuss only those whose having no husband is not self-willed: widows and the unmarriageable. The woman who refuses to marry, or a wife who leaves her husband, presents a special case. A number are found in asceticism, and subsequent chapters will discuss factors that allow a woman to reject marriage, and the conditions that might dispose her to asceticism. Here I wish to discuss only those whom one might justly characterize as casualties of the prevailing socio-religious order, those who would prefer the properly married status of *grhinī*, a woman householder. For all of these women, institutionalized asceticism is a potential alternative. In fact, earlier writers suggested a direct causal relationship between one of these conditions, widowhood, and entry into asceticism (Oman 1905, 245; Ghurye 1964, 222–23). My research indicates a somewhat more complex pattern and cautions against a theory that sees all the women who undertake formal asceticism as doing so out of social duress. However, we are still faced with the fact that the female

41

ascetic world is composed predominantly of women who have been denied full participation as wives and mothers in the propitious world of householdership, and who are thus not *grhinis*

The identification of proper womanhood with householdership poses a serious problem for those who cannot enter or remain in that status. Householdership is the norm against which even women ascetics as a group are assessed. Most householders, and certainly all the female ascetics I know, are very aware of the fact that though some ascetic women achieve an enhanced ritual status and occasionally even economic independence, and though the ascetic robes alone entitle them to respect, they are still in some profound sense aberrant. This cannot but affect their attitude toward themselves as well as the perceptions and attitudes of the larger society. In order to understand the female ascetic's self-definition, and in order to make sense of the socio-religious processes at play in the relationship between the life of woman-as-*grhini* and the life of woman-as-*sādhu*, we must clarify the position of those women who are neither.

Out of the forty ascetic women in Benares who are thirty-five years of age or older, more than two-thirds are widows. The community also contains women or girls who for a variety of reasons have never been married at all. Less than a dozen of these chose asceticism rather than marriage. For the majority, marriage was not possible in the first place and so, like widows, they are involuntarily without husbands. To clarify the peculiar status of these girls or women who before taking initiation were doomed to remain outside the householder *āśrama*, through widowhood or other factors not of their own making, this chapter is divided into three parts. The first focuses on widows and the conditions of widowhood in the sectors of high-caste society from which the women ascetics of Benares come. The second clarifies the category of "girls and women who are unmarriageable." The third identifies the difficulties faced by all those who are involuntarily without husbands and shows how the transition from the problematic status of a woman who is outside householdership into a woman within institutionalized asceticism can radically alter their lives.

WIDOWHOOD: GENERAL RESTRICTIONS ON *VIDHAVADHARMA*

In the earlier discussion of the textual definition of women's religious duties, I noted that the *Strīdharmapaddhati* gives careful

attention to *vidhavadharma*, the way of life appropriate to a widow (45r.5–48v.6; Leslie 1989, 298–304). In this text, marriage is a sacrament lasting for a woman's lifetime: even after his death, her husband remains her god, she must be strictly celibate, and her daily life should demonstrate continued remembrance of him. Because the widow's regime is designed to eliminate all passion, she is prohibited from indulging in any activity that is believed to be sensually arousing. Thus, she divests herself of all physical attractiveness by shaving her head and removing the auspicious signs of married status; she no longer wears colored garments, uses perfume, or sleeps on a bed; and she must adhere to a restricted diet by eating only one meal a day of those foods considered benign and pure and undertaking frequent fasts. Tryambaka does not believe that widows are especially polluting (*Sdhp* 47[2]r.4–7), and in fact, as can be seen today, most upper caste, orthodox, and well-to-do widows expend great effort in maintaining a high level of ritual purity, conscientiously avoiding contact with impure people and things. But Tryambaka does assert that widows are to enjoy no freedom at all; their dependence is simply transferred from one male to another, from deceased husband to living son, so that the truly devoted widow will not undertake any activity at all without first requesting permission from her sons (*Sdhp* 46r.8-9; Leslie 1989, 300).

Even a casual acquaintance with social history however, reveals that widowhood has been shaped by more than just textual sanctions such as these. Any assessment of the status of widows must combine textual prescriptions with observations of widowhood in social context. For the truth is that widowed girls and women frequently suffered physical and emotional violence far beyond anything condoned by *śāstrik* authority. Members of early twentieth-century reform movements such as the Brahmo Samāj, which actively encouraged widow remarriage, publicized these facts quite forcefully. But the dreadful treatment of widows at the hands of their in-laws and society at large has continued even to the present day, sanctified by tradition. It is clear that from an early period, textually based prescriptions combined with other more diffuse prejudices and practices to create an entire catalogue of anomalous and particularly vulnerable female persons.[1] Consider the issue of blame: Even today, many families hold their young widowed daughter-in-law responsible for their son's death, and the woman herself commonly internalizes this, feeling sorrow, shame, and guilt over her loss. Or, take the question of remarriage: The

taboo against widow remarriage remains so strong that few contemporary men would accept even a young widow as a prospective bride.[2]

The tenacity of traditional expectations is perhaps most dramatically seen in the outpouring of popular support for those rare cases in which a woman becomes a *satī*. The practice of sati,[3] a widow's self-immolation on her husband's funeral pyre, has no firm basis in classical religious injunction.[4] In general, it is neither anticipated nor encouraged, and it is certainly nowadays illegal. Yet the idea continues to command awe, and many people recognize it as an appropriate and meritorious act. One of the fullest behind-the-scenes descriptions of a sati is from the late 1950s, by Maharani Padmavati Gaekwad of Baroda, whose close friend, Sugan Kunverba Sisodia of Jodhpur, in defiance of the law, secretly and methodically arranged her own self-immolation. The Maharani's account, which according to Allen and Dwivedi (1984, 304) is the "last recorded instance of a royal sati," vividly conveys the hysterical approval of the Rajasthani populace. More recently, in 1987, an eighteen-year-old Rajasthani woman, Roop Kanwar, committed sati. Though her action was condemned in sophisticated and, largely, urban circles, to thousands of others she is a heroine; in fact, following ancient tradition she has been deified and is worshiped as a *satī*, a very powerful folk-goddess.[5] Only a tiny proportion of Hindu widows have undertaken *satī* in this century. By far the majority have lived out their lives subject to deeply entrenched, negative notions about widows. The fact that widowhood is stigmatized among upper-caste Hindus from all parts of the subcontinent leads us to wonder where the ideological roots of this general prejudice might lie.

ATTITUDES TOWARD WIDOWS: THE FEAR OF INAUSPICIOUSNESS AND FEMALE SEXUALITY

The stigma attached to widowhood is a product of several factors that may be subsumed under two different themes. One is quite explicitly recognized in the culture at large, arising out of the extraordinarily high value placed on auspiciousness and the aversion to any thing or person considered inauspicious. The other, only rarely articulated, is nonetheless pervasive; it stems from the disdain for, and fear of, uncontrolled female sexuality.

In discussing notions of female spirituality in the first chapter, we noted that auspiciousness as a value permeates life and

thought in Hindu India. All that is fertile, life-giving, and nurturant is *maṅglik*. Most auspicious places, times, and persons are liable to a temporary or periodic decrease in their worth, but the widow, hitherto a married woman and so supremely auspicious a person, has by her husband's death become permanently inauspicious. In that she is not a wife and is no longer potentially reproductive, and in that she constantly reminds others of death, she is quintessentially *amaṅglik*.[6] She is an anomaly and really ought not to exist. For this reason she is pushed to the edge of society where she remains, to a large degree, invisible, a nonperson. The liminal status of widows is confirmed by their exclusion from the center of normal community activities, from the entire range of life-affirming ritual and social events integral to family and caste solidarity.[7] Other facts testify to their marginality as well: In rural society among the most likely candidates for witchcraft accusations are the village widows (Carstairs 1983).

The inauspiciousness of widows is an explicitly acknowledged fact. Less directly expressed but tacitly understood and recognized is an equally derogatory stereotype that associates widowhood with sexual availability and, by extension, prostitution. The roots of this sentiment are not hard to locate given that one of the salient features of *strīsvabhāva*, as classically defined, is woman's wanton passion. It is for this reason that she must always be under the authority of some male person. By contrast, a widow is unguarded: without the protection of a husband, her *adharmik* nature is bound to assert itself.[8] She is thus, like the prostitute, an embodiment of lustful and uncontrolled sexuality. It is not at all surprising to learn that many of the common words for widow, such as the Hindi *rand* (which occurs in the rhymed couplet cited in the introduction), or the Panjabi *randi* (Das 1979, 97), are obscene terms of abuse that also mean "a whore."[9]

Nor is it surprising that, in order to escape the inevitable suspicions of concupiscence, so many widows adopt lifestyles which emphasize ritual purity and self-denial, or religious paths which preclude all forms of worldliness. The tragedy is that only widows in affluent families can afford to lead the sort of circumspect and exclusively religious lives that might render them above suspicion. There is wide variation in the treatment of widows, but there remains a remarkable consistency in the attitude toward them, which rests on deeply rooted fears of inauspiciousness and female sexuality.

VARIATIONS IN THE EXPERIENCE OF WIDOWHOOD

Widows among the Female Ascetic Community

During the course of this research the topic of widowhood arose quite often. Nearly all the women I knew had widowed female relatives, and most older ones had been widowed themselves, often at a very young age. In discussing their own lives and those of their mothers, aunts, or female in-laws, the women spoke of conditions that span a period of approximately eighty years, 1900–1980. It became clear that a wide variety of factors could, and still can, alter the lot of a high-caste widow. These include: regional variations in a widow's right to property, the practice of the levirate (called *niyoga*), the age and maternal status of the widow herself, the socioeconomic status of the family, and less well-defined factors such as the personalities of various family members, especially a female in-laws and correlatively, the willingness of a male relative to intervene on her behalf.

With few exceptions widows throughout India inherited none of their husband's property.[10] The majority of classical texts stipulate that a widow's affines or her natal family, to which some authors say she may return, must provide her shelter and security. Of the widows I met from twice-born, mainly Brahmin and Kṣatriya families, most were allowed to remain with their in-laws; a few returned home to their parents, but all were disinherited and forbidden to remarry.[11] Some *dharma* texts encourage the levirate (Kane 1941a, 599–607), but it does not seem to have been thought a necessary injunction. It was no doubt originally intended as a protection for the widow (Altekar 1973, 140). Tryambaka appears to rule that it is unlawful unless commanded by a husband before his death (Leslie 1989, 300–02, 309–10). None of the widows I met had been taken in marriage by a brother-in-law.[12] Rather, it appears that widows are, as in the past, more often liable to concubinage or sexual appropriation by a male affine without the formal protection of marriage.[13]

Childlessness is another major variable: Widowed women with young children still have a role to play in the family (Kondos 1982, 255), but a childless widow, without the protection she might receive as mother to a son of the lineage, could easily be put out of her in-law's house. If she could not return to her parents, she might be forced to take work as a cook or family servant. If she remained with her in-laws, she was often treated as no more than

a servant in any event. Owing to the practice of prepubertal marriage, not outlawed until 1929,[14] several of the older women in my study were widowed before child-bearing age. Most who remained with their in-laws suffered at the hands of family members, sisters-in-law in particular. Despite maltreatment, these women considered themselves fortunate. As we shall see in a moment, many widows in this century have been forced into beggary and subjected to even worse fates, prostitution, rape, disease, and starvation.

The lot of a widow can vary depending on the economic status of the family into which she married and on her level of education, as is now more common (Srinivas 1978, 21–25). Specific factors of village life, struggling urban poverty, or comfortable affluence can alter conventional caste-based behaviors so that, for example, an impoverished Brahmin family in a city slum might rely on the cash earnings of a widowed daughter-in-law. In wealthy merchant households, many a widow has established herself as head of the family, exercising effective control over sons and property. Since the turn of the century, widows from well-to-do and western educated families, while still suffering from earlier prohibitions against remarriage, could turn to teaching or social service, devoting themselves to the education and welfare of young girls or health care for the sick and poor.[15]

The Kashivas Widow Survey, 1975–77

The women I knew form only a small minority of the widows in Benares, and the fact that many of them are ascetics suggests that they might be atypical. But interesting comparative data come from a study conducted in 1975–76 by a researchers at Benares Anthropological Institute, the Manava Vidhya Mandir, supervised by Professor Baidyanath Saraswati.[16] Saraswati's team surveyed 440 widows in the city and conducted in-depth interviews with 70 of these women.[17] The largest group, nearly 150, is Bengali; the second largest group is Nepali. (There is a similar distribution of regional origins among female ascetics.) The accounts of Bengali women are particularly instructive. While it is important to bear in mind that they represent only those widows who came to Benares and that we lack data on the fate of the larger population of widows who remained in Bengal, it appears that of all the widows in Benares surveyed by the research team, the Bengalis had suffered the most dramatic ill-treatment from their in-laws.[18] It is Saraswati's opinion that the ill-treatment of Bengali widows is a product of at

least two factors, one of which is the law, specific to Bengal, that governs a widow's inheritance. In contrast to other parts of India, Bengali law specifies that a widow has a legal right to her husband's property (Altekar 1973, 139). This law, however, which was originally intended to protect the widow, has more frequently motivated affines to send her away so that the property might be distributed in her absence.[19]

The second reason for a strong connection between Bengali widows and Benares turns on the sanctity and magnetism of the city itself. Every Hindu hopes to make at least one pilgrimage to Kāśi. This dream figures significantly in the life stories recorded by Professor Saraswati and his researchers, because the in-laws of many Bengali widows had used it in a deceit. Typically, the in-laws blamed the young widow for her husband's death, a fact which, in the first instance, had overwhelmed her with shame and guilt. The relatives were aware of the powerful attraction a pilgrimage to Benares might hold, and shortly after the obsequial rites gave the widow a lump sum specifically to make the journey. This allowed her to fulfill both a long-standing and immediate desire. After all, does not pilgrimage to this holiest of cities removes the accumulated sins of centuries, even the sins of a woman responsible for her husband's death? However, hundreds of miles from home and unaccustomed to life as a pilgrim, the widow soon ran out of money, at which point she had three options: to find employment, to enter a widows' āśram or to beg. Employment as a cook, which is appropriate to a Brahmin widow, is not easy to secure without proof of one's identity, and life in a widows' āśram can be unbearable. As it turns out, only a few of the widows in Saraswati's survey were attached to an institution for widows; others rented rooms or were in the employ of some family. One can only speculate about the fate of others who were less fortunate.

By comparison, my widowed Bengali informants had had far less disturbing experiences. This is in part because many of them were fortunate to have had either children to raise during their widowhood or else consanguinal relatives to protect them. But, more important, and distinguishing them from the majority of those widows included in Saraswati's study, is the fact that the widowed women I knew all had access to formal asceticism as an option. Institutionalized asceticism radically altered their status, just as it can alter the status of any woman who, for whatever reason, falls outside the protective domain of the gṛhiṇī, the ideal wife, mother, and householder.

UNMARRIAGEABLE GIRLS AND WOMEN

The observation that widows are one of several types of women
who fall outside the blessed domain of householdership reminds us
again of the essential characteristic of the average woman's reli-
gious life: it is so consistently identified with marriage and family
that to be a proper woman is to be a *gṛhiṇī*. Widows are former
*gṛhiṇī*s without husbands. To the category of "the widowed" one
might well add the woman who is rejected and driven away by her
husband, and the woman whose husband becomes a renouncer.
Some of the ascetic women I met are in fact rejected wives, but as
we have scant information on the lot of such women in the larger
society, I shall not consider them here. And although the ambigu-
ous status of the wife of a renouncer has not gone unnoticed,[20] the
information is, again, sparse and an insufficient basis for analy-
sis. One can speak with more certainty about the condition of
unmarriageability. In upper- and middle-class society, marriages
are still usually arranged by the parents. Certain conventional
ideals in a bride, such as beauty and youthfulness, are of great
importance, and marriage itself, as the central ritual of group ex-
change in caste society, is a prominent marker of status. There are
three different sets of circumstances that might render a girl unfit
for the marriage market.

First, it is very difficult for the parents of a girl who is physi-
cally deformed or considered unattractive, intellectually deficient,
or mentally unstable, to find a family willing to accept her as a
bride. Second, despite its illegality, an adequate dowry is essential.
In traditional high-caste society, marrying a daughter into a family
of rank is crucial to the maintenance of status. To conclude such a
marriage requires a substantial dowry, and a family might have
neither the money nor goods stipulated by the parents of the groom.[21]
Or a family may be "blessed" with too many daughters so that
dowries will be available only for the elder girls. In the case of
many young unmarried women and girls I met, the devastation of
war has posed the most serious obstacle. Specifically, the East-
West Pakistan War in March through December, 1971, forced thou-
sands of families to flee from East Pakistan, now Bangladesh, into
India. Most lost their land and possessions and many children
were orphaned. Girls and young women who have been orphaned
or whose families are impoverished stand little or no chance in the
high-caste marriage market. Third, a woman's marriage prospects
are bound up with conventional expectations. While dowry is the

most visibly problematic, even among sectors of the urban upper class that reject dowry, there is still an unspoken rule that the prospective bride should be younger than the groom, certainly no more than about twenty-seven or twenty-eight years of age, and that she should not be better educated than he. (In fact, she really ought to have a degree or certificate that is slightly inferior to his.) Unfortunately, young women with keen intellects who excel academically and pursue higher degrees can educate themselves out of the marriage market, often before they realize it. They are unmarriageable and suffer the stigma of spinsterhood just as much as those girls or women rejected for reasons of physiology, character, or finances.

To date, no one has gathered together whatever references to "women without husbands" exist in the ethnographic literature. Rama Mehta has looked at the divorced woman and the western-educated woman in modern society (1970, 1975), but her accounts focus on an urbanized elite. My observations of householder life in Benares and its surrounding villages suggest that some of these unmarriageable girls, particularly those with physical disabilities or for whom sufficient dowry is lacking, frequently become second, unofficial "wives" to men who are prepared to accept them, often as part of a negotiated marriage to another sister whom the man formally weds.

All the types of non-*grhastha* women described in this essay, widows, rejected wives, and the various unmarriageables, are found in the ascetic community. I conclude by looking at the socioreligious processes behind the problems such women face, and the solutions asceticism offers.

WOMEN WITHOUT HUSBANDS: THEIR SPECIAL PROBLEMS AND THE ATTRACTION OF ASCETICISM

Women without Husbands and the Ideal of Proper Womanhood

To help understand the special difficulties faced by women who are involuntarily without husbands, recall the previous essay's discussion of the woman who does have a husband, the ideal woman householder. There, it was noted that a woman's life is governed by ideas expressed in the notions of *strīdharma*, her appropriate duties, and *strīsvabhāva*, her inherent nature, and that notions of her appropriate duties are altogether more consistent than the assess-

ment of her inherent nature. Both ideas value wifehood and motherhood most highly, and a woman's religiosity focuses overwhelmingly on promoting the well-being of her family. Women are particularly constrained by conventional concerns for the maintenance of ritual purity and sexual propriety. If they are chaste and obedient, meticulous in matters of ritual purity and, at the same time, fortunate enough to bear many children, they will be honored not only for their virtue, but also for their auspiciousness. In their assessment of a woman's character and religiosity, people thus refer to several values, of which purity, chastity, and auspiciousness are most important. In the ideal *grhinī*, all of these are found: As wife the married woman is ritually circumspect and her sexuality is appropriately controlled, and as mother she is the walking form of auspiciousness.

By contrast, those discussed in this chapter—widows, unmarriageable girls, and women—are outside the *dharma* of the *grhinī*. They cannot participate fully in *strī-ācār*, nor even identify with its values, because this body of traditional lore and ritual attends so specifically to events in the lives of women who are properly functioning members of a household. I have noted that the extensive and largely pejorative vocabulary for widows in India underlines their liminality. Unmarried women do not exist, linguistically. There is no word for "spinster" in either Hindi or Sanskrit, no word that refers to a woman who is over the age of thirty but unmarried. The word for an "unmarried girl," *kanyā*, is sometimes used in speaking of an unmarried woman, but it is conceptually dissonant, and people admit it is inappropriate. *Kanyā* means "virgin," and no one feels quite right using it to speak of, for example, the many middle-aged, unmarried women academics in the city's universities.[22] The deprecating locutions and outright vulgarities employed with reference to widows, and the linguistic silence on spinsterhood, all point to the anomalous status of women without husbands.

Let us look a little more closely into the ways in which their peculiar status poses serious problems, and the manner in which, should a woman be so inclined, taking initiation into formal asceticism can better her lot.[23] Women without husbands no doubt suffer a wide range of difficulties, but two appeared especially problematic in the lives of the women I studied. First, they were all in an economically precarious situation; and second, these unmarried and unhoused women and girls raise the specter of sexual impropriety. In what ways, then, has formal asceticism—as opposed to the simple

and informal adoption of a style of life more ascetical than their
grhiṇī counterparts—been able to ameliorate the indignities of
financial hardship and sexual denigration? The following reflections
are presented not as a comprehensive account, but as examples of
the socioreligious and socioeconomic processes that underlie insti-
tutionalized female asceticism in Hindu India which allow us to
construct a clearer picture of just who these ascetic women are.

HOW ASCETICISM CAN EASE ECONOMIC HARDSHIP

Economic hardship might not befall an educated, unmarried, or
unmarriageable professional woman, but it is a serious problem for
widows and orphaned or destitute high-caste girls. Consider the
case of widows. In Benares some widows are relatively safe from
abuse, because both the state government and institutions such as
Vaiṣṇavite temples have established dormitory-type residences for
them. The best known of these is Bhajan Aśram on Mīr Ghāṭ,
where the widows receive a meal and a space to sleep if they sing
devotional songs all day long; it accommodates thirty to thirty-five
women. Although one impoverished widow I encountered during
my research periodically attached herself to the Bhajan Aśram, she
and other widows consider it to be a demeaning institution, prin-
cipally, they said, because one should sing out of true devotion, not
out of dire need. There are Christian societies such as the Sādagati
Nivās on Śivāla Ghāṭ, a home for destitute women run by Sisters
of Mother Teresa's order; it can house about forty women. The
stigma of widowhood remains, however, and people joke easily about
such widow-residences, which they characterize as hovels of queru-
lous old hags. In fact, noisy disputes are common: The women live
in conditions of great social and economic deprivation and in conse-
quence tend to quarrel over food, fuel, and their few possessions. In
well-kept, government-funded institutions, widows receive a ration
of milk each day; in contrast to other widows their government
pensions are secure.[24] They generally owe this good fortune to a
relative or neighbor who dealt with the complex paperwork required
to gain entry into the establishment. Illiteracy renders most older
widows helpless in face of such bureaucratic requirements.

Apart from the grave economic problems of the sort reported by
social scientists, journalists, and social workers, most widows are
powerless in other ways. It was often this sense of helplessness
that led some of them to seek succor from local female ascetics,

many of whom attract widows as followers. By taking a formal initiation into discipleship, by accepting religious instruction, and by moving into an *āśram* or other ascetic establishment, these widows acquire both social and ritual status: they officially become the disciples of an ascetic woman who in turn becomes formally their guru. In return for devoted service, often very arduous labor, they achieve a significant degree of economic security as well. These disciples are called *celī*, as opposed to *śiṣyā*, which indicates a primarily spiritual relationship.[25] Indeed, some ascetics treat widows, and handicapped women and girls, more like servants than disciples.

What happens when a widow or other disadvantaged woman becomes an ascetic herself? If she enters an established, well-organized institution, she is assured a degree of financial security she would otherwise never know. She may even become an economically powerful *mahantinī*, an abbess or prioress of a monastery. If suitably educated, she might find that the ascetic robes grant her the legitimacy and credibility required to establish, for example, a lucrative girls' school. Though the large majority of female ascetics in Benares own no property at all, it is significant that at least fifteen do, and that of these, five own property in their own names and are by all conventional standards well-off. But this is rare; more commonly, membership in an ascetic institution only assures a woman basic food and shelter (which, of course, is still far more than the poor day laborer enjoys).

There are also young women who are orphaned, or from a high-caste impoverished family. In fact, just over 50 percent of the total female ascetic population in Benares consists of young and adolescent girls and young women whose relatives could not afford to marry them into an acceptable family. Financial hardship is the most readily apparent reason for sending them to a respected ascetic establishment, but another major factor is also at play here: an overriding concern for the control of female sexuality and the maintenance of ritual purity.

HOW FORMAL ASCETICISM CAN PROTECT AND ENHANCE FEMALE PURITY

All women without husbands raise the specter of sexual impropriety. To return to a central aspect of *strīsvabhava*, unguarded women are, by nature, liable to fall into promiscuity and, thus, their sexuality must be controlled and channeled. Marriage is the primary prophylactic against

wanton female sexuality. It is for this reason that the onset of menstruation marks a crucial transition in the social and ritual status of a girl in Hindu society, and it is this which causes the family of a postpubertal unwed girl such anxiety. Sociologists (e.g., Das 1979) have noted that the sexuality of women poses a slightly different problem in North India than the south: in the north, it is the honor of the caste that is threatened, while in the south it is its purity. In either case, girls' and women's sexuality must be controlled. Historically, considerations such as these played an important role in encouraging child marriages and the traditional forms of symbolic prepubertal marriage found in various parts of the country. Prepubertal marriage is now illegal, but the sexuality of young women is a persistent concern, and it is in this light that we must view the special predicament of impoverished and or-phaned girls. Lacking the institution of marriage and the *dharmik* structure of *grhastha*, unmarriageable girls or women, and widows, are constantly suspect. It is my impression that while the more conventional concerns about women's ritual impurity are less evi-dent today than they appear to have been in the past, the fear of female sexuality persists. Thus, in the ascetic community, although most sectarian traditions ignore or consciously reject the barriers that otherwise set woman apart as ritually equivalent to *śūdras*, and more polluting than men of their own class, many of these same traditions take the problem of sexuality seriously and insist on absolute celibacy.

This account of the dilemma of women and girls who are in-voluntarily without husbands, and of the manner in which formal asceticism can alter their ambiguous status and remove their so-cial disabilities, follows, perhaps, too functionalist a line of inter-pretation. The first chapter warned against the view that all female ascetics are victims of an oppressive socioreligious order. I wish to reiterate that cautionary note, because even though it is evi-dent that the female ascetic world is predominantly composed of women and girls who have for a various reasons been excluded from the status of wife, mother and householder, it is also the case that not every person of this category becomes an ascetic. Thus, while factors of a sociocultural sort which give rise to eco-nomic, ritual, and psychological disabilities, can and do provide sufficient reasons to incline a woman toward asceticism, they are neither necessary to, nor inevitably the cause of a woman's deci-sion to enter the ascetic world.

The ritually constructed Hindu social universe creates grave difficulties for women who fall outside the status designed for them: economic hardship, social indignity, and psychological cruelty. But to focus only on the social structural implications of her status is to ignore the powerful ideology underlying renunciation and all other forms of institutionalized asceticism, an ideology that sees householdership as being inferior to the life oriented toward spiritual liberation. And to see all women ascetics as social castaways or to present asceticism solely as a flight from socioeconomic hardship is to take an overly cynical view of the situation. Female ascetics not only argue for the practical advantages of *sādhu dharma*, the way of life of the ascetic, over those of *grhastha dharma* and *strīdharma*, but also are articulate exponents of its spiritual benefits and passionate defenders of its ideological superiority.

3
Unity and Diversity I
Basic Terminology

The first two chapters looked at how textual and popular ideas of women's appropriate duties and inherent nature serve either to discourage or to facilitate asceticism for them. This chapter and the next focus directly on the ideological and social universe of asceticism itself. What one notices first about this alternate world is its variety. For example, the visitor to Benares who takes a walk near the central bathing steps, Daśaśvamedha Ghāṭ, could easily locate several ascetic establishments, and in the morning could encounter a dozen male ascetics, out of a total population of about 1,500, each of whom might well carry a different set of ritual paraphernalia and display a distinctive pattern of sectarian markings on his body. Even a brief conversation with them would be likely to reveal differences in belief and practice. Were the visitor to venture further south along the river to, say, Assi Ghāṭ, he or she might be fortunate enough to meet a good number of the approximately 140 female ascetics who live in this city, and would discover that they, too, are remarkably diverse. Great variation in appearance is also found among female ascetics: some wear white sārīs, others wear red; some do not wear a sārī at all, but tie around their torsos a much shorter piece of cloth dyed a bright yellow or ochre. Some keep their heads shaven, others have loose, flowing tresses; some oil their hair, wearing it neatly trimmed to ear lobe length, others train it into matted locks by rubbing it with ashes. On inquiring about their lifestyle, a visitor would again find diversity, even contradiction; some insist on absolute celibacy, others do not; many adhere strictly to a diet of fruit and milk, others eat meat or fish,

or take betel and other intoxicants as well. Most travel frequently
to other sacred centers or to visit relatives and disciples, but a few
never leave the city. Some hardly think of a god or goddess; others
transform the entire day into a ritual of worship in honor of their
chosen deity. And so on.

However, to observe and emphasize only the diversity of the
community is to ignore the features which unify it; moving beyond
appearances, it becomes evident that certain institutions and be-
liefs are common to all ascetics. The variety is indeed significant
but before we can make sense of it an acquaintance with some
basic facts of asceticism is essential. In particular, one must exam-
ine the key institutions and ideas that give the community its
ideological coherence, and one must familiarize oneself with its
basic terminology. To this end, I have selected some terms from
ascetic vocabulary: first, some that encapsulate crucial elements of
ritual and belief; and second, the most common terms used to speak
of asceticism and ascetics, from both ascetic and popular discourse.
The former will suggest something of the unity of asceticism; the
latter something of its diversity.

THE UNITY OF ASCETICISM

Female and male asceticism are not different in regard to values
and institutions. In general, women and girls enter the ascetic life
by the same process as men, and there is no body of doctrine or
practice that is the exclusive property of one sex.[1] What we have
before us is an asceticism with male and female practitioners. It
may well be that men and women appropriate institutions in dif-
ferent ways and to different ends, but based on my own research
among female ascetics in Benares, conversations with dozens of
male ascetics in that city and elsewhere, and a reading of the
currently available studies of male asceticism, I am led to conclude
that female ascetics espouse the same set of core ideals as their
male counterparts, and that they participate in the same institu-
tions and are subject to the same codes of behavior. In what fol-
lows, then, when I speak of "the ascetic" I mean to include male
and female practitioners; and when I speak of "asceticism" I refer
to the totality of ascetic institutions, practices, and beliefs in which
males and females both participate. Their way of life coheres around
a number of crucial notions. I will deal here with three sets: first,
the pair *sansār* (Skt. *saṃsāra*) and *mokṣa*. *Sansār* means two things:

metaphysically, the cycle of birth and death; sociologically, the social world embodied in householdership. *Mokṣa*, "release," thus refers to liberation from both. Second, *Sādhanā*, "discipline," and the related notion of *sādhudharma*, the totality of ascetic disciplines. And finally, various terms for the relationship between a teacher/ preceptor (most commonly a *guru*) and his or her pupil/disciple; and the ideas and practices of *dīkṣā*, "(ritual) initiation."

Sansār and Mokṣa

First of all, ascetics seek release from the bonds of *sansār*, release described in positive terms as the attainment of *mokṣa* or *mukti*. Some ascetic women uphold the primacy of *mokṣa* as a goal in life, arguing that when a woman has fulfilled her *dharma*, it is perfectly legitimate in middle-age or later to renounce it. Others, more radically, argue that for some women at least the *dharma* defined by marriage and motherhood is inappropriate at any age; asceticism and a life oriented toward *mokṣa* is consistent with their spiritual status throughout this current life. Women describe the state of salvation in different ways. Some say simply that they will achieve *mokṣa*, others describe it in more gnostic terms as knowledge of the Absolute. Theistic ascetics tend more often to describe *mukti* as a great vision of or union with the Supreme Being. Finally, there are some who, in delightfully abstract terms, speak simply of "arriving."[2] These ways of describing the goal refer to a state that, however it may be formulated, assures one freedom from rebirth. And all ascetics see freedom from rebirth as the highest goal. Second, and by implication, ascetics devalue householdership and householder *dharma*. In placing spiritual release above all else, the ascetic ignores most of the conventional values governing the householder's life, which is lived in the hope of a blissful existence in heaven or a good rebirth on earth. As one *sannyāsinī* explained it to me, "In *gṛhastha* you know great pleasure and sorrow, but you cannot know peace; that life is in a state of constant change and so your mind cannot become still. In the ascetic life you are single-minded, and so you can achieve salvation."

Implicit in the use of *sansār* to mean the cycle of life, death, and rebirth, is the recognition of *karma* as the principle upon which the entire cycle hinges. *Karma* as both action and achievement ensures that progress can be made within the cycle by fulfilling one's religious duties as a householder. In the case of women, it is

strīdharma that leads to a better birth in the next life. But ascetics reject both householder *dharma* and the goal of a good rebirth. They seek to escape rebirth entirely and to be released from *sansār* forever. Because it is conceived as ever moving and as inherently unstable, *sansār* in this grand sense is often translated as "the transient world." Articulate, English-speaking Advaitin ascetics describe *sansār* as "the phenomenal world" or "the world of appearances," emphasizing that it is ignorance which accounts for *sansār*; in this view, *sansār* is a mental construct rather than an external reality. Most ascetics express the popular understanding of *sansār* as something that, while penetrating each person, is still more of an externally verifiable process in which one finds oneself than the product of an incorrect way of looking at things. Ultimately, such different conceptions reflect different philosophical stances; but few ascetics are philosophers. The great majority, both male and female, describe the world as they see it in metaphorical rather than philosophical language.[3]

In addition to its metaphysical referent, *sansār* has, among ascetics at least, a sociological referent. They often employ the word to describe the entire domain of ordinary human relations, the social world defined and supported by householdership. Indeed, in their view the social world is the primary referent of *sansār*. The words *sansār* and, especially, the adjective *sansārik*, often translated "worldly," invariably arise when ascetics discuss the way of life of the householder and all the affairs to which householders must attend. Notions about "the world" and "wordliness" have a lengthy history in Western traditions and so the specifically Hindu character of these terms needs clarification. In my view, what distinguishes Hindu understanding here is that certain powerful ritual values, such as the scale of purity-impurity, characterize social relations, so that the social world is a ritually constructed one. It is of great importance to the understanding of asceticism that the social world is conditioned not only by political and economic values of the sort that Western social theory treats as fundamental, but in addition and preeminently, by a specific concatenation of religiously conceived ritual values. It is important because, despite the fact that all ascetics are unified in their spiritual goal and in their rejection of "the world," they can reject this ritually constructed social world in different ways.

One major factor accounting for diversity is precisely this variability in relation to the world. For, of some ascetics it may be said that they are "in the world but not of it;" of others, that they are

"of the world but not in it." That is, they may be *in* the world through their social relations with other humans but not *of* it because they ignore the ritual values inherent in these relations; conversely, they may be *of* the world through their respect for the ritual values such as purity, upon which the householder world is predicated, yet not *in* the world because they conscientiously restrict their social relations with householders, and even with other categories of ascetics. Distinctions such as these emerge more clearly in the following chapter. For the moment, the point to note is that though ascetics may well differ in the specific nature of the relations they have with the social world as a ritual construct, they all seek escape from the cycle of rebirth as a metaphysical reality.[4]

It is clear that from a larger perspective the social world is only one part of the total cycle in which everything is caught up: plants, animals, humans, and, some would say, even the demons and gods. Yet I have noted frequently in conversation with female ascetics a tendency to conceive of *sansār*, the cosmic cycle, as coextensive with the transient social world of householdership[5], For example, one day I heard a group of Nepali ascetics discussing the burdens of womanhood. Marriage, pregnancy, childbirth, and the business of getting on with one's in-laws, they agreed, is the sum of woman's *sansārik* existence; it is all one big *cakkar*, a spinning wheel of confusion, an apt description for the ties that bind women to the cosmic *cakkar*, the perpetual wheel of *sansār*. Since wifehood and motherhood and all that is contained in the status of *grhiṇī* is so crucial to the perpetuation of *sansār*, women being the ones who give birth to the human race, it is with a special poignancy that women equate householdership with *sansār*, and then speak of leaving *sansār* behind. Bearing in mind the earlier discussion of *strīdharma* and *strī-ācār*, one can readily see that the woman who rejects or renounces householdership does not simply enter an alternate lifestyle, but embraces a set of values profoundly different from those of the ideal wife and mother.

Sādhanā and Sādhudharma[6]

Ascetics' guidelines for behavior are often called *sādhudharma*.[7] *Sādhu* is the most general term for ascetic, the one people commonly use when referring to ascetics as a class; *dharma* here means "duty." There is a technical issue in Brahmanical law as to whether an ascetic has a *dharma*, a set of duties, at all. Most Brahmin lawgivers attempted to assign them a *dharma* (Kane 1941b, 931),

but at least one, Vaikhānasa (c. 300–400 CE) wrote of renouncers, "for them there is no right (*dharma*) and wrong (*adharma*), no truth and falsehood, no purity and impurity [or] such-like duality" (Olivelle 1977, 46n39). Those renouncers who themselves wrote on *yatidharma* (e.g., Vāsudevāśrama, Olivelle 1975) took great pains to prove that the renouncer's behavior does not consist in positive duty (Kane 1941b, 940).[8] Nowadays both householders and ascetics use the word *sādhudharma* in such a way as to imply the existence of a more or less unitary code of behavior, perhaps in ironic imitation of the householder's code of conduct, *gṛhasthadharma*. In reality there is no clearly defined *dharma* that all ascetics must follow, nothing comparable to, for example, the pan-Christian monastic vow of poverty, chastity, and obedience. There is only a collection of lifestyles which householders recognize as being in some sense(s) both ascetic and antisocial, and which ascetics conceive of as free from and superior to the constraints and goals of conventional *dharma*. There are many specific codes of behavior, but these are looked upon as discipline, *sādhanā*, rather than law, *dharma*, and taken together they contradict each other on many points. No consistent body of rules can be extracted from the various disciplines observed in the ascetic world. So when used to refer to the behavior of ascetics, the word *dharma* speaks more of a general way of life than a precise code of behavior, and *sādhudharma* refers to the totality of disciplines that constitute the way of life of the ascetic.

The existence of the word *sādhudharma* and its everyday usage suggest that ascetics are perceived to share a different way of being in the world. Indeed the various disciplines that collectively constitute *sādhudharma*, and thus the hundreds of thousands who follow them, are unified by two crucially important principles: their commitment to a singular goal, liberation from the cycle of *sansār*; and their rejection of and separation from householdership.[9] These two facts express the core values of ascetic ideology, unify the community and render *sādhudharma* a coherent notion. They are as significant for female ascetics as for male.

Teacher/Preceptor and Pupil/Disciple

No one legitimately enters a community without first requesting a fully initiated ascetic to accept him or her as a disciple. If the ascetic agrees to the request he or she becomes that person's spiritual preceptor, or *guru*, inaugurating a relationship so thoroughly

dyadic that it is impossible to describe one without reference to the other. There are different types of preceptor in the community, the most consistently used term being *guru*. By contrast, differences of type and status among disciples are reflected in a larger number of words for disciple. Whatever the terms, the preceptor-disciple relationship is at the very heart of what it means to be an ascetic, because at full initiation into asceticism all the criteria defining the disciple's customary social and religious status are replaced, and, ideally effaced, in the person of the *guru*, the preceptor. Simply put, the guru becomes the disciple's progenitor or progenitrix, and the disciple enters into an entire fictive or symbolic kinship network centered on the guru as father or mother.

As just noted, a person becomes a postulant by first finding a fully initiated ascetic who is willing to accept him or her as a disciple. There is no general term for the postulancy upon which the disciple embarks, nor is there a single ritual to mark its commencement. However, most preceptors give the postulant a new name, which may well be changed again at full initiation. The practice is common enough that though the naming ritual is usually simple and informal, many ascetics speak of it as a *dīkṣā*, initiation, specifically as *nām-dīkṣā*, the name initiation (*nām*, name). Some *guru*s conduct a simple ritual by giving the postulant something to eat, such as a piece of fruit, calling it his or her (the *guru*'s) sanctified food, *prasād*, and may receive one or two rupees in return. Postulants commonly alter their style of dress, as directed by the *guru*, but they do not wear the garments or ritual markings of a fully initiated ascetic, and they bear none of the proper titles of their *guru*'s order. Though not ascetics they are disciples, and their guru and other ascetics will refer to them by one of the several terms that convey the status of postulant disciple.

The most common of these are *cela/celī* and *sevak*.[10] Both highlight the inferior position of the disciple and emphasize the role of a devoted servant. Very young ascetics, such as orphaned boys or girls, are always called *cela* or *celī*, as are older ascetics such as the impoverished widows discussed in the previous chapter, who may never move beyond the stage of postulant. The terms *cela* and *celī* denote the junior status of someone whose primary role is to attend to the needs of others (*celī* can be used to mean "maidservant," and is to be heard used in this sense quite outside the ascetic context). The term *sevak* conveys servitude even more clearly: it refers to a person who gives or performs a service (*sevā*), and it may also be

used outside the ascetic context to refer to a servant or attendant. In fact, during the probationary period the relationship between preceptor and disciple is very much one of master and servant, an ethos which sometimes persists even after full initiation.

Although the probationary period is intended to test the resolve of the postulant, with some preceptors arguing that it is necessary actually to discourage prospective candidates, there are no agreed upon rules governing the relationship between preceptor and postulant. Different sects, and even individuals in the same sect, differ on such points as how much intimacy the postulant should enjoy with the preceptor, or how long this period should last, from a few days to a set number of years. In all cases postulants are instructed in the general lifestyle of the *guru* to whom they have become attached, but particular or esoteric items of belief and practice will not be divulged. It is no small matter to determine a person's suitability for the life. Even when it is not physically arduous, as it almost always is, the preceptor must assess the postulant's psychological strength, his or her ability to withstand the emotional stress that results from abjuring familial and other social ties. In part, requiring the postulant to wait on the preceptor, to attend to the preceptor's every personal need in the way a servant would do, is a means of testing the postulant's sincerity, will, and stamina. Having judged the postulant a suitable candidate, the *guru* accepts responsibility for his or her initiation.

The person who thus approves the candidate always becomes his or her spiritual preceptor, that is the *guru* in the fullest and most formal sense; but he or she is not necessarily the one who performs the ritual of initiation, *dīkṣā*. In some sects the preceptor who offers spiritual guidance and the preceptor who intiates are the same person, but in other sects several distinct types of preceptor are recognized. In the latter case, the various preceptors, all of whom are called *guru*, are differentiated by prefixes which specify their function. Thus the initiating preceptor, whom ascetics view as little more than a ritual technician, is called the *dīkṣā-guru*, the initiation preceptor. The person who sponsors the postulant and in whose name he or she is initiated is called the *śikṣā-guru*, the teaching preceptor (*śikṣā*, education, instruction, teaching). For this latter the novices retain affection, attentiveness, and utmost respect. The *śikṣa-guru* is the spiritual preceptor, and in what follows it is the *śikṣā-guru* who is described. The traditions which make this sort of distinction in fact are few, but their membership is large and so the separation of preceptorial functions is a well-known fact.

Having taken initiation, the postulant, now ascetic, formally becomes the disciple of the *guru* who attested to his or her suitability, and was thus responsible for the initiation. He or she formally becomes the candidate's spiritual preceptor. When an ascetic is asked, "Who is your *guru?*," he or she invariably responds with the name of the person who is in the relationship of spiritual preceptor. In the case of those who recognize more than one type of preceptor, a more specific question must be posed to elicit the names of those other preceptors, since the term *guru* on its own is taken to refer to one's spiritual preceptor, the *śikṣā-guru*. The fully initiated disciple is designated by several terms, of which the most common by far is *śiṣyā*. This word is usually translated "disciple," but its more precise meaning is "pupil," emphasizing the disciple's status as student and that of the *guru* as teacher. Preceptors need not necessarily be learned, and in fact many are not; but they are still teachers, even if they instruct only by an exemplary life. A general anti-intellectual stance characterizes certain sectarian traditions, particularly those that emphasize ecstatic devotionalism and the attainment of occult powers. Teaching, in the sense of guidance and instruction in spiritual matters, is indeed a crucial component of the preceptor's role, but since he or she is also an exemplar, some choose to recognize this dimension by a second set of terms: *siddhă* for the preceptor and *sādhak/sādhikā* for the disciple. *Siddhă* as a noun is perhaps best translated as "adept"; in its adjectival form it means "accomplished" or "perfected." *Sādhak/sādhikā* means "aspirant"; the Hindi-English Dictionary gives "one engaged in or devoted to spiritual attainment [or] accomplishment." The terms *guru* and *siddhă* for preceptor are not mutually exclusive: Some who call their male preceptors *siddha* and their female preceptors *siddhā* acknowledge that they are also *gurus* (a favored designation is *sādhak-guru*), but they prefer to emphasize the element of accomplishment implicit in the terms *siddhă*, also because these terms speak of the occult dimension of spiritual power. In fact, whatever terms a given community uses, the preceptor in all traditions is colored by the occult, magical, or miracle-working skills conveyed by the terms *siddhă*.

The preceptor-disciple relationship is asymmetrical and highly charged. In general, ascetics accord the preceptor extraordinary authority, and it is the preceptor's prerogative and duty to exact arduous personal service from the disciple. The latter is commonly called by one of the terms for postulant noted above, *cela/celī* as "servant," while the preceptor has to teach the beliefs and super-

vise the daily practice particular to his or her sect (or to him or herself alone), and to dispense advice on all sorts of personal matters. Frequently this moral tutelage is more in the nature of command than advice. The preceptor's authority is exercised independent of sex and age: A woman may be *guru* to a man, and a young person to someone older than himself or herself. In return, the disciple serves the preceptor like a son or daughter and absorbs the preceptor's teachings, empowered by the conviction that these teachings constitute a superior gnosis and technique for attaining salvation.

Although the preceptor-disciple relationship is formally solidified by ritual initiation, one feature that appears to be of utmost importance to the two participants is that the relationship is voluntaristic, albeit usually mystically predestined, and personalized. It is thus unlike most other relationships in the larger society, where factors over which one has little control such as age, sex, caste (*jāti*), and status class (*varṇa*) often determine the character of one's relationships with others. A person's meeting the ascetic who will eventually become his or her *guru* is always portrayed as inevitable. In this construction of events the initial encounter with the preceptor is a finding, in the sense of a sudden appearance in answer to the disciple's ardent quest. For example, ". . . and then one day, when I was in Vindhyacal, she appeared and became my *guru*." It is believed that the guru knows the disciple at once, recognizing his or her specific sufferings, needs, and hopes, and that he or she has the power to save the disciple, or at least to show the path to salvation.

For these reasons alone, new initiates are inclined to surrender their will completely to the preceptor, and one is thus liable to hear them speak of the preceptor in language appropriate to a deity. Ascetics vary in the degree to which they consider the preceptor to be fully divine. This is partly a matter of philosophical orientation. Devotional theists, for example, seek in the guru the grace of a loving deity, while monists aspire to knowledge of the Absolute. But all agree that the preceptor participates in divinity. Two crucial attributes signal the superior status of the preceptor. First, he or she has the power to absorb at least some of the disciple's bad *karma,* that is the negative *saṃskāra*s, previous actions that leave imprints on one's present and future lives. Second, the true preceptor has personal experience of salvation, or to phrase it otherwise, has attained true knowledge, which is shown by the ease and frequency with which he or she enters the trance-like state of *samādhi*. Certain common phrases encapsulate conceptions of the *guru*'s role

and relationship to God or the Absolute. Some view the preceptor as a "sign-post": the guru "points to God" or "establishes the path to God." Some emphasize the *guru*'s mercy or compassion, holding that by his or her grace alone is the disciple liberated. Some claim that the *guru* is divine: "*guru* and God are one." Still others assert that the preceptor is in fact "greater than God."[11]

Given the multifarious components of the *guru*'s status, blending formal and informal, transcendental and mundane elements, it is no surprise that the tone of the relationship between preceptor and disciple can vary greatly, especially in its initial stages. I have seen the most intimate devotion on the part of the disciple, and also, occasionally, disciples whose interaction with their preceptor consisted of an unemotional performance of all their duties of service. Between others there is a warm and casual, yet, on the part of the disciple, always deferential camaraderie; while the interaction of still other preceptors and disciples appears highly ritualistic and governed by punctilious formalities. All in all, what I observed most often in the community is that the preceptor is a demanding master-parent-teacher concerned for the spiritual education of his or her "ascetic child," but at the same time an intimate counselor. The life histories I collected show that most preceptors are sophisticated students of human personality. Indeed, they compare favorably with psychotherapists in our society: The therapy a truly good preceptor offers the disciple is a discipline admirably tailored to his or her temperament, which skillfully addresses private anxieties and hopes with the mythology and special techniques of asceticism's rich tradition. Along the way, the preceptor becomes the disciple's primary confidant(e) in a relationship that may, in time, mature into a profound friendship.

Philosophical differences between sects account for significant differences in the preceptor-disciple relationship, but soteriology is also important here, because while the *guru* is necessary to the attainment of spiritual liberation, there is no agreement on the exact role that he or she plays in the disciple's quest for it. The quality of the relationship depends on other factors too: the number of disciples a preceptor has (in my data this ranges from one to hundreds); the recognized spiritual status of the preceptor (demonstrably accomplished *gurus,* who often become renowned as "saints," can be very idiosyncratic in relation to their disciples, particularly the closest ones); the amount of property over which a preceptor, as head of an ascetic institution, has jurisdiction (secular activities distracting from his or her spiritual duties); and,

perhaps most important of all, the individual temperaments of the two parties, since this is a ritual relationship which, unlike many others, provides scope for complex interpersonal dynamics that are always creatively expressed through and justified by the unique idiom of ascetic religiosity.

THE DIVERSITY OF ASCETICISM

There are a dozen or so different Sanskrit and Hindi words which are translated as "asceticism," and an even greater number as "ascetic," a fact which has not escaped the attention of textual scholars. For example, Chakraborti's history of ancient Indian asceticism (1973) pays special attention to the multitude of Sanskrit words commonly used for "ascetic," such as *parivrājika, sannyāsi,* and *śramaṇa,* and M. G. Bhagat's opening chapter is devoted to the concept of asceticism (1979, 9), discussing *tapas, brahmacarya,* and *yoga.* Scholarship should differentiate between terms and insist on their special nuances, and in this, ethnography can often be of use. But while historical and philosophical studies of these terms provide insight into the discourse of *paṇḍits* and other scholars, to accept the meanings found through textual analysis as indicative of popular usage is a mistake. Not only are the texts silent on certain forms of asceticism, but further, uses of the Hindi versions of many Sanskrit terms diverge in striking ways from their textual counterparts. Let us turn from text to context to examine some of the terms one is liable to hear in Benares. A look at the core Hindi words for "asceticism" and "ascetic" reveals the degree to which popular discourse recognizes diversity; it also highlights the particular differences that appear significant to the average person.

Asceticism as a Way of Life

There are many terms that refer to asceticism as a way of life. In the course of fieldwork I most often heard people use the following: *vairāgya, tyāg, tapasya,* and *sannyāsa.*

Vairāgya may be translated as desirelessness, dispassion, or equanimity. People occasionally use it to indicate asceticism as a lifestyle, but more often it describes an inner disposition. It is a central notion of Hindu thought as a whole and refers above all to the psychological state of nonattachment. Ascetic usage is even more emphatic; it signals disgust with the world, and it is the

fundamental prerequisite for taking initiation. *Vairāgya* is an important item of householders' and ascetics' vocabulary because it refers to the inner dimension of asceticism and keeps alive its idealistic component. It is sometimes used judgmentally: To say that an ascetic has *vairāgya* means that he or she, unlike most other ascetics, is possessed of the true spirit of renunciation.

Tyāg: While the dictionary definition is relinquishment or abnegation, its everyday usage is closer to the Western notion of ascetic renunciation. People use it to speak of self-control in the context of formal discipline. Householders conceive of the *tyāgi/nī* as a quiet, *yoga*-practicing ascetic who endures the deprivations of homelessness and stays in some secluded spot; he or she is imagined to practice restraint, though not austerities, at a distance from society. Thus, while it is possible for even a householder to evince *vairāgya*, desirelessness, to follow *tyāg* by becoming a *tyāgi/nī* implies that one is no longer an ordinary householder, but has taken a serious ascetic vow.[12]

Tapasya: This refers to the practice of particularly unnatural and awesome austerities. All householders equate *tapasya* with extreme self-mortification. They are generally agreed that while physical restraint of some sort is inherent in asceticism, severe austerities are not, and only a few people practice them. Individual ascetics of whatever sect may take the name or be given the title *Tāpasvinī*, often shortened to *Tāpasi/nī*. People recognize that good or true *tāpasvi/nī*s exist, practicing *tapasya* far off in a cave somewhere, but they also believe that such people are truly rare. Unlike *tyāg* most *tapasya* is performed in public. Though ideally intended to move the gods into submission or to control the cosmos, dramatic austerities are often directed simply at the purses of passersby who, awed by the courage of the more exhibitionist practitioners, throw them coins or rupee notes. Most sects have a penance-practicing branch or division, and even those ascetics who do not undertake such austerities are well aware that *tapasya* is sanctified by tradition. Of all the elements of the ascetic complex (Ghurye 1964, 15) it is the most ancient, predating institutionalized asceticism. Certain penances seen today, such as the five-fires penance, are more than two thousand years old (Ghurye 1964, 33).[13] *Tapasya* should not be confused with *tap*, which also denotes a type of self-imposed austerity. It is a common item of householder women's religious discourse, referring to a regime of self-denial such as the regular pursuit of *vrata*s, typical of middle-aged or older women. Though *tap* may have a devotional component, it is almost always directed

toward goals such as health, fertility, and financial or academic success. It is the sort of personal sacrifice and self-control possible while still remaining a householder, and is to be distinguished from institutionalized asceticism.

Sannyāsa is the term that scholarly literature and discourse most often identifies with asceticism as a way of life. Literally, it means "to throw down completely." Its proper translation is "renunciation."[14] Most important, *sannyāsa* is the technical name of a specific social institution whose rules of entry have received detailed attention in the lawbooks, and it is incorrect to equate it with asceticism. Of the various ancient antisocial asceticisms, it was the only mode to which the Brahmin lawmakers accorded legitimacy. For this reason it is often called Brahminical asceticism. People in Benares by and large regard *sannyāsa* as a stage of life reserved for one's old age, a notion that persists despite the fact that many youthful renouncers are to be seen. Renunciation is largely an ideal and people do not often think of it in terms of its representatives. It still bears the classical connotations of dignified surrender in advanced age of one's right to direct and control the affairs of the household, and a subsequent commitment to liberation.

These terms referring to asceticism as a way of life reveal that it is a multiform phenomenon. *Vairāgya* indicates a psychological state that is both the prerequisite and goal of asceticism. *Tyāg* indicates quietude and the asceticism of one who has abandoned human society. *Tapasya* is the practice of dramatic penances. *Sannyāsa* refers to the stage or style of life known as renunciation. People know that there is more than one way of being ascetic, a fact even more apparent when we look at the range of terms which refer to them as a class.

Ascetics as a Class: *Sādhus, Sannyāsīs,* and *Svāmīs*

Several of my academic acquaintances with strong village ties have told me that throughout rural Uttar Pradesh, Bihar, and parts of Bengal one hears people speak of ascetics in general as *bairāgis.* Although, as has been seen, the literal meaning of *bairāgi (vairāgi)* is "one who is without passion or desire," it is also the technically correct name for Vaiṣṇava ascetics in particular. I have never heard the word used in its generic sense in Benares, and I suspect this is because residents of the city are exposed to such a wide variety of ascetics that they know the word refers to ascetics of only one

sort, those who are members of Vaiṣṇava sectarian traditions. Many Benarsis know that there are also *bairāginīs*, Vaiṣṇava female ascetics, and even ordinary folk do not confuse *bairāgi/nīs* with *sannyāsi/nīs*. They belong to two distinct traditions, and look quite different.

In Benares the phrase one most often hears referring to ascetics as a class or more particularly to the ascetic community, is *sādhu log*, people (*log*) who are *sādhu*. Since the word *sādhu* means good or noble, the phrase once conveyed the idea of a community of virtuous people, but today, when the word *sādhu* is used on its own by householders, it is rarely free from negative connotations. Benarsis tend to reserve the word for ascetics of only one sort, those who are visibly indigent, perhaps mendicant, but almost certainly scantily or at best improperly clad. That is to say, ascetics of whatever sect whose behavior and appearance evince a dramatic disregard for conventional norms are liable to be called *sādhus*. Both male and female ascetics of this type are found in Benares, and the word *sādhu* is used with reference to the women as well as the men. Sometimes one hears householders call such women *sādhu-mā*, in recognition of their femaleness (*mā*, mother).

Ascetics do not think the word *sādhu* at all demeaning, and both male and female speak of themselves as the *sādhu samāj*. *Samāj* means both community and society, and the phrase indicates that they view themselves as a separate society and are proud of it. The respectability of the term *sādhu* is evident at any event that finds ascetics congregated, when the word arises frequently in their conversations. For example, on the occasion of an intercommunal feast, two of the young women ascetics who had helped in the preparation of the food and who stood peeking into the room where senior ascetics sat in rows, called to me, "Come and see the *sādhu*s eat!" When ascetics use the word *sādhu* to refer to themselves as a class, they include both males and females, but they do have a term for female *sādhu*, *sādhinī*, although I have never heard a householder use it. Interestingly, its usage highlights the behavioral characteristics that householders perceive as integral to *sādhu*-hood: an ascetic, male or female, uses *sādhinī* when speaking about women who lead a mendicant or peripatetic lifestyle and who thus demonstrate a degree of independence and assertiveness uncharacteristic of the majority of female ascetics. Sectarian affiliation is not a criterion here, since female ascetics of Śaiva, Vaiṣṇava, or Śākta (goddess-worshiping) orientation may all fall into the category of *sādhinī*.[15]

On the streets and in general conversation the visitor to Benares soon learns that there is another equally well-known term to indicate a type of ascetic: *sannyāsi*. Householders use it to refer to respectable renouncer-ascetics who are properly domiciled in large establishments, and speak highly of *sannyāsi*s who, in their view, wear decent garments and are well-behaved. Renouncers are affiliated with the Śaiva side of Hindu asceticism and the characteristic color of their garments is a brownish-orange shade, *gerua*, usually translated as "ochre."[16] This color is so closely associated with renunciation that it serves as an epithet: People who live near a female renouncer are liable to call her *geruavalī*, the ochre-clad woman, and just the sight of an ascetic wearing garments of this color is sufficient to classify him or her as a *sannyāsi/nī*. While some Benares residents know that many people they call *sādhu*s are also renouncers, a fact which is often not immediately apparent if the fellow's sole garment is a tiny, dusty-colored g-string, there is still a tendency to identify only the respectable among them as *sannyāsi*s, and many people will, unsolicited, contrast *sādhu*s with *sannyāsi*s.

The contrast between *sādhu*s and *sannyāsi*s merits further comment because it is salient in the conversation of people who reside at places where ascetics congregate, usually sacred centers. Benares, Haridwar, and Rishikesh are the main centers of Uttar Pradesh. (It might be that only in such centers is the word *bairāgi* not used as a generic term for ascetic). Interestingly, the connotations of *sādhu* and *sannyāsi* vary between these places. In his study of *sannyāsi*s and *āśram*s in Rishikesh, Ross recorded the results of interviews conducted among the general population (1965, 333–43). It appears that quite like Benarsis, Rishikesh residents are well aware of variability among ascetics and differentiate between the *sādhu* and *sannyāsi* (no female ascetics are mentioned), but some people have a rather more idealized view of the former. This is probably because in the Haridwar-Rishikesh area there are a number of highly esteemed solitary ascetics who live isolated in the foothills. Ascetics call these people *virakta*s, which as an adjective means detached (from the world), and as a noun, recluse, but householders call them *sādhu*s. Thus, in the Haridwar-Rishikesh area the term *sādhu* may have a different connotation than in Benares. Swami Sadananda Giri's sociological study of *sannyāsi*s in Benares, Haridwar, and Rishikesh confirms this: Unlike Benares, in Rishikesh the *sādhu* is praised and the *sannyāsi*s "who live in big *āśram*s" are criticized (1976, 79).

A third, though somewhat restricted, term has become very popular in Benares, used with reference to a type of ascetic which householders recognize as distinct within the *sannyāsi* population, and which contrasts even more sharply with *sādhu*. This is the *svāmi*. *Svāmi* simply means "lord" or "master," and conveys a mixture of respect and intimacy. Many women use it to address their husbands. With the establishment of the Rāmakrishna Saṅgha and, more recently, the Bhārat Sevā Saṅgha, it has come to stand for the especially learned and socially active type of *sannyāsi* produced by these organizations. The *svāmi* is visually distinguished by the fact that he wears a well-tailored *kurta* (a type of shirt) over a *luṅgi* or *dhoti*, and often a turban, all of which are dyed an ochre color.[17] Nearly all householders in Benares respect ascetics of the *svāmi* type, who in their view exemplify the highest virtues of wisdom and disciplined social service. The term *svāmi* itself has gained such approval in the householder community that many contemporary *gurus* style themselves thus, and the title has become well-known in the West. But not all ascetics are so generous in their praise; many criticize *svāmi*s for their involvement in householder affairs.

Female Ascetics as a Class: Sannyāsinīs, Brahmacāriṇīs, and Mātājīs

What terms serve to designate female ascetics as a class? It is not clear that this notion is entirely meaningful to people other than ascetics themselves, and householders living in proximity to them. In the course of his or her life the average Hindu is liable to meet or hear of certain women who are locally, sometimes nationally, renowned as *guru-mās* (mother-*gurus*), and who as preceptors are considered to be saints or holy women. But though such *guru-mās* are almost always ascetics, their asceticism is not of primary significance to their followers; they are taken to be exceptional rather than instances of an entire class of women. Thus though many people happen to know or know of women who are in fact ascetics, few recognize female asceticism as an institutionalized phenomenon. On the other hand, most residents of Benares know full well that female ascetics exist and that there are different kinds. Not everyone employs the technically correct terms for the various types, but most are familiar with at least one *sannyāsinī*, *brahmacāriṇī*, or *mātājī*.

Some householders in the city know that there are female renouncers who are properly called *sannyāsinī*s. The three or four

especially successful ones who, for example, are heads of their own establishments, are readily identified as *sannyāsinīs* by the well-to-do with whom they interact. On the whole, however, the term is not often used. Communities of *sannyāsinīs* are found at only two places in the city, and even the people who live nearby and regularly see them do not necessarily identify them as such. Yet the term makes good sense, so that when, as very often happened, I introduced the word into a conversation, people quickly saw what I meant and then used it themselves. Ascetics, of course, are far more knowledgeable on the subject. Even if they do not know any (many Vaiṣṇavas, for example, either have no occasion to meet female renouncers, or actively avoid *all* renouncers), most of those who attend the great ascetic festival of India, the Kumbha Melā, will have seen *sannyāsinīs* camping and marching with the men of their respective divisions in the Daśanāmi Sampradaya. In fact, while many ascetics in Benares know and interact with *sannyāsinīs*, some, both men and women, stated that the Kumbha Melā was the only occasion on which they had seen *sannyāsinīs*.

Benares is perhaps again unique in that it has a large population of young female ascetics whose appearance and lifestyle differ greatly from those of *sannyāsinīs* and even more strikingly from those of the *sādhinī* type noted above. They are called *brahmacāriṇī*, a term which we may translate as "celibate student," and there are over twice as many of them as renouncers. They are around twenty-three years old, and live in convent-like communities under the guardianship of female preceptors. Modest in appearance and demeanor, wearing plain white saris and with their hair cropped, *brahmacāriṇis* are highly regarded and readily, even proudly, identified by the householders who live in the vicinity of their convents. Ascetics also recognize *brahmacāriṇis*, but owing to their dependent status and the fact that most know their *gurus* rather than the young women themselves, they tend to speak of them as "Gaṅgā Mā's students" or "Ānandamayī Mā's girls."

Both *sannyāsinī* and *brahmacāriṇī*, as well as *sādhinī*, a term used only within the ascetic community, refer to specific kinds. How does the average Benarsi speak of ascetic women in general? If there is any word that refers to female ascetics as a class, it is *mātajī*. Householders may, as noted above, call female ascetics *sādhu*, and address them individually as *sādhu-mā*, but most often they simply refer to and address them as *mātajī*, "respected mother." Popular literature usually renders *mātajī* as "holy woman." In this sense, the term is probably the most consistently used feminine

counterpart to *sādhu*, popularly rendered as "holy man." Often I could make my interlocutors understand the substance of my research by saying that I sought to learn about the life of *mātajīs*. The terms discussed in this chapter have been:

1. To suggest the unity of Hindu asceticism:
 sansār / mokṣa, rebirth and/or social-ritual life versus liberation
 sādhanā, (ascetic) discipline, and *sādhudharma*, the totality
 of ascetic disciplines
 guru, teacher/preceptor

2. Terms for a *guru*'s disciples:
 śiṣyă, pupil
 sādhaka/sādhikā, aspirant, practitioner
 cela/celī, servant
 dīkṣā, initiation

3. To suggest the diversity of Hindu asceticism as a way of life:
 vairāgya, desirelessness, dispassion, or equanimity
 tyāg, relinquishment, abnegation or (in a western sense)
 renunciation
 tapasya, (practice of) severe austerities
 sannyāsa, (institutionalized) renunciation

4. To suggest the idea of ascetics as a class:
 sādhu, (used by householders, pejoratively) ascetics who are
 indigent, mendicant, scantily, or at best, improperly clad;
 (for ascetics, approvingly) virtuous people
 sādhu-log, people who are (the world of) *sādhu*s
 sannyāsi, renouncer
 svāmi, (respectfully) lord, master

5. To suggest female ascetics as a class:
 sādhinī, (never used by householders; used by ascetics approvingly) someone who leads a mendicant or peripatetic
 lifestyle
 sannyāsinī, renouncer
 brahmacāriṇī, celibate student
 mātajī, respected mother

4

Unity and Diversity II

Sectarian Affiliation, Spiritual Path, and Ascetic Mode

Asceticism presents us with a profusion of beliefs and practices, many kinds of visual discrimination—bodily markings, ritual paraphernalia, sartorial styles, and the like—and great disparities in the socioeconomic and ritual status of its practitioners. This diversity might not be immediately apparent to the scholar who conducts an in-depth study of a single sect or tradition, but it cannot be missed by those who explore the ascetic population of a major center such as Rishikesh, Bhubaneswar, or Benares,[1] and it is strikingly evident on the occasion of religious festivals such as the Kumbha or Gaṅgā Sāgār gatherings (melā),[2] to which ascetics flock in great numbers. Despite this diversity, one is at the same time keenly aware of a unity within this world, a unity which turns on goals and values and which is markedly expressed in ascetic self-perception: they reiterate that they are *not* householders and that while householders fulfill their *dharma* in anticipation of an afterlife in heaven and a subsequent good rebirth on earth, they seek final liberation or release from the entire cycle of birth, life, death, and rebirth. They view themselves as a distinct subculture or social universe, *sādhu samāj*, the society of ascetics.[3]

Conventional approaches to the study of asceticism see sectarian affiliation as the primary factor in its diversity. Accordingly, typologies of the sects have been constructed that compile, with varying degrees of thoroughness, the beliefs, practices, and kinds of visual discrimination of each sect.[4] It is true that, given the

forehead markings and ritual paraphernalia of an ascetic, one can
refer to the standard typologies and with reasonable accuracy as-
sign him or her to a specific sect. Problems arise, however, when
one turns to belief and practice, for here there is no internal con-
sistency, no necessary correlation between an ascetic's daily reli-
gious life and his or her sectarian affiliation. Common beliefs and
practices traverse the entire range of sects. It is not unusual to find
members of distinct sects who in daily practice have more in com-
mon with each other than with others in the same sect as them-
selves. Take, for example, the practice that focuses on the ascetic
ritual fire called *dhūnī*. There are *dhūnī sādhus* among the Kānphaṭa
Yogis (Briggs 1982), the Rāmānandi Tyāgis (Burghart 1983b), and
the Nāga-Avadhūtani section of the Daśanāmi Sampradāya (Sinha
and Saraswati 1978). The Kānphaṭas, Tyāgis, and Daśanāmis con-
stitute three distinct sectarian traditions, but their respective *dhūnī*
sādhus pursue an almost entirely similar discipline, while at the
same time radically contrasting with their fellow sectarians.[5] This,
with other instances to be noted shortly, suggests that in the unrav-
eling of ascetic diversity perhaps too much explanatory value has
been attributed to the sect and sectarian affiliation.

Return for a moment to the sense of unity noted above, the
community's self-perception as separate from and united against
the lifestyle and values of householders. If the sectarian typologies
of historians and ethnographers have provided a means to ac-
count for diversity, we turn to the theoreticians when musing
upon ascetics' peculiar and profound sense of distinctiveness. In
this our primary guide is still Louis Dumont, whose analysis of
renunciation grounds a structuralist model of the entire Hindu
socioreligious order.[6] Borrowing Weberian concepts, Dumont dis-
tinguishes between world renunciation as life-outside-the-world and
householdership as life-in-the-world (1960, 43ff; 1965, 91ff). There
is little doubt that his analysis of the polarity of world renunciation
and householdership, and of their fundamental incompatibility,
remains valid and useful. But as we shall see shortly, some prob-
lems do remain.[7]

RESEARCH QUANDARIES

Like most recent researchers investigating asceticism, no doubt, I
entered the field armed with the guidelines for sectarian affiliation
established by scholars such as H. H. Wilson, J. N. Bhattacharya,

Sir R. G. Bhandarkar, and G. S. Ghurye, and with the Dumontian theoretical analysis of world renunciation. Only a few months had passed before I faced several problems of classification and interpretation which neither the sectarian typologies nor the theoretical approach could properly address. The first arose from the recognition that renunciation (*sannyāsa*) is not synonymous with asceticism. Dumont is a major source of unclarity here, as he argues that the institution of renunciation is so central to the formation of what we now know as Hinduism that all major religious developments in it, including sects, are products of the world renouncer (1960, 59; 1980, 24, 187). To accord the renouncer such primacy in sectarian development is either to see renunciation as synonymous with asceticism, or at least to make it the sole paradigm. This view was contradicted by my preliminary research, which found not only that the majority of sects in Benares have no renouncers as members, but also that very few of them have renouncers at the core of their organization, or renunciation as their dominant paradigm. In fact, renunciation is only one type of Hindu asceticism. Granted, the idea and ideology of renunciation are dominant and other types of ascetics are liable to define themselves in relation to it. But ascetics are precise in their attitudes toward renunciation and they never confuse it with other types of asceticism.[8]

A second problem, closely related to the first, turns on the fact that a good number of contemporary ascetics are members of no sect at all. They practice a type of asceticism which in their view is quintessentially nonsectarian because it is the most ancient and pure lifestyle. They are celibate students, *brahmacāris* (m.) and *brahmacāriṇī*s (f.), and their asceticism is *naiṣṭhika brahmacarya,* lifelong or perpetual celibacy. Third, and perhaps most important of all, by the end of my research I had discovered, as just noted, that ascetics of two different sects may well pursue the same ascetic discipline. The *dhūnī sādhu*s are but one case; there are others: celibate students in the Ramakrishna Sangha, which has Śaiva sectarian affiliation, have more in common with the celibate students in one of the biggest Vaiṣṇava *āśram*s of Benares than they do with the renouncer ascetics in their own Sangha. All devotionalist ascetics are, in terms of daily practice and theological stance, remarkably similar, whether the object of their devotion be Kālī, Kṛṣṇa, or Rāma. In short, commonalities in ascetic practice appear right across the gamut of sects.

Such a complex situation needs clarification. It urges one to search for a framework, a conceptual schema to organize and analyze the

copious and diverse ethnographic data. I offer here such a framework, drawing upon both my own and others' research, which attempts to accommodate the great diversity found within asceticism, yet at the same time to represent its distinctiveness in relation to householdership. It is put forward in the hope that other students of asceticism will find it useful enough to apply and, in the process, refine it.

Ascetic diversity may be seen as a product of three distinct but related phenomena:

1. *Sectarian affiliation* pertains primarily to social organization. Most ascetics are members of unique, differently named sects, socioreligious traditions that are perpetuated by the rituals of initiation.

2. *Spiritual path* turns on religious belief and practice: All ascetics follow a particular spiritual path as a means to attain liberation.

3. *Ascetic mode* refers to what is specifically ascetic in ascetic religious practice. All ascetics undertake a particular type or mode of asceticism.

There are perhaps a hundred named sects, a dozen or so spiritual paths, and at least four or five different modes of asceticism. Standard approaches tend to conflate these three phenomena, spiritual discipline and ascetic mode being subsumed under sect. But there is in reality no consistent correlation between these phenomena; knowledge of the sectarian affiliation of a given ascetic does not necessarily inform us about his or her spiritual discipline or mode of asceticism. Let us take these three aspects of ascetic diversity in turn so that we may perhaps more clearly see their nature and articulation.

1. SECTARIAN AFFILIATION

A unique, individually named socioreligious tradition is called a *sampradāya*.[9] This is the dimension of asceticism most accessible to study, mainly because it is crucial to ascetic social identity: To a large extent an ascetic's *sampradāya* determines his or her name and peer group, and the details of his or her appearance. The customary translation of *sampradāya* is "sect," although one also finds it rendered as "tradition" or "school" (i.e., school of thought). Though some scholars advocate abandoning the word "sect,"[10] others, myself included, find it appropriate and useful; but it requires clarification and qualification.

In the study of Christianity, the term sect refers to a group of people whose religious beliefs depart from an established doctrinal norm or standard of orthodoxy. Typically, because its beliefs are judged to be wrong or false, the legitimacy of the sect and its members is called into question. This approach is problematic in a Hindu context, for no single center of doctrinal authority exists that might pronounce such a judgment. Competing claims are more likely to be hierarchically ranked, and ranked differently by different sects, rather than declared wrong or false.[11] But, apart from this, the *sampradāya*s of Hinduism are comparable to Christian sects in that each *sampradāya* identifies itself as a distinct religious tradition and claims to possess a unique soteriology (Burghart 1983a, 649). In this fundamental sense, the *sampradāya*s are sectlike, and provided we bear in mind the somewhat different status of the sect as a religious phenomenon in Hinduism as a whole, the term can be useful.

The array of practices and beliefs found among sects is so great one hesitates to say that any criterion for differentiating between them is primary. But of the several widely recognized principles of differentiation, four are especially striking:

darśan, religio-philosophical orientation;

dīkṣā, ritual of initiation;

devatā, deity; and

ādiguru, founding-preceptor.

The first two, *darśan* and *dīkṣā*, encapsulate complex doctrinal distinctions between the sects. By and large only ascetics, and very few of them, are sufficiently acquainted with the great number of religio-philosophical schools and initiation rituals to speak authoritatively about doctrinal matters. The second two, *devatā* and *ādiguru*, are altogether more exoteric phenomena: Even the average householder can recite the names of several teacher-preceptors who founded major sects, and he or she will most certainly be aware that ascetics profess allegiance to specific deities. Allegiance to a particular founding preceptor and deity, which is the basis for theistic distinctions between sects, is also the aspect of sectarianism that matters most to ascetics. Many identify themselves and are identified by the name of their *ādiguru* (e.g., the Nimbarkis are a *sampradāya* founded by Nimbarkācārya, the Rāmānandis by Rāmānanda, etc.), but, just as important, the *sampradāya*s are organized into clusters according to the deity they honor, and the

ādiguru is customarily deified and worshiped as an incarnation of that deity. For these reasons sectarianism is a more theistic than doctrinal phenomenon, and theistic affiliation accounts for the most crucial aspect of the ascetic's public identity. Sectarianism is a feature of Hinduism as a whole, but there are more sects among ascetics than householders, albeit that recent research indicates that many sects which flourished even in the early twentieth century now have only a handful of practitioners, or none at all. The total number of *sampradāyas* in Benares is about twenty (Sinha and Saraswati 1978, 51). At least sixty-six sects have recently been reported for the state of Uttar Pradesh (Tripathi 1978, 6), but no one knows how many there are in South Asia as a whole. Theoretically, because the sect is an initiatory lineage, any *guru* can declare that he or she and the disciple constitute an independent *sampradāya*. But the vast majority of ascetics enter a sect by well-established initiation rituals, and each one considers his or her sect to be distinct from and superior to all others.

THE SANĀTANĪ-SANTAPANTHĪ DISTINCTION

The largest criterion which divides the ascetic community turns on what one can only translate as orthodoxy: ascetics recognize a sharp distinction between the sects that are *sanātanī*, orthodox or traditional—*sanātanī* means both ancient and eternal—and those that are not. As a group, unorthodox sectarians are called *santa* or *santapanthī*, "those who follow the creed or path (*panth*) of a *sant*." *Sant* is the name for North Indian religious leaders who founded major reform movements from the fourteenth century, often with an ascetic elite at the core of their organization. The *sanātanīs* are orthodox because they follow the Veda, accept the traditional Brahmanical socioreligious order, and honor all deities. The *santapanthīs* are "unorthodox" because they reject caste and, in some cases, image worship; but also, and greatly offending traditional ascetics, they reject the corpus of sacred literature, either in part or in its entirety.[12] As orthodox ascetics phrase it, *santapanthī* are *avaidik* (non-Vedic) and honor *guruvāṇī*, the word or teaching of the preceptor, rather than the Veda. By contrast, orthodox ascetics claim to be *sanātana dharmīs*, followers of the eternal *dharma* revealed in the Veda.[13]

Although the *sanātanī-santapanthī* distinction is important, ascetics do not always agree about how to apply it, and so the status of some sects is equivocal. Existing typologies indicate that

there is just as little consensus among scholars. With the exceptions of Sinha and Saraswati (1978, 47–48) and J. N. Bhattacharya, who designates "Worshippers of Great Teachers" as a separate class (1968, 289), the *sanātanī-santapanthī* distinction is not articulated by most writers. The tendency has been to allocate what ascetics designate as *santapanthī* sects to the categories of reformist or miscellaneous. A few examples will illustrate both the significance of the distinction between orthodox and unorthodox, and some of the issues crucial to its application.

The Kabirpanthīs and Rādhā Soāmis are frequently treated in the typologies as reformist Vaiṣṇavas (Ghurye 1953, 89–9; Tripathi 1978, 46, 48), but both are clearly in the *santapanthī* camp. Sant Kabir Das is notorious for his rejection of *varṇāśramadharma* and of all iconic representations of the divine, and the founder of the Rādhā Soāmi Satsang, Śiva Dayāl Sahib, declared himself to be the Perfect Guru (Sant Satguru) and the Supreme Being (Farquhar 1913, 157). All ascetics I know affirm that the Kabirpanthīs and Rādha Soāmis are *santapanthī*, as do members of these sects, householders, and ascetics alike[14].

A few sects are not so easily classified because, though *panthīs*, they have consciously tried to establish themselves as orthodox. An interesting case is the Svāminārāyaṇa sect, whose founder Sahājānand has an ambiguous status even within his own tradition: One subsect argues that Sahājānand declared himself to be a complete manifestation of the Supreme Person, and superior even to Kṛṣṇa (Williams 1984, 49, 67f). According to Svāminārāyaṇa tradition, on the occasion of a debate between one of their Acāryas and an orthodox Daśanāmi abbot, held in the 1870s and mediated by Benarsi *paṇḍits*, the Acārya successfully defended his tradition against the charge of being *avaidik* (Sinha and Saraswati 1978, 142). However, though they have this battle to their credit, and though they claim membership in the spiritual lineage of Rāmānuja, other ascetics do not, in general, accept Svāminārāyaṇas as orthodox. Nor do most scholars: Ghurye treats them as outside the traditional Four Branches of Vaiṣṇavism (1964, 207); Tripathi, following popular ascetic usage, refers to their founder as a *sant* (1978, 41); and Sinha and Saraswati's typology clearly assigns them to the *sant sampradāyas* (1978, 255).

The Dādūpanthis provide a comparable example. They worship the two books of Dādū's sayings and reject all classical ritual, yet they have nonetheless been influenced by both Advaita philosophy and the organizational structure of the orthodox Daśanāmi Renouncers (Wilson 1862, 57–58; Ghurye 1964, 196ff.;

Thiel-Horstmann 1991). Moreover, departing from the principles of Dādū, they are now concerned with caste. Ascetics of my acquaintance argue that these traits are accretions, and that the Dādūpanthi's current caste-consciousness, for example, marks an attempt at upward mobility (Tripathi 1978, 47). In this, the Dādūpanthis follow a route traveled earlier by the Udāsis and Nirmalas. Both of these sects were founded by *sants* of the Sikh Guru Nānak's spiritual lineage and both worship a book, the Guru Granth Sahib. However, each in its own way has moved toward the orthodox camp. The Nirmalas recognize caste, read the Guru Granth Sahib as an Advaita Vedāntin text, and attach their fighting ascetics to the Daśanāmi Renouncers. The Udāsis worship the Five Deities of orthodoxy, follow classic Śaiva ascetic disciplines such as *dhūnī sādhanā*, and adopt the traditional organizational structure of the Daśanāmis (Wilson 1862; Ghurye 1964, 142–48; Sinha and Saraswati 1978, 138–39; and Tripathi 1978, 40, 48). Ascetics clearly identify the Nirmalas and Udāsis as spiritual descendants of Nānak. In my experience, the Udāsis are generally accepted as being closer to orthodox sects than the Nirmalas. The former is called a *sampradāya*, the latter always a *panth* (Tripathi 1978, 40, 48). Sinha and Saraswati (1978, 254) allocate both to the *santapanthī*s, and most ascetics would concur.[15]

Estimates of the proportion of orthodox to unorthodox ascetics vary, partly due to the ambiguous status of a few sects, but also due to inconsistencies in the criteria used to define a sect's status. Tripathi's data, for example, suggest that at least one-half of the sixty-six sects he records for Uttar Pradesh are nontraditional.[16] Sinha and Saraswati's figures are more precise: ten out of twenty-one ascetic *sampradāya*s they list are *panthī*s,[17] yet in terms of actual numbers they constitute only one-eighth of the total population (1978, 51). It appears that though there are more *santapanthī* than *sanātanī* sects, by far the larger number of ascetics are orthodox.

THE TWO GREAT SIDES OF HINDU ASCETICISM

The *sanātanī-santapanthī* distinction is important to my typology of sects, but the cleavage of most practical significance to ascetics is that between the two great sides (*taraf*) of Hinduism: the Vaiṣṇavites and the Śaivites.[18] *Taraf* means "side" in both a literal and figurative sense—as in "side of the street" and 'side of an argument'—and it reflects a long history of rivalry. Articulating

and preserving this division is primarily the work of militant ascetics on both sides. In fact, ascetics also speak of these *taraf* as two *dal*—meaning crowd, gang, or troop—and the distinction is carefully maintained by the spatial arrangements at the Kumbha Melā, where the Śāmbhu *dal* (Śāmbhu is an epithet of Śiva) camps separately from the Bairāgi (Vaiṣṇava) *dal*.[19]

The two sides correspond to the largest theistic division in Hinduism, between those who worship the deity Viṣṇu and those who honor Śiva. (By convention, and following the larger pattern of theism, ascetic Śāktas, who worship the Goddess as supreme, are allocated to the Śaiva side.) Each of these theistic camps consists in a number of *sampradāya*s, those on the Vaiṣṇava side being somewhat better organized and more clearly distinguished than those on the Śaiva.[20]

Vaiṣṇava Ascetics (Bairāgi/nīs, Vairāgi/nīs): The Four Branches and Nine Sects

Vaiṣṇava ascetics worship Viṣṇu, Rāma, or Kṛṣṇa, the latter two seen as incarnations of Viṣṇu, and their consorts Śrī (Lakṣmī), Sītā, and Rādhā respectively. They are organized into four branches, *Catur-Sampradāya*, which is a sort of umbrella organization for nine sects. Each branch (here in arabic numerals) is aligned with a different religio-philosophical stance (*darśan*). Sects within a branch are mostly distinguished by deity affiliation. Thus:

1. The Śrī Sampradāya, the oldest of the branches, has two sects, (i) the Rāmānujis and (ii) the Rāmānandis. Both follow the Qualified Monism (*viśiṣṭādvaita*) of the philosopher-ascetic Rāmānuja, but (i) the Rāmānujis worship Viṣṇu with his consort Lakṣmī,[21] while (ii) the Rāmānandis worship Rāma and Sītā.

2. The Sanaka Sampradāya has one sect, (iii) the Nimbārkis, or Nimavats, who follow the Dual-non-dual (*dvaitādvaita*) philosophy of their founder, Nimbārkācārya, and worship Rādhā-Kṛṣṇa.[22]

3. The Brahma Sampradāya has four sects, (iv) the Mādhvas, (v) the Mādhva-Gauḍiyas or Caitanyites, (vi) the Rādhāvallabhas, and (vii) the Sakhīs. The Mādhvas (iv), the Rādhāvallabas (vi), and the Sakhīs (vii) follow the dualist (*dvaita*) philosophy of Madhvācārya,[23] but while the Mādhvas

(iv) worship Lakṣmī-Nārāyaṇa,[24] the Rādhāvallabas (v) worship Rādhā-Kṛṣṇa[25] and (vii) the Sakhīs are a transvestite sect who identify themselves with Rādhā and worship Kṛṣṇa as their husband.[26] The Mādhva-Gauḍiyas (v), or Caitanyites, like (vi) the Rādhāvallabas (vi) and the Sakhis (vii), are Rādhā-Kṛṣṇa worshipers, but they do not follow Madhvācārya's *dvaita* philosophy. They adhere to Nimbarkācārya's *dvaitādvaita* system, but, for reasons that are not entirely clear, have affiliated themselves with the Brahma Sampradāya.[27]

 4. The Rudra Sampradāya has two sects, (viii) the Vallabhas and (ix) the Viṣṇusvāmis. Both follow the Pure Monism *(śuddhādvaita)* of the philosopher-ascetic Viṣṇusvāmi, and both worship the youthful form of Kṛṣṇa, Gopāl-Kṛṣṇa.[28]

 As discussed earlier, the term for ascetic Vaiṣṇavites is *bairāgi/ nī* (f.), meaning "one who is without attachment." *Bairāgi/nī* is counterposed to *sannyāsi/nī*, the term for the category of ascetics who are the best known and most influential members of the other side of Hinduism, the Śaiva *taraf*.

The Śaiva Side of Asceticism: Renouncers, [Jogis, Śaktas, and Śaivites][29]

No organization comparable to the Vaiṣṇava *Catur-Sampradāya* is found on the Śaiva side, which comprises a number of disparate groups that cluster around four traditions. Unlike the Vaiṣṇava *sampradāya*, these four traditions cannot be neatly distinguished according to deity and philosophy. Although these criteria do operate, the founding preceptor *(ādiguru)* and ritual of initiation *(dīkṣā)* are just as important. The four traditions are:

 1. The Daśanāmi Renouncers *(sannyāsi/īs)* are an initiatory tradition, defined by a specific ritual of initiation. They have no subsects, but there are four named divisions (also called sections): (i) Dandi, (ii) Paramahansa, (iii) Nāga-Avadhūtani, and (iv) Gharbari Gosain.

 2. The Nāthapanths, more commonly known as Gorakhapanths or Jogis, are a sect in which all members trace their lineage to a specific preceptor. They are subdivided into Kāṇphatas

and Aghors (also called Aughors).

3. The Śāktas are defined by allegiance to a specific deity, the Goddess.

4. The sectarian (i.e., *āgamik*) Śaivites are defined by allegiance to Śiva.

1. The Daśanāmi Renouncers (sannyāsi/nīs)

The Daśanāmis are the most important Śaivite ascetic tradition. Indeed, two of the other three traditions, Jogis and Śāktas, have especially close relations with them, some of their ascetics being members also of the Daśanāmi Sampradāya. *Sannyāsi/nī*s are Renouncers, "those who have renounced." Daśanāmi Renouncers are often referred to as Śaṅkarite ascetics, first, because the eighth-century philosopher Śaṅkarācārya is believed to have organized all the renouncers of his day into a kind of monastic order—the Daśanāmi Sampradāya—with ten named lineages (*daś nām*, ten names) and, second, because all ascetics in this order profess his monistic philosophy, Advaita Vedānta. Their allocation to the Śaiva side rests on the ascetic nature of Śiva, and Renouncers claim that they represent the original tradition of asceticism. It bears mention, however, that for them Śiva is far more of a tutelary deity than an object of adoration. Unlike the Vaiṣṇava ascetics, most of whom worship Viṣṇu or one of his incarnations, Renouncers are less likely to worship Śiva than they are to identify with him, usually in one of his ascetic aspects. Some, adhering strictly to Śaṅkara's Advaita philosophy, honor no representation of Śiva at all, but identify themselves with the formless Brahman. Finally, seemingly as a paradox, there are Renouncers who are Vaiṣṇavites, honoring one form or other of the deity Viṣṇu. This peculiar state of affairs arises because the Daśanāmi Sampradāya, the Ten Names Order, is not really a theistic sect at all. Rather, it is a tradition defined by a specific ritual of initiation, renunciation, or *sannyāsa*. Renouncers are thus united neither by *devatā* nor by *darśan,* but rather by *dīkṣā*: The only thing Renouncers have in common is that they have all undergone the ritual of entry into renunciation, *sannyāsa dīkṣā*.

The Renouncers have no subsects. As just stated, they do have four divisions, also called sections: Daṇḍi, Paramahansa, Nāga-Avadhūtani, and Gharbari Gosain. No consistent criteria distinguish the divisions from each other, but two features figure

prominently: previous caste status and current spiritual discipline. Thus, taking each division in turn:

(i) All Daṇḍis are Brahmins; they adhere strictly to the classical regulations governing *sannyāsa*, so that they are, for the most part, fourth-stage-of-life Renouncers, and they abandon all rituals. Apart from meditating on their identity with the Absolute (*Brahman*), they do nothing at all. This, of course, does not preclude the pursuit of knowledge and so some devote themselves to study of the sacred texts.

(ii) Many Paramahansas are Brahmins, but there are also members of other twice-born castes among them. They focus primarily on study, teaching, and preaching, activities that bring them into frequent contact with the larger society, and so they are quite worldly. In the past, they also actively engaged in trade and commerce. In all respects they are closer to the Nāga-Avadhūtani division than to the Dandis because recognizing an ascetic as a Daśanāmi Paramahansa depends on affiliation with one of the basic organizational units (*akhaas*) found among that division.

(iii) Although there are Brahmins among them, many Nāga-Avadhūtanis are from *kṣatriya* and *śūdra* castes. Nāga is the term for male members and Avadhūtanī for the female. Their spiritual discipline emphasizes physical culture, the practice of *haṭha yoga* in particular, and the performance of a wide range of esoteric rituals. They represent the militant tradition of Śaiva asceticism; until the mid-nineteenth century, in their capacity as mercenaries and traders, they often held the balance of power in North Indian kingdoms. The admission of women and *śūdra*s to the Daśanāmi Sampradāya is correlated with the rise of militant asceticism. Non-Brahmins and women are found in greater numbers among the Nāga-Avadhūtani division than among the Dandi and Paramahansa, and it is from this division that the fighting ascetics come. The basic units within the Nāga-Avadhūtani division are called *akhaa*, which means "regiment"; there are eight such *akhaas*. The establishments in which Nāgas and Avadhūtanis live are also called *akhaas*; here the term coincides with nonascetic usage, in which an *akhaa* is an open-air gymnasium or a training ground for athletes. The *akhaas* greatly affect the ritual and social life of all renouncers.

(iv) Gharbari Gosains are Householder Renouncers. At some point in the past, ascetics of at least two of the ten Daśanāmi lineages (Giri and Puri) married, and their descendants, in parts of North India and Nepal, at least, have a close if complex relationship with establishments belonging to the Nāga-Avadhūtani division. Though they have a Daśanāmi name and a Daśanāmi

affiliation, when they become Renouncers, as many of them do, they must also undergo the rite of entry into *sannyāsa*. At that point, they are fully integrated into the Nāga-Avadhūtani division. Ascetics of all these divisions undergo *sannyāsa dīkṣā* to become Renouncers. (The Nāga-Avadhūtani have a set of additional initiatory rites unique to their division.) The preceptor in whose name an ascetic is initiated bequeaths his or her lineage title—one of the ten names—to the initiate, thus perpetuating the lineage and the tradition. Apart from this initiation, these four divisions have little in common. Their previous caste backgrounds, their present spiritual discipline, and the lifestyles associated with their spiritual paths vary greatly. Their philosophical stance is not unitary: Dandis and Paramahansas, in general, profess to be Advaita Vedāntins, but Nāgas and Avadhūtanis are not easily characterized. Consonant with their emphasis on physical culture, in the practice of yoga and of warfare, many follow an ascetic discipline that is rooted far more deeply in classic dualist Sāṃkhya philosophy than in Vedānta. Moreover, as just noted, there are Vaiṣṇava proponents of *Viśiṣṭādvaita, Dvaitādvaita,* and *Śuddhādvaita,* who take *sannyāsa* to become Daśanāmis. The most striking feature of the Daśanāmi Sampradāya is its ability to contain comfortably so many contradictions in philosophy, spiritual discipline, and ascetic lifestyle. This is possible largely because of the character of Renunciation. Crucial aspects of Renouncer religiosity are understood only by reference to *sannyāsa* itself, a topic to which I return later in discussing the modes of Hindu asceticism.

This outline of Śaiva and Vaiṣṇava ascetics highlights the orthodox (*sanātanī*) sects. The various *santapanthī* sects who admit theistic affiliation align themselves with one or other of the two great sides, seen most clearly at the Kumbha Melā, when members of the various *panthas* camp with the orthodox ascetics of their deity: for example, the Kabirpanthi camp with the Bairāgi/nīs, the Dādūpanthis and Udāsis with the *Sannyāsi/nīs*.

KINDS OF VISUAL DISCRIMINATION: SIGNIFYING SECTARIAN AFFILIATION

Having noted some of the variability across the range of *sampradāyas,* let us turn to their most common and salient consistencies. Certain generalizations hold true for all ascetic sects, most notably that sectarian pride leads ascetics to create self-conscious and sometimes competitive communities. The members of a sect assiduously try to distinguish themselves from those of all others.

One obvious way to do this is by adhering to specific guidelines for comportment and behavior. Each *sampradāya* selects various kinds of visual discrimination so that its ascetics wear a particular color and style of garment, mark their bodies in certain places with distinctive sectarian patterns (*tilak*), and carry or display ritual paraphernalia made according to precise designs and out of specific substances. These kinds of visual discrimination are rarely arbitrary. Colors, bodily markings, and ritual items symbolize aspects of sectarian religiosity, such as the deity or deities the sect honors, the religio-philosophical system it espouses, or the states of mind it strives to cultivate. Taken together, the colors, marks, et cetera express dimensions of the sect's concept of salvation and the way to that salvation. The distinctive appearance and behavior of ascetics from different *sampradāyas* emphasize the fact that they consider their path to liberation to be unique. For underlying all sectarian discriminants and at the core of sectarian identity is each sect's conviction that it possesses an original and superior way to escape the cycle of life, death, and rebirth so as to attain liberation.

The *sampradāya* has received much attention in studies of asceticism because it is the aspect that presents itself most vividly. It gives the ascetic his or her primary social identity, and to a great extent determines the face that he or she prepares for the world. Most early historical and sociological studies made sectarian affiliation primary and assumed that a comprehensive typology of sects could adequately represent asceticism. In my view, sectarian affiliation is just the starting point. True, before we can discuss popular and scholarly terminology, or even summarize the relevant studies of asceticism, we need to know at least the following: that ascetics are members of *sampradāyas*, socioreligious traditions we call sects; that the *sampradāyas* are in general, but with important exceptions, theistic, so that most express some kind of allegiance to one of the two great deities, Śiva or Viṣṇu, and that sectarian affiliation provides the primary basis for the ascetic's public identity. However, ascetic diversity goes far beyond sectarian identity. To know an ascetic's sectarian affiliation is not necessarily to know anything at all about the spiritual path or mode of asceticism that he or she follows.

2. SPIRITUAL PATH

The second determinant of diversity of asceticism, after sectarian affiliation, consists in differences in spiritual path. The indigenous terms translated as spiritual path are *mārg, path,* and *ācār,* all of

which refer to a body of customary practices pursued for the purpose of attaining a religious goal. *Mārg* and *path* both mean way, path route, and *ācār* means conduct or practice. Popular wisdom has it that in Hinduism "the goal is one but the paths are many"; introductory books on the subject often isolate three such paths or ways, derived from the *Bhagavad Gītā*: the way of action (*karma mārg*), the way of knowledge (*jñāna mārg*), and the way of devotion (*bhakti mārg*). Facile as this *trimārg* classification may seem, my research suggests that all the many spiritual disciplines found among ascetics may indeed be identified with one of these three paths: ritualism, gnosis, or devotionalism. A comprehensive discussion of this would require lengthy and detailed descriptions of the day-to-day activities of a good number of ascetics. My data indicate that there are at least a dozen spiritual disciplines, maybe more, the *karma* and *bhakti* paths being the most diversified. Here I shall confine myself to a brief presentation of several disciplines, so as to demonstrate how the three paths are creatively translated into practice.

The *rasa* theory, which is a sort of "doctrine of sentiments," and was originally developed by literary theorists, is a good point of departure. Popular among certain Vaiṣṇava sects such as the Rādhāvallabhas and Rāmānandis, the *rasa* doctrine distinguishes between different attitudes a devotee may establish with a deity: friendly (*sakhya*), parental (*vātsalya*), servile (*dāsya*), erotic (*sṛṅgāra*), and blissful (*śānta*). These attitudes, fundamentally and explicitly devotionalist, are each actively expressed in distinctive spiritual disciplines. For example, those ascetics who follow the parental mode and who treat the image of their deity (usually Bālrāma or Bālkṛṣṇa) as a little boy, undertake from morning to night a series of activities, accompanied by emotions of a motherly or fatherly sort, that are quite distinct from the activities and emotions of those who express, say, the erotic attitude. The parental ascetics spend many hours a day holding the images in their arms, singing to them, rocking them, and feeding them sweets. Male erotic ascetics adopt women's clothing and behavior, even feigning women's biological functions, so that for three days each month they menstruate. Their emotional life is decidedly homoerotic, and qualitatively different from that of ascetics who adopt the parental stance. The discipline each type of ascetic follows is, at the behavioral level, quite distinct. But both of these disciplines are rooted in devotionalist sentiment and are creative, if standardized, interpretations of the *bhakti mārg*.

The notion of ritually efficacious action underlying the second of the spiritual paths is likewise expressed in diverse behavior patterns. Disciplines having their roots in the *karma mārg* include:

regular practice of postures and breathing exercises (*yogāsanas, prāṇāyām*), undertaking of fasts, pilgrimage, or austerities (*vrata, yatra, tapas*), performance of fire rituals (*homa* or *dhūnī*) and deity worship (*pūjā*), and commitment to good works or social service (*sevā*). The discipline of the modern day "ascetic social worker" (such as the Svāmis and Prabrājikas of the Ramakrishna Mission) is very different from that of the traditional, extra societal, and antisocial *dhūnī sādhu*. Yet both are *karma yogins*, treading the path of action, the *karma mārg*.

Finally, a number of spiritual disciplines are based on the third path, the *jñāna mārg*. Many ascetics report that *japa-dhyān* (*mantra* repetition) is the essence of the way of knowledge, others insist that study of texts and preaching to householders are quite consonant with this path. Still others take an anti-intellectualist stance, arguing that true knowledge can never be gleaned from books, but only by withdrawing from the world, and to this end, they assure us, a good *cilam* is just fine. Though the cannabis *sādhanā* of the *sādhu* ascetic may appear radically opposed to that of the renouncer ascetic who runs a seat of Sanskrit learning, both claim the pursuit of knowledge as the basis of their spiritual discipline.

What is the relationship between spiritual path, sectarian affiliation, and ascetic mode, to be discussed shortly? First, there is no necessary correlation between a sect and a discipline. A sect commends a specific philosophy, and although certain paths and/or disciplines may be observed more frequently in one philosophical school than another—the various disciplines rooted in the *jñāna mārg* are certainly most appropriate to Advaita Vedānta—in reality there is a very fluid relationship between philosophy and spiritual discipline. In terms of sectarian organization, it is noteworthy that while sects are relatively inflexible in matters of philosophy, they are quite accommodating when it comes to spiritual discipline. That is to say, while philosophical and theological innovations are liable to result in the formation of new sects, or the division of sects into subsects, variations in spiritual path and the spiritual discipline to which these paths give rise lead not to new sects or subsects, but rather to the formation of divisions within a sect. There are many examples of this, especially in larger sects such as the Vaiṣṇava Rāmānandis and Daśanāmi Renouncers. Second, and crucial to intrasectarian debate, the different disciplines found in most large sects are ranked, so that the different divisions are assigned to different grades of spiritual attainment. Third, while

the relationship between discipline and philosophical perspective may be quite flexible, the same cannot be said of the relationship between discipline and ascetic mode. Thus, if one knows an ascetic's spiritual discipline, one is far more likely to guess correctly his or her mode of asceticism than the sect to which he or she belongs or the philosophy he or she professes. This is because the various asceticisms are soteriologies. They are different paths, ways, or routes to salvation, although they do together constitute a special kind of *mārg* or *path* in that they take as their first principle the rejection or renunciation of householdership. It is understandable, then, that in the notion of *sādhanā* we should find spirituality and asceticism so creatively conjoined. The process by which the spiritual paths and their several disciplines are bonded to different ascetic lifestyles is clarified by looking at modes of asceticism.

3. ASCETIC MODE

Sectarian affiliation and spiritual path are not exclusive to asceticism. Householders may join a sect by taking householder initiation from the preceptor, and they may choose to follow a spiritual discipline without taking formal ascetic vows. Many people become increasingly spiritual as they age, some spending their entire day in religious activities. What distinguishes ascetics from such householders is, quite simply, their asceticism. Over the course of history, certain ancient and disparate practices and beliefs have emerged as recognizably coherent modes of asceticism. I refer to them as modes because each is a different, institutionalized way of being ascetic; each is marked by a unique ritual of initiation and comprises a different concatenation of beliefs and practices, which dictate a distinctive lifestyle. These modes of asceticism, I argue, express distinctive ideologies. The principles underlying a given mode of asceticism are revealed by examining rituals of initiation, and the customary behaviors peculiar to its ascetic lifestyle. It is here that one can most cogently discuss the relationship between householder and ascetic because the various asceticisms are, so to speak, located at different points or positions on the larger socioreligious map of reality. Here certain Dumontian phraseologies are most useful, such as those which distinguish between life-in-the-world and life-outside-the-world.

Of the several modes of asceticism three are relatively well represented in the historical and sociological data:

1. Renunciatory asceticism *(sannyāsa);*
2. Celibate asceticism *(brahmacarya);*
3. Tantric asceticism (called by several terms, such as *tantrayoga, nāthyoga,* and *tantra sādhanā).* A reading of the available literature leads me to conclude that there may be at least two other distinctive ascetic modes:
4. One that appears to be characteristically *panthi* (there are remarkable similarities in the initiation rituals of the Sikhs, Kabirpanthīs, Nirmalas, Udāsis, Dādūpanths, Rādhāsoāmis, and Garibdāsis, for example), and
5. Another that appears to rest on *āgamik* initiation (there are striking similarities in the asceticisms practiced by Śaivasiddhāntins and Vīraśaivas).

However, to date we lack detailed studies of either the initiations or customary practices of these last two asceticisms, and so can only speculate that they may perhaps constitute an additional two modes. There is much that could be said about the other, well-known modes of asceticism, renunciatory, celibate, and tantric. I will summarize their initiation rituals, and then aspects of their underlying ideologies so as to highlight the relationship each establishes with the larger world of the householder.

Sannyāsa: Renunciatory Asceticism

Sannyāsa is the best known mode; entry into this lifestyle is marked by a dramatic ritual in which one symbolically throws away the world. From its earliest codification, renunciation has been marked by a radical ritual of entry in which the candidate severs ties with family, place, and property, surrendering all social and ritual identity. Still today, the phrase uttered after having announced one's intention to renounce is, "None belongs to me, to none do I belong." In a more prosaic though no less startling phrase, he or she declares, "I leave absolutely everything behind." An essential element of this ritual is the symbolic placing of the ritual fires in oneself, indicating the abandonment of householdership. Even more dramatically, some ascetics perform their own funeral rites after cremat-

ing an effigy of themselves. In the core of the ritual, the *guru* asks the initiate a question to this effect, "Do you wish *grhasthāśram* or *sannyāsāśram*?" After the initiates have answered, "*Sannyāsāśram*," the *guru* tells them to repeat three times a phrase stating that they renounce the world, gives them a new set of ochre-dyed garments and various other items of paraphernalia, pronounces a mantra in their ear, and bestows on them a new two-word name. They are then always known by this title.

Renouncers today are a heterogeneous lot. About the only thing they have in common is their initiation into renunciation and the fact that they all wear ochre-colored clothes. Otherwise, they pursue a variety of activities: study, meditation, preaching, teaching, wandering, begging, traveling to sacred centers, administering temples, hostels, and rental properties, undertaking physical exercises and yoga, indulging in gambling and intoxicants. By householder standards, the majority appear to lead a life of indolence. In their spiritual discipline, Renouncers tend toward the path of knowledge, but many appear decidedly irreligious. Those who are well established conduct hymn-singing sessions and deliver short sermons or tell sacred stories to the householder disciples who visit them. But these same Renouncers devote a large portion of their time to worldly affairs, such as litigation over property or the running of private schools, and they dispense advice to their disciples on a host of practical matters as well. All renouncers wax eloquent on the subject of renunciation and laud the freedom it bestows. They take seriously the attainment of *mokṣa*, but few see it as a goal for which they must strive. Rather, they firmly believe that the taking of *sannyāsa* itself assures them liberation at death.

Brahmacarya: Celibate Asceticism

The mode of asceticism called *naiṣṭhika brahmacarya*, what I call celibate asceticism, is a significantly different phenomenon from renunciation; it is the oldest form of institutionalized asceticism in India, predating renunciation by perhaps hundreds of years. Perpetual celibacy as a distinct mode of asceticism derives from the ancient Vedic institution of studentship (*brahmacarya*), the first of the four stages of life. As the stage of life preparatory to marriage, householdership, and social adulthood, it ensured that the adolescent received essential instruction in Vedic lore and ritual. Historically, celibate asceticism appears to have emerged simply by the extension of studentship into a lifelong status, achieved more by

default than by acclamation: One simply refused to marry and thus to enter the second stage of life, householdership. To the best of my knowledge, there is no ritual of entry into *naiṣṭhika* status, nor are there any texts devoted specifically to defining its *dharma*. In this sense, celibate asceticism is less institutionalized than renunciatory asceticism. Celibate asceticism occurs in several ways:

1. As a novitiate in some modern ascetic organizations that have introduced studentship, usually for twelve years, prior to initiation into *sannyāsa;*

2. As an institutionalized lifestyle entirely independent of sectarian identity—certain ascetics deny or reject all sectarian affiliations and define themselves simply as *brahmacāri/ṇīs;*

3. As a mode of asceticism underlying many sectarian traditions.

The rituals of initiation characteristic of such sects conflate sectarian initiation rituals with the classical rite of entry into studentship, which is not an initiation *(dīkṣā)* but a life-transition rite *(sanskār,* Skt. *saṃskāra).* In contrast to renunciatory asceticism, there is no single ritual of initiation into celibate asceticism. *Brahmacarya* takes different forms in ascetic society, which dictate differences in the details of the initiation rite, but several features are consistent: The rite itself is a two- or three-day affair that commences with the shaving or cropping to earlobe length of the initiate's hair; the initiate fasts for that day and night, and then takes a ritual bath on the following morning; at a specially prepared place, the *guru* sits and is approached by the initiate who offers *dakṣiṇā,*[30] which may consist of money, a white *dhoti,* or simply fruits and flowers; at a time carefully chosen by an astrologer, the *guru* then whispers a *mantra* into the initiate's ear. There are additions to and variations on this, according to whether or not the initiation is sectarian. In all cases, initiates are instructed in the ways of their new lifestyle and a communal feast is held.

Naiṣṭhika brahmacarya has two notable features of Vedic studentship: celibacy and pupilage. As with practices such as strict adherence to a vegetarian diet and observance of all the rules governing pollution, celibacy is intended to guarantee as high a degree of purity as possible. Pupilage has two essential requirements: study of the sacred texts and service to the *guru.* Celibacy, ritual purity, study, and service dictate a carefully supervised, conscientious lifestyle, and a perpetual dependency.

Brahmacāri/ṇīs are strictly celibate, wear white garments and keep their hair clipped short or shorn. They live a circumscribed life of devotional or ritual service to the *guru*, and follow a regime of Vedic study which may also include maintaining sacrificial fires.

In all this, celibate asceticism clearly differs from renunciatory asceticism. First, the celibate ascetic does not renounce the world. Though commitment to such asceticism halts one's progress through the stages of life, one's class status is by no means altered: sectarian or not, celibate ascetics observe the rules governing caste, class and gender. By adherence to all prescriptions governing sexuality, food, social interaction and ritual practice, *brahmacāri/ṇīs* seek to strengthen their pure qualities (*guṇa*). Second, *brahmacāri/ṇīs* remain within the fertile world of *karma*, so that their actions accumulate merit. The centrality of vows to this mode testifies to the vitality of the ascetics' *karma*. Foremost of these vows is celibacy itself, but *vrata* has come to mean, more specifically, "a fast," and all *brahmacāri/ṇīs* have an extensive vocabulary to describe a range of diets or controlled eating patterns. Third, the celibate remains always under the tutelage of a *guru*, who is invariably conceived of as an *avatār*, an incarnation of deity. This is true whether the *guru* is a charismatic, a full-fledged renouncer, or the latest teacher in a spiritual lineage that is itself traced to a divine personage. Unlike the renouncer who attains independence, individuality, and the right to initiate others, the *brahmacāri/ṇī* is perpetually submerged in the identity of the *guru*, dependent on his or her grace. Appropriate to the dependency of *brahmacarya*, no celibate ascetic has the right to initiate others. Celibate asceticism thus has no independent social existence: there are no lineages of *brahmacāri/ṇīs*.

Tantric Asceticism

No ascetic mode contrasts more with *brahmacarya* than the tantric. Tantric asceticism is a far less coherent phenomenon than either renunciation or celibacy, and is less successfully institutionalized. It rests on oral tradition, and because it attends more precisely than renunciation to the private whims of its practitioners, it is even more individualistic. The broad range of practices found in tantric asceticism may be reduced to a few categories, but before outlining them, I must clarify the term "tantric." My usage follows that of the ascetics. It designates those who ascetics themselves

define as tantric: those who have the will and courage to undertake "a fierce discipline" (*uttejak sādhanā*). Those who others call tantric have studied under an acknowledged adept (*siddhă*) and are said to have acquired powers (*siddhis*) by practicing very difficult *kriyā*s, "acts." The range of *kriyā*s varies, but it is widely believed that tantrics use sexual rituals to gain powers. Tantrics themselves do not deny this, but they more commonly stress the disciplined relationship they have with their *guru*, attributing their accomplishments to his or, occasionally, her powers as a teacher, and to their own courage as a disciple. The emphasis is always on the difficult character of the discipline itself, and the almost obsessive bond with the *guru*.

There is no single rite of initiation into tantric asceticism, but some themes are common in the accounts I was able to gather (most tantrics speak elliptically about such things). Setting aside the specifically sectarian aspects, which dictate, for example, the items one will wear, all initiates go through a period of testing and are actively discouraged from taking formal ascetic vows. All tantric ascetic initiations have elements that mock or invert features of Brahmanical life-transition rites. All initiations take place over a period of time and mark definite stages in the progress of the disciple. All involve eating or drinking substances that are forbidden or simply common (liquor or jaggery), which are often put directly into the mouth of the disciple and accompanied by punning questions. As with all initiations, special *mantra*s are transmitted.

Tantric ascetics divide into three groups. One consists of those who practice yogic postures, breath control, and various other *kriyā*s in order to render the body supple, aid in meditation, gain a vision of the deity, and achieve the blissful state of *samādhi*. Also included in this group are those who perform austerities (*tapas*). The second type consists of those who practice the feared "left-hand" (*vamācār, bamācār*) tantric path. The elaborate ritual complex said to have been cultivated by left-hand tantrics in the past finds only partial expression in contemporary asceticism, but its logic remains and provides legitimacy for practices and behaviors that other ascetics would reject. And although none engage in the rituals with corpses that left-hand tantrics are said to have practiced formerly, many still practice meditation at night in cremation grounds (*śmāśan sādhanā*). They seek bliss but, in addition, aim to cultivate the psychic or occult powers that inevitably accompany intense meditative and yogic practice. Indulgence in immoral, impure, and antisocial ritual activities is simply a quick route to such pow-

ers. The third category consists of those who may engage in any of the above—*yoga, tapas, vamācār*—but who use their tantric skills as professional sorcerers and sorceresses. There are many different terms for such tantrics, but most often they are simply addressed by their ascetic name and referred to as the man, or woman, who does *tantra-mantra* or knows *jādu-ṭona* (both are terms for sorcery). They are usually attendants at the shrines of non-Sanskritic deities and are consulted for a variety of reasons. They may be the mouthpiece for the deity whose shrine they attend, but more of their work consists in the correct application of spells and gestures and the preparation of amulets or magical diagrams.

One of the most notable features of the tantric's spirituality is that it argues not only for the possibility of full liberation in this life but also for full divinization, with all the knowledge and powers of omniscience on the one hand, and all the personal attributes and eccentricities of divine ascetics such as Śiva, Dattātreya, Parvatī, and Bhairavī on the other. All tantrics believe they have very special powers, and none separates the acquisition of power from the notion of spiritual liberation. Tantric ascetics describe their goal in different ways, emphasizing the stage of bliss or madness that it brings. To be intoxicated, wanton, or mad is evidence of spiritual attainment and the freedom that this mode of asceticism expresses. And, most important, all identify themselves with the ascetic or at least antisocial aspects of Śiva or the Goddess (as Śakti), several more radical practitioners taking on the appearance of fierce forms of these deities.

CONCLUSION

Each of the asceticisms we have considered defines itself in a different way to the social world that is correlated with a different relationship to the espoused goal of asceticism itself, spiritual liberation. Recall first the Renouncers. The rite of entry into *sannyāsa* establishes a person's ritual death. Initiates symbolically cremate themselves or, at least, publicly acknowledge their death by the act of performing their own funeral rites; they divest themselves of the primary signs of householder status and deny all former social relationships, stating clearly that they wish to throw away the world completely; and on removing their householder garments to don ochre ones, they achieve another identity, a new name, and a distinctive appearance. The key to understanding renunciatory

asceticism is the ritual of *sannyāsa* itself, a ritual that is, in essence, a rejection or abandonment. Nothing in this ritual resembles the vow or positive affirmation of a set of principles one commonly associates with initiation. As a mode of asceticism, renunciation is clearly a negative state; in the words of Patrick Olivelle, renunciation is defined more by what it is not than what it is (1977, 30). The most forthright comment one can make about renouncers is simply that they are not householders. But what gives renunciation its distinctive ethos is that, while abandoning the ritual values of the social world, renouncers do not abandon society. The negation of their former ritual identity, so clearly established in the rite of entry into *sannyāsa*, releases renouncers into a freedom that allows them to move throughout society with confidence. As a result they travel freely, are comfortable with the opposite sex, and dispense advice to householders of all levels of society. Freedom from conventional concerns for purity permits them to interact with others in a manner that would alarm the average householder. Renouncers may not be of the world, but they are free to remain in it. The negation of one's former ritual identity is a dying to the world. They use the word *samādhi*, which refers to the highest mystical state, to describe their physical death. In the opinion of most renouncers, entry into *sannyāsa* is a cremation, signaling their death to this world. A renouncer's physical death generates no impurity, and neither biological nor ascetic kin are polluted by it. Unlike householders, renouncers are not cremated; they are invariably buried or thrown into a sacred body of water, preferably the Ganges. In fact, renouncers do not die at all; they "take *samādhi*," that is, their death is an automatic entry into the bliss of enlightenment.

Celibate asceticism is a process that one undertakes rather than an act which itself assures liberation. As a processual mode, *brahmacarya* is still actively engaged with *karma*. Unlike renouncers, who are relatively indifferent to caste, celibates guard themselves against polluting contact with others, including not only all householders but, further, other ascetics who do not follow *brahmacarya*. They will never take food from a *sannyāsi/nī*, for example. Thus, although *brahmacāri/ṇīs* maintain physical separation from society, they are in many ways still very much "of the world" in that they accept the ritual categories characteristic of householdership. They work within the system, so to speak, striving like the householder for purity, but for a degree of purity that the average householder, caught in the exigencies of normal social life, can never attain. Withdrawal from society allows them

to achieve a status that is "purer than pure," a status that is critical in the process of working toward salvation as they understand it.

How very different is tantric asceticism. Two themes appear prominent in the tantric mode: centrality of the body as a vehicle for the attainment of salvation, and conscious inversion of the rules governing normal social relations. Both can, and often do, result in the abrogation of *dharma*. In the case of women, this means that *strīdharma* is flaunted. Thus, for example, tantric female ascetics choose their own sexual partners, use intoxicants, and engage in all manner of activities no proper woman would dream of doing. The centrality of the body is evident, of course, in the practice of *yoga*. But just as important, and more prevalent among tantric ascetics as a class, many of whom never perform *yoga* at all, is their full identification with a deity. By comparison with other ascetics, who live in anticipation of liberation, tantrics believe themselves to be, and act as if they are, already divine.

In terms of their relationship to salvation, if *brahmacarya* as an ascetic mode is a process by which one attains *mukti*, and, if *sannyāsa* constitutes 'the threshold of *mokṣa*' (Olivelle 1975, 81), the practitioner of *tantra* has indeed already arrived (Parry 1985a, 62). The spirituality of all ascetics is radically different from that of all householders, but the ascetics' concept of salvation and the relations they establish with the social world differ markedly according to their mode of asceticism. Celibate ascetics are in many ways closest to the householder because they respect most of the ritual values on which the Hindu social world is predicated. They care about purity, their behavior is decorous, and householders regard them highly. Tantric ascetics stand directly opposed to the celibates. Like them they recognize the ritual values of the social world, but rather than upholding purity, morality, and social conventions, they reject or, rather, reverse them entirely. Moreover, they seek power. They move about at the periphery of the social world and are either disdained or feared. Toward older ones householders display some ambivalence: though disreputable, the ascetics who do such things may, and probably do have occult powers, so it is best to be wary of them. Renouncer ascetics are located at a point midway between the celibates and tantrics: they do not uphold conventional ritual values, but neither do they flagrantly violate them. Because they are relieved of many ritual restrictions, they are extraordinarily free and may even participate in the conventional socioeconomic power structures of society.

At the risk of oversimplification, one might say that renouncer ascetics renounce their ritual identity and are free to move about in the world, which they treat as a social universe stripped of its ritual definitions. Celibate ascetics strive to avoid careless social relations because they accept and respect the purity-pollution based hierarchies that characterize the ritually defined world. Finally, tantric ascetics turn the entire system on its head. Unlike *sannyāsi/ nīs*, but like *brahmacāri/nīs*, they still recognize ritual relations as defined by purity and pollution, but in contrast to the latter, they do not flee impurity, but rather embrace it. For tantrics this world is filled with power: it is to be seized and expressed in one's own person as the divine Himself or Herself.

5

Socioreligious Aspects of Female Asceticism in Varanasi

Varanasi is the eternal city of Lord Shiva, who as Yogeshwar is the greatest ascetic of all. Writing in the seventh century CE the Buddhist pilgrim, Hiuen-Tsiang, described Varanasi, with its ten thousand Śaiva ascetics, as the ascetic center of India (Beal 1969 II, 44–45), and recent studies attest to its current primacy.[1] Presently it contains the largest number of female ascetics in India: a tenth of the city's approximately 1,300 ascetics are women and girls.[2] Although householders remain, in general, unaware of them as a distinct group, more than a few individual ascetic women have achieved notoriety as *gurus*, preachers, and even, in the role of abbess, as litigious landladies. We now have several good studies of Hindu asceticism with data of a sociocultural sort (Ghurye 1964, Miller and Wertz 1976, Tripathi 1978, Sinha and Saraswati 1978, Gross 1979, Burghart 1983a and b). They focus, however, almost exclusively on male ascetics, and their comments on women tend to be brief. This essay provides a sociological outline of female asceticism in Varanasi. The data are extensive and one must be selective. I begin with three general points.

First, in institutionalized asceticism, the relationship between the social and the religious is very complex. Asceticism is a way of life in which every action, or nonaction as the case may be, is religiously meaningful and socially significant. Ascetics form a distinct community whose organization is almost entirely dependent on religious institutions. Their primary social unit is the sect, and

an India-wide network of sectarian affiliations provides an endur-
ing social structure. The process of recruitment and integration
into a community is based on a characteristic Hindu spiritual bond,
the *guru*-disciple relationship. And finally, of course, the entire
edifice of institutionalized asceticism is built upon a religious goal,
spiritual liberation, so that entry into the community ideally sig-
nals one's commitment to a transcendental quest. But social, eco-
nomic, and political factors also figure as both the conditions for
and the products of a person's entrance into asceticism, and in the
case of women, some of these factors differ from those which exist
among men.

Second, there are no female ascetic organizations entirely dis-
tinct from the male, no independent orders of female ascetics.[3] The
common terms for Buddhist and Jaina female ascetics, *bhikṣunī* and
sādhvī, may well be translated as "nun," their social organization
being in many ways comparable to Christian female monastic or-
ders, but this word does not comfortably translate any of the many
Indian terms for a female ascetic. *Sannyāsinīs*, *bairāginīs*, and
avadhūtanīs do not form communities set apart, with their own
structures and disciplines. In terms of religious practice, male and
female ascetics are almost entirely similar. Members of the same
sectarian tradition may follows remarkably diverse paths, but differ-
ential treatment of the sexes is not in general a basis for differences
in practice. Rather, diversity stems from factors such as variations
in geographical and caste origins, personal idiosyncrasies, and rec-
ognized differences in degree of spiritual attainment. For the most
part, females join asceticism in the same way as their male peers
and, having taken initiation, receive the same training. Like men,
their geographic and caste backgrounds vary. They are just as idio-
syncratic, and their status is assessed by the same criteria.[4]

Third, women become ascetics for a wide variety of reasons,
and a summary of the social, cultural, and economic factors that
push them toward asceticism cannot adequately reveal the degree
to which strivings of a more religious or spiritual sort draw them
to this way of life. It is thus wise to bear in mind that an outline
such as the following, which highlights social structural pressures
and processes, risks obscuring the role that the private quest for
mokṣa plays in the lives of ascetic women.

The main part of this chapter has two sections. The first outlines
the socioreligious organization of female asceticism in Varanasi. The
second summarizes some of the basic data on the backgrounds of the
women and girls who have become ascetics there and discusses several

important social and religious factors contributing to their entry into asceticism. An appendix deals with the religious establishments of young women ascetics in Varanasi. By offering a few answers to the questions, "What kind of ascetics do women become?," "What kind of women become ascetics?" and, "How is it that women can become ascetics at all?," I hope to contribute in some measure to the study of women's religious life and to the sociology of asceticism as a whole in Hinduism's most sacred center.

THE ORGANIZATION OF FEMALE ASCETICISM IN VARANASI

Because asceticism as a value is so integral to Hindu life and thought, one meets many people who, while still remaining house-holders, adopt ascetic practices and lead ascetic-like lives. In any discussion of asceticism it is important to specify just whom the term "ascetic" refers to. As has been discussed in the introduction and previous chapters, by my definition an ascetic is a person who has been formally initiated into a tradition of asceticism by a spiri-tual preceptor, a *guru*.[5] In the ritual of initiation one renounces or rejects householdership in favor of an ascetic identity, and embarks on a discipline whose goal is the attainment of spiritual liberation. There are several paradigms of asceticism, some marking a more radical separation from householdership than others. But all are entered through a ritual process which emphasizes the disjunction between ordinary life and a life oriented toward spiritual libera-tion, and all signify a major change in ritual status. For women, the change in identity and status following initiation is particu-larly dramatic, since unlike men, women are unequivocally identified with householdership, home, and family. The society into which a woman enters differs radically from the society in which she lived as a householder. Three aspects of the religious organization of female asceticism show its distinctive character: its sectarian dis-tribution, residence pattern, and ritually defined social relations.

Let us start with the overall organization of asceticism. In 1978, Professors S. Sinha and B. Saraswati published the results of a two-year field research project, carried out in 1968–69, on asceti-cism in Varanasi. Their book, *Ascetics of Kashi*, is an important contribution. Based on a careful census of the city's ascetic popu-lation and their establishments, it is the first comprehensive sur-vey of a large ascetic center in India, and affords the first reliable statistics on women in institutionalized asceticism. For various

reasons, trustworthy data on ascetics are difficult to gather. Sinha
and Saraswati offer the figure of 2,000 as "a very liberal estimate"
of the ascetic population in Varanasi (1978, 50). This includes both
the 1,284 ascetics who they found to be permanently in established
religious institutions, and an additional several hundred who are
not so easily located, either because they live outside a known
establishment or because, while counting Varanasi as their home
base, they are itinerant and thus liable to escape enumeration. We
cannot be certain how many of these unidentified ascetics are fe-
male, but among the permanent ascetic residents, they counted 97
women. During the period of my research, between 1976 and 1981,
I located a total of 134 ascetic women and girls.[6] Thus, given a
settled ascetic population that still stands at approximately 1,300,[7]
around one-tenth of the ascetic community in Varanasi is female.
Even with an apparent increase, some of the reasons for which we
will discuss below, women continue as a minority in the ascetic
population. They are, however, a significant minority, whose mem-
bers both profit by and contribute to the perpetuation of a truly
vital institution.

THE SECTARIAN DISTRIBUTION OF FEMALE ASCETICS

Women are found in almost every major ascetic sectarian tradition
in Varanasi. The sketch of the overall structure of sectarianism
given in chapter 4 does not exhaust the subject, because there are
also individual ascetics and communities of ascetics who escape or
deny sectarian affiliation of any sort. I label them independent
ascetics because, though they pursue a respected and ancient mode
of asceticism, celibate studentship, *brahmacarya*, as a group they
are not members of a sectarian tradition, but are devotees of char-
ismatic and nonsectarian *gurus*. From one perspective we may
regard communities of independents as incipient sects; from an-
other they are ascetic revivalists, attempting to subvert the history
of sectarianism and return to a more pristine, nondenominational
ascetic life.

 The available research data do not allow us to describe the
distribution of orthodox sects for the whole of India. In Uttar
Pradesh, the province in which Varanasi is situated, Vaiṣṇavas
predominate (Tripathi 1978, 4–5). In Varanasi itself the situation
is reversed: Śaivites outnumber Vaiṣṇavites, but not by a great
margin: 48.3 percent Śaivas to 31.9 percent Vaiṣṇavas (Sinha and

Saraswati 1978, 51). Despite the fact that for centuries Varanasi has been associated with the god Śiva, Śaiva ascetics appear never to have established exclusive rights here. Compared with, for example, Ayodhyā, an almost entirely Vaiṣṇava center, or Rishikesh, a Daśanāmi *sannyāsi/nī* stronghold, Varanasi is a microcosm of orthodox sectarianism. Finally, as far as the independent category goes, we know only that in the late 1960s fewer than one-tenth of the ascetic population could be thus labeled. Sinha and Saraswati designate them "Others."

How, then, is the female community distributed across this sectarian spectrum? In terms of the *sanātanī-santapanthī* distinction discussed in chapter 4, there is in my data only one woman of the unorthodox variety. Liberal *santapanthī* sects such as the Dādūpanthīs or the Garibdāsis, both of whom are famous for accepting women, *śūdras*, and in some cases even untouchables (Ghurye 1964, 197, 207; Sinha and Saraswati 1978, 51), appear never to have gained a strong foothold in the city. Female asceticism in Varanasi, therefore, is almost exclusively confined to what the ascetics recognize as orthodox sectarian traditions. The largest group of female ascetics is Vaiṣṇava, the second largest consists of those women and girls who fall into the nonsectarian independent category, and the third largest is Śaiva. The ratio is 46:31:22 (see Table 5.1). There is a sharp contrast between Vaiṣṇavites and Śaivites, ascetics of each side being easily distinguishable by their different colored garments and sectarian marks. Their initiation rituals and names are distinctive, and, most important, the mode of asceticism each pursues is significantly different. The independent ascetics who have no sectarian identity lack the elaborate visual discriminants of the Śaivites and Vaiṣṇavites. They are distinguished primarily by their mode of asceticism, celibate studentship.

In general, the Vaiṣṇavites, who constitute just under half the female ascetic population, wear white garments, maintain their hair at earlobe length, and are meticulous in the application of the sectarian bodily markings whose patterns symbolically represent various aspects or attributes of the deities they worship. Initiation into Vaiṣṇava asceticism is typically sectarian: features of certain Vedic rites (*sanskārs*, Skt. *saṃskāras*) have been grafted onto what are distinctively sectarian (*āgamik*) rituals so that the initiate enters simultaneously a particular mode of asceticism and an exclusive community of belief.[8] In the Varanasi female ascetic community, four of the nine traditional Vaiṣṇava subsects are represented: there

Table 5.1 Sectarian Distribution of Female Ascetics in Varanasi

I. Sanātanī (Orthodox) Ascetics

The Vaiṣṇava Side	
Nimbārki Sampradāya	55
Rāmānandi Sampradāya	3
Vallabhācārya Sampradāya	2
Rāmānuji Sampradāya	1
	61 *total*
The Śaiva Side	
Daśanāmi Sampradāya:	
Avadhūtani*	16
Paramahansa	9
Daṇḍi	2
Śākta	2
Self-initiated sannyasins	1
	30 *total*
Independent (non-sectarian) Ascetics	
Anandamayī Mā Saṅgha	38
Akhanda Mandali	1
Sharada Kutir	3
	42 *total*

II. Santapanthī (Unorthodox) Ascetics

Brahma Kumārī Ishvariya Vishvavidyalaya	1 *total*

Summary: Total Number of Female Ascetics: 134

Sectarian Division	*Number of Female Ascetics*	*Total (%)*
Sanātanī		
Vaiṣṇava	61	46%
Śaiva	30	22%
Independent	42	31%
Santapanthī		
(only one division represented)	1	

* Included in the Avadhūtani division are 2 Gharbari Gosains

are fifty-five women and girls in the Nimbārki *sampradāya*, three women in the Rāmānandi, one in the Rāmānuji, and two women who are Vallabha sectarians. As a rule, Vaiṣṇava female ascetics are addressed by their ascetic name, such as Sītā or Lakṣmī, suffixed with "Devī" or "Dāsī," according to the tradition of their sect. One refers to them, however, by their specific sectarian name (Nimbārki, Rāmānuji, etc.) except when speaking of them as a group. Then, one calls them *bairāginīs* and, in so doing, consciously distinguishes them from the female ascetics of the other great side of asceticism, the *sannyāsinīs*.[9]

Slightly under one-quarter of the female ascetics in Varanasi fall into the Śaiva side. The majority of them entered asceticism by undergoing the radical and dramatic ritual of *sannyāsa*, world renunciation.[10] While the *sannyāsinīs*' ochre-dyed robes easily identify them among the general female ascetic population, this sartorial style obscures their presence in the community of male *sannyāsi* peers. The women drape their ochre garments in a fashion identical to the men and they carry the same ritual paraphernalia. Like them they have the option of keeping their hair shorn or letting it grow; if they leave it long, it is tied on the head according to the same rules governing the men in their order.

Orthodox ascetics aver that women can be initiated into only one of the three named divisions in the Daśanāmi *sampradāya*, the Nāga-Avadhūtani, and that all the so-called *sannyāsinīs* one meets are, properly speaking, not *sannyāsinīs* at all, but rather *avadhūtanīs*. In fact, women are, and probably always have been initiated into all three divisions. Today in Varanasi there are two *sannyāsinīs* in the Brahmin Daṇḍi tradition, nine who have been initiated by Paramahaṃsa Daśanāmi *gurus* and so claim Paramahaṃsa status; and sixteen Avadhūtanīs, initiated directly into an *akhārā*, which is the proper name for the organization to which the Daśanāmi Nāgas and Avadhūtanis belong (Ghurye 1964, 103). Gharbari Gosain women are also initiated primarily into the *akhārās*; the two Gharbari Gosain women in this study are both Avadhūtanīs. In addition, there are two Śāktas and one self-initiated (*svadīkshitā*) *sannyāsinī;* in ritual, lifestyle and appearance these women are similar to other *sannyāsinīs* except that the Śāktas wear red garments.

The third sizable group of female ascetics in Varanasi, independent, nonsectarian *brahmacāriṇīs*, are all members of establishments founded by or in the name of twentieth-century *gurus*, two of whom are renowned women saints, Ānandamayī Mā and Śāradā Devī. There are forty-two such independent ascetics; a few will eventually enter into *sannyāsa*, others will remain celibate students all their lives. As celibate students under the authority of respected female ascetic *gurus*, all *brahmacāriṇīs* follow a carefully regimented schedule of meditation, worship, and traditional Sanskrit studies, and have little contact with either the larger ascetic community or the world of householders. The same is true, in general, of Vaiṣṇava female ascetics: their asceticism, though sectarian, is largely based on the *brahmacarya* paradigm. We cannot here explore the ritual and doctrinal bases for the various and complex lifestyles found on

either side of Hindu asceticism. Overall, the Vaiṣṇava sects are more precise in their specifications for daily behavior, and compared with the Śaiva side, Vaiṣṇava women and girls certainly lead a very circumscribed life. The younger ones, for all intents and purposes, may be said to lead a conventlike existence, as do the independents, under the watchful guardianship of their ascetic mother (guru-mā). By contrast, the Śaivites, who are for the most part sannyāsinīs, lead very free lives. They pursue an asceticism that focuses far less, if at all, on acts of devotion to a guru or deity than on meditation, yogic postures, and travel to sacred centers. Unlike Vaiṣṇavas, most of whom live in Varanasi exclusively female communities, sannyāsinīs are perfectly comfortable in the presence of male ascetics.

RESIDENCE PATTERNS OF FEMALE ASCETICS

Female ascetics find shelter in a wide variety of establishments and vary greatly in the degree to which they travel. At any given time there are no doubt fewer itinerants among the female than the male population, but though the female community is for the most part monastic it is not entirely sedentary. A number of female ascetics in this city are Nepali sannyāsinīs, and they are highly peripatetic. In general, sannyāsinīs and Rāmānandi bairāginīs travel frequently, whether on pilgrimage to tīrthas they particularly favor, or on visits to ascetic "relatives" at branch establishments of their own sampradāya. These women are in the minority, however, and they too count Varanasi as their home base. Most women live permanently in religious institutions, which can be for ascetics only, such as a maṭh or akhāṇā, for Nāgas and Avadhūtanis, or which house ascetics and householders, such as certain kinds of āśram complexes that include places for ascetics, pilgrims' quarters, temples, et cetera, or a mandir, a temple or shrine with living quarters for ascetics. One hundred and thirteen female ascetics are dispersed among nine establishments in which all the residents are fully initiated ascetics (see Tables 5.2 and 5.3). The smallest of these is a maṭh sheltering only three people. One of the two largest, a traditional Vedic school (kanyā gurukul) for nearly forty brahmacāriṇīs, is part of an even larger āśram complex. Four of these nine establishments are exclusively female while in the remaining five, male and female ascetics coreside. Residents of the exclusively female establishments are nearly all Vaiṣṇavites whereas in the coresidential establishments they are all sannyāsi/nīs, Nāgas,

Socioreligious Aspects of Female Asceticism in Varanasi 111

and Avadhūtanis. I include five pilgrims in the Varanasi popula-
tion, whose primary base is elsewhere, but who visit the city, often
staying for long periods. They are *sannyāsinīs* who live in
coresidential establishments.

Of the other twenty-one ascetics, just under half live in places
that are not, strictly speaking, ascetic at all, such as rooms near or
attached to small temples or shrines of which they are the officiating
priest. The other half live in rather grand religious edifices of the
āśram-cum-temple sort. In the latter case, the women occupy the
highest status in their respective establishments, taking charge of the
spiritual and economic welfare of the mainly nonascetic inhabitants.

Table 5.2 Residence Patterm of Female Ascetics in Varanasi

I. Type of Accomodation	Vaiṣṇava	Śaiva	Independent / Santapanthī	Total
Residences exclusively for ascetics				
Kanyā gurukul	38	0	38	76
Āśram	17	1	0	18
Maṭh	0	13	3	16
Akhāṛā		3	0	3
				113
Residences for ascetics and non-ascetics				
Aśram complexes	4	7	2	13
Room/house				
(owned or rented)	2	5	0	7
Widows' āśram	0	1	0	1
				21
				134

Summary

Type of Establishment	Number of female ascetics	Total (%)
Exclusively for ascetics		
Large	93	69
Small	20	15
Mixed residences		
large aśram complexes	13	10
householder accomodations	8	6
	134	100

Table 5.3 Residence Pattern by Size and Type of Establishment

Type and Size of Establishment	Vaiṣṇava	Śaiva	Idependent/ Santapanthī	Total
I. Exclusively Ascetic Residences				
Large establishments				
exclusively female	55	0	38	93
coresidential	0	0	0	0
Small establishments				
exclusively female	0	2	3	5
coresidential	1	14	0	15
II. Mixed householder and ascetic residences				
Large āśram complexes				
(i) with other ascetic residents	2	5	2	9
(ii) as sole ascetic resident	1	3	0	4
Householder accomodation				
(ii) as sole resident	2	6	0	8
Total:	61	30	43	134

THE GURU-DISCIPLE RELATIONSHIP

The superstructure of asceticism is built on the *guru*-disciple relationship. There are several types of *guru*; *sannyāsi/nī*s, for example, customarily recognize five. In terms of social organization the most important is the *dīkṣā guru*, the *guru* who initiates or in whose name one is initiated, and who becomes one's fictive mother or father. Initiation ushers a girl or woman into a new community, an ascetic family (*parivār*), which gives her a large network of fictive kin. All those initiated by one *guru* are sisters-in-the-*guru*, *gurubahan*; the male *guru* of one's own *guru* is called the grandfather *guru*, *dādāguru*; male ascetics who are brothers-in-the-*guru* (*gurubhāī*) of one's own *guru* are called uncle *guru* (*chāchāguru*), and so on.

This fictive kinship system is a most important dimension of ascetic life. In the coresidential communities, there is a comfortable sibling relationship between males and females of the same age, and a pronounced respect for older female ascetics. Unlike Vaiṣṇava

female ascetics who at initiation receive feminine names, such as Sītā Dāsī or Gaurī Devī, *sannyāsinīs* and *avadhūtanīs* have gender-blind names: Durgā Giri, Om Bhārati, and Indra Puri are all females, but they could just as well be men. Though *sannyāsi/nī* names do not convey gender, among them also there is a tendency to conceive and speak of women as if they were female relatives, mothers in particular. Male ascetics refer to the women in their establishments or organizations as *hamārā māīlog*, literally "our mother-folk," and so offer them the respect reserved for the mother in Hindu society. In fact, female ascetics as a group are called *mātājīs*, respected mothers. Concomitantly, both ascetic and lay disciples of female ascetics address their preceptors as *guru-mā* or *guru-māī*, "mother *guru*."

Women may and do become *gurus*, and so are entitled to nearly all the highest ritual statuses found within ascetic society, a situation unparalleled for women in the larger society of householders. They are *gurus* to both women and men, householders and ascetics. Five women *gurus* in Varanasi each claim a lay following of twenty-five or more people (see Table 5.4). Ānandamayī Mā had thousands of devotees and, until her death in 1982, was arguably the greatest saint in India. Two other women are together mother-*gurus* to more than forty Vaiṣṇava Nimbārki *brahmacārinīs*; one of these, Śobhā Mā, has a branch *āśram* just for her male disciples. The sole unorthodox female ascetic, Brahmakumārī Surendar, is head of a religious community of about a dozen householders, and the two celibate male ascetics who run the affairs of the establishment are directly under her supervision. Śāradā Vallabha Devī, respected for her competence in the Vaiṣṇava philosophy of Vallabhācārya, is spiritual and temporal head of Gītā Bhavan, an elaborate *āśram* complex in which is situated the very popular Kṛṣṇa temple, Gopāl Mandir.

A disciple's relationship to the *guru* combines *bhāv*, emotional attachment, and *sevā*, service. In an *āśram* whose members take the *guru* to be an instrument of the divine, as one who bestows the grace that is essential for salvation, one observes profoundly adulatory behavior and attitudes toward the mother. In two of the Varanasi *āśrams*, the *guru* is considered to be divine: one is worshiped as a manifestation of the goddess Kālī, the other as both Kālī and an incarnation of Kṛṣṇa. It is only highly successful female ascetics who command such intense devotion, and out of the several women in Varanasi who are at the center of large religious organizations or establishments, only two have achieved sainthood.[11]

Table 5.4 Preceptorial Ties of Female Ascetics in Varanasi

	Vaiṣṇava	Śaiva	Independent/ Santapanthī	Total
I. No disciples	55	18	40	113
II. With disciples over 25 disciples	3 (Gaṅgā Śāradā Vallabha Dev, Śobha Mā)	0	2 (Anandamayī Mā, Brahmakumārī, Surendar)	5
10–15 disciples	2	6	1	9
less than 5 disciples	1	5	1	7
				134

There are nine women who have smaller circles of ten to fifteen disciples each, and another six who claim only one or two. In most instances the relationship these disciples have with their *gurus* is best characterized as a deferential friendship. Particularly among *sannyāsi/nīs*, the mixture of respect and affection between *guru* and disciple varies. If the disciple, male or female, has undergone full initiation, the relationship is liable to be strikingly egalitarian,[12] and it can defy the conventional roles defined for women in householder society. If, on the other hand, the disciple has not undergone an initiation but nonetheless lives with the *guru*, the situation may be quite different. There is often a thoroughly pragmatic bond between a *guru* and a handful of female disciples who are widows. As servant-disciples (*celīs*) of established ascetic women, these widows gain both a modicum of financial security and the legitimacy which ascetic affiliation affords. Though inevitably the majority of female ascetics in this city are disciples (*śiṣyā*) rather than *gurus* with disciples of their own, three-quarters of those who do have disciples are in fact heads of *āśrams* or *maṭhs*. In this capacity they are thus often at the center of a large ritual kinship network, exercise considerable spiritual authority, and, like their male peers, may well engage actively in the political or economic affairs of their establishments.

Much more could be said about the socioreligious organization of female asceticism. The three aspects treated here indicate its complexity and heterogeneity. Women are members of numerous sectarian traditions with different ascetic styles. They live in widely

divergent types of ascetic community. And there are many positions available to them within the *guru*-disciple kinship network. That these three aspects of female ascetic organization provide women with a remarkable range of socioreligious statuses is clearly evident in the Varanasi community. There are great differences between, for example, a *sannyāsinī* such as Vidyādevī Saraswatī, proprietress of Bhārat Dharma Mahāmaṇḍala, whose substantial land holdings have obliged her to spend days in court; the nearly forty *brahmacāriṇī*s of the conventlike Annadā Devī Kanyāpīṭha, who follow a rigorous schedule of study, work, and worship under the care of their learned Nimbārki *guru-mā*, Gaṅgā Devī Pañcatīrtha; the vigorous and peripatetic Avadhūtanīs of Ganesh Puri Maṭh, who still take alms in the lanes of Varanasi; the impoverished Gharbārī Gosain, Puṣpa Rānī Giri, who relies on the offerings left at the Śiva *liṅga*s she tends; and the controversial *sannyāsinī*, Santosh Puri Gītā Bhārati, whose skills as an orator have enabled her to leave Varanasi for the metropolis of New Delhi. It is clear that female ascetics live in a social world that is different from that of the female householder. One may well wonder just what kind of woman or girl would enter this world, and what larger social and religious forces in society contribute to its construction.

THE SOCIAL AND RELIGIOUS BACKGROUND OF FEMALE ASCETICS AND ASCETICISM

It is not easy to learn about a person's life prior to asceticism because, by definition, ascetics have left their former identity behind. We are fortunate to have some comparative data on the lives of ascetic men previous to initiation (Miller and Wertz 1976; Tripathi 1978). My research indicates that in some important ways the backgrounds of female ascetics in Varanasi differ from the men's. And certainly, the socioreligious factors that provide the conditions for and legitimation of female asceticism are of another kind.

A thumbnail sketch of female ascetics in Varanasi might appear as follows: The majority of ascetic women and girls are from orthodox, high-caste Bengali and Nepali families. Age dramatically divides the community in two: there is a small group of older, mostly widowed women whose average age is sixty-three, and a far larger group whose ages cluster around twenty, most of whom are unmarried. The girls and young women, mostly Bengali, are Vaiṣṇava and independent ascetics, residing in exclusively female,

conventlike *kanyā gurukul*s. The older women, mostly Bengali and Nepali, are nearly all *sannyāsinī*s living in small, usually coresidential *āśram*s and *maṭh*s. Young female asceticism appears to be largely an urban phenomenon. Most of the young women and girls in the Varanasi ascetic community have arrived over the past fifteen years from Calcutta, where either they or their parents learned of the three Bengali women *guru*s who head the *kanyā gurukul*s. Approximately one-fifth of these younger women are middle-class, well-educated Calcutta natives, the rest are impoverished refugees from former East Pakistan, now Bangladesh. They and the older ascetics, who come from high-caste rural families, enter a community which for the most part assures them physical and emotional security. Although they pursue very different types of discipline, they all enjoy the respect of the community. Let me unravel this terse description by introducing some larger social and religious facts which contribute to the making of female ascetic communities.

SOCIORELIGIOUS STATUS: CASTE, ORTHODOXY, AND FAMILIARITY WITH ASCETICISM

First, a striking feature of female ascetics is that they are overwhelmingly high caste. Tripathi's survey reveals that male ascetics in Uttar Pradesh come from all castes (Gross 1979, 200–02) and that just over one-quarter are *śūdra*s (Tripathi 1978, 84), this is not the case with female ascetics in Varanasi. Only two women lay no claim to twice-born status, and neither of them is *śūdra* or untouchable; one is a Sikh[13] and one a foreigner (see Table 5.5). In the twice-born population, all three classes (*varṇa*) are found: nearly 90 percent are Brahmins, a handful are *kṣatriya*s, and the rest identify themselves as *vaiśya*s.

Second, female ascetics as a group come from what they describe as very traditional and orthodox backgrounds.[14] For example, older ascetics stated that the women in their family were obliged to observe *pardah* (purdah, the secluding of women). Ascetics of all ages reported that their parents performed ritual deity worship at least twice a day, and were strict in adhering to the rules governing caste interaction. In fact, half of the thirty women with whom I was able to discuss the issue come from families whose male members are religious specialists of some sort, temple priests and singers, so that as youngsters they were familiar with a variety of religious rituals and roles. Many reported that their families respected ascetics greatly, feeding and listening to the mendicants who came to their homes.

Table 5.5 Reported Caste Origins of Female Ascetics in Vāranāsi

Dvija (twiceborn)	Vaishnava	Śaiva	Independent/ Santapanthi	Total
Brahmin	51	29	37	117
Vaishya/Kayastha	9	1	2	12
Kshatriya				3
Non-Hindu				
Sikh			1	1
Foreign	1			1
Total				134

Third, the majority had more than a passing acquaintance with asceticism as a way of life before joining the community. If a female ascetic does not have an ascetic relative—fourteen of the twenty to whom I posed this question do, and for half of them that relative is a woman—then she is certain to have at least one family member who is a follower of a *guru*. In either case, ascetic relatives or family *guru*s are often responsible for bringing women into the community. Indeed, a pattern emerges in the life histories of successful, charismatic female ascetics: invariably, their spiritual precocity is recognized by relatives who carefully nurture them into sainthood (Miller and Wertz 1976, 79). These outstanding personalities are in the minority. By far the greater number of ascetics never become well-known, yet a previous familiarity with asceticism also seems crucial in their decision to enter it.

VALUING THE FEMININE

But do these features of the background of female ascetics not pose a paradox? How is it that women and girls, nearly all from traditional, orthodox Brahmin families, should undertake such an unconventional lifestyle? While there are no doubt many social and religious processes at work in the construction of female asceticism, it seems to me that two are of major importance. Both stem from the high valuation given to the feminine in Hindu thought and experience.

On the one hand, there is an ideological spectrum exemplified by Śāktism or goddess worship, and Tantrism which, in its emphasis on the feminine either as a principle (*śakti*) or as Goddess

(*Devī*), provides doctrinal justification for according great respect, even preeminence, to women. On the other, by apotheosizing the idea of woman, Hindu tradition equally traps real women and girls within the roles of wife and mother. Thus, while one of the most important religious bases of female asceticism lies in the legitimacy conferred upon women by a ritual and philosophical tradition which enshrines the feminine, some of its most compelling social factors are rooted in the stress to which ascetic women and girls are subjected through their rejection of or exclusion from the traditional, normal style of life. Both of these themes are complex but crucial to understanding female asceticism.

TANTRISM AND ŚĀKTISM: RELIGIOUS IDIOMS FOR FEMALE AUTHORITY AND INDEPENDENCE

Śāktism and Tantrism are closely related phenomena; in separating them I follow a popular distinction: Śāktas are those who worship the Goddess and tantrics are people who worship the feminine, but who also engage in ritual forms of sensual indulgence and seek occult powers. In Banarasi religious discourse, the Śākta is thus a respectable devotional theist, while the tantric is an esoteric ritualist. The two religious expressions may well overlap, but in polite society one openly admits only to being the former.[15]

In its most vulgar forms Tantrism is associated with the ritual sexual use of women, as, for example, in the stereotypical portrayals of female tantric ascetics in the eighth-century plays *Mālātī and Mādhava* (Coulson 1981, 353ff.) and *Mattavilāsa Prahasana* (Lockwood and Bhat 1981, 19ff.). However, beside this must be set the lesser known fact that women have successfully appropriated tantric ideology to their own benefit, in the past as in the present. This is possible because Tantra elevates *śakti* as the source of power, creativity, and ritually efficacious knowledge. In practice, this means that women are ideal *gurus*. Additionally, because in tantric thought the masculine and feminine principles are contained in the physical persons of the practitioners, the path to liberation requires the collaboration of both sexes. In the tantric tradition women are "the embodiments of a theological principle as well as a ritual necessity" (Dimock 1966, 101), and sectarian history demonstrates that an outstanding woman can make a virtue of this necessity. As shall be seen shortly, traditional female asceticism is largely a tantric affair, the tantric recognition of women's precepto-

rial capacities and the specific sexual embodiment of the divine having encouraged women's participation in its ritual tradition.

Śāktism stresses in a somewhat different and far more emotional way the superiority of the divine feminine. It is associated with worship of the high forms of the Goddess, in particular, Durgā and Kālī. If Tantrism emphasizes the sexually creative powers of the feminine, Śāktism idealizes the maternal function, seeing the Divine Mother in all women.[16] The elevation of woman as mother is Śāktism's main contribution to female ascetic practice and spirituality: As noted earlier, the collective term for female ascetics is *mātājīs*, "holy mothers."[17] The influence of Śākta and tantric ideology varies greatly from region to region in South Asia.[18] In Varanasi a most notable feature of the female ascetic community is that its members come overwhelmingly from culture areas in the north of the subcontinent in which tantric traditions and Śāktism have flourished: More than four out of five of all the female ascetics in Varanasi are from Bengal and Nepal (see Table 5.6).

Bengalis are, of course, well known as goddess worshipers, and nearly all the Bengali female ascetics here come from such families. In addition, perhaps because of its Śākta orientation, another factor distinguishes Bengal from most other areas of India: its

Table 5.6 Geographical Origins of Female Ascetics

Origin	Vaiṣṇava	Śaiva	Independent/ Santapanthī	Total
Bengal	54	10	37	101
North India				
Uttar Pradesh	3	7	3	13
Maharashtra	0	0	2	2
Gujerat	0	1	0	1
Punjab	0	0	1	1
Nepal	1	9	0	10
South India				
Andhra Pradesh	2	1	0	3
Madhya Pradesh	0	1	0	1
Tamil Nadu	0	1	0	1
Foreign	1	0	0	1
Total	61	30	43	134

women were the first to profit from the social reforms of the late
nineteenth and early twentieth century (Borthwick 1984). For sev-
eral generations now, Bengali women have had access to education
and the freedom to choose a career, and to reject marriage. This
freedom should not be misconstrued; independent women are com-
pelled even more than others to demonstrate conformity to high
standards of sexual propriety, a cultural demand that is best met
by adopting a decidedly ascetic style. The unmarried woman can
legitimately exercise freedom and independence only within a reli-
gious idiom. Given such cultural expectations, female ascetics
present a remarkable combination of independence and authority,
albeit within the context of a disciplined, communal, and respected
ascetic life.

Bengalis are the largest linguistic and cultural group in the
Varanasi female community, and it is from their ranks that nearly
all the renowned women saints of the city come. Three Bengali
women are, together, *gurus* to two-thirds of the female ascetics,
their ninety disciples residing in the largest female establishments
in the city. As noted above, two of these *guru-mā*s, Anandamāyī
Mā and Śobha Mā, are considered divine; the third, Gaṅgā Mā, is
said to be one of the greatest Sanskrit scholars in North India.
Gaṅgā Ma and Śobha Mā are both Vaiṣṇavites, disciples of the
Nimbārki *guru* Santadās Bābājī Mahārā; Ānandamayī Mā is non-
sectarian. But all initiate their disciples into celibate studentship,
modeling the daily schedule of their *kanyā gurukul*s on the classi-
cal *brahmacarya* paradigm, only their students are girls, not boys.
All have established themselves as authoritative figures, pursuing
innovative, even controversial practices. For example, one has
modified Nimbārki Vaiṣṇava ritual, introducing an advanced ini-
tiation in which the *brahmacāriṇī* is married to the deity of that
sect. All female ascetics are entitled to idiosyncratic interpretations
of their sect's tradition, and there is little doubt that these re-
nowned Bengali *guru*s profit additionally from the cultural and
historical circumstances which, within particular religious contexts,
vouchsafe women a high status.

Not all Bengalis here live in conventlike establishments. Nine
are on the Śaiva side of asceticism, and most of them have taken
sannyāsa. They, nine Nepalis and three women from Uttar Pradesh,
comprise the *sannyāsinī* contingent in the Varanasi female ascetic
community. With few exceptions, these women are in the *akhārā*s,
the Nāga-Avadhūtani division of the Daśanāmi Order. *Akhārā*
ascetics have traditionally pursued tantric discipline (Ghurye 1964,

104; Sinha and Saraswati 1978, 93) and we have ample evidence, as noted earlier for the Nāthapanthis, that before the decline of tantric ritual in the early decades of this century, there were many more women in these organizations.[19]

The allocation of women to the *akhārās* is, in fact, one of the main reasons why so many *sannyāsinīs* are in Varanasi. The history of the initiation of women and *śūdras* into the Daśanāmi Order is still imperfectly reconstructed, but we do know that of the eight traditional *akhārās* (Ghurye 1964, 103ff.), women have most often been admitted into the Juna, and in the two centers where this *akhārā* is strong, Varanasi and Haridwar, *sannyāsinīs* of the Avadhūtani division are found in numbers. Juna, which has its headquarters in Varanasi, is the *akhārā* to which nearly all the *avadhūtanīs* in this city belong. Moreover, before their *sannyāsa* initiation, at least four of the *avadhūtanīs* here had practiced an explicitly tantric *sādhanā* with male ascetics of the Nāthpanthi tradition which has close ritual and organizational ties with the Nāga-Avadhūtani section of the Daśanāmis. Of the ascetic idioms that express the range of Hindu ideologies that honor the feminine, it is the tantric which primarily accords women legitimacy. And, despite the fact that most of the old practices are dead, women still have a place, for they occupy an important niche in the ritual traditions of certain sects.

That women find a distinctive freedom within renunciatory asceticism is clear in the case of the Nepalis, whose strong representation in the female renouncer population is noteworthy. Their numbers are out of proportion to the those of the Nepali householder community in Varanasi, which, compared to the Bengali for example, is relatively small. Based on reports by well-traveled ascetics and statements of the Nepalis themselves, it is quite likely that in the population of Nepali women at large there are more ascetics than among any other group of women in South Asia. The taking of *sannyāsa* is a well-established and popular tradition among Brahmin Nepali women.

Some sociologists have observed the similarities between women in Bengal and Nepal. In both areas they are assured a degree of independence uncharacteristic of other parts of the subcontinent, provided they pursue it within appropriate contexts. As noted by Dr. G. S. Nepali, Brahmin and Chettri householder women in Nepal enjoy a great measure of freedom in a nonsexual sense, that is, economic and social freedom,[20] and according to Nepali *sannyāsinīs* themselves, the even greater independence assured by *sannyāsa* is

a compelling factor in their decision to undertake this lifestyle
(Caplan 1973, 179).

THE CULTURAL DEMAND FOR PURITY: IMPOVERISHMENT, WIDOWHOOD, AND ASCETICISM BY CHOICE

There is, then, a range of notions that support women in particular
ascetic statuses, as *gurus*, saints, incarnations of the goddess, in-
heritors of a tantric ritual nexus. But what of the social stresses
arising out of Hinduism's idealization of wifehood and motherhood?
Again, there are many factors to consider, but one of the most
striking is that the majority of the female ascetics in this city are
women or girls excluded from the propitious status of the female
householder. Here age emerges as a crucial variable. The female
ascetic community is divided by age and marital status into two
blocks: a very large group whose members are unmarried and whose
ages cluster around twenty, and a smaller group of mostly widowed
women whose average age is sixty-three (see Table 5.7). These age
groups are consistently correlated with the two distinctive types of
asceticism, celibacy and renunciation, and it will be useful to treat
each as a separate component in the ascetic community.

Consider first the younger ascetics. Fully two-thirds of the fe-
male ascetics in Varanasi are under the age of forty; still more
remarkable, one-half are between the ages of seven and twenty-
three. All these young women and girls have been initiated into
asceticism. Even the dozen or so very young girls have been given

Table 5.7 Reported Ages of Female Ascetics in Varanasi

	Vaiṣṇava	*Śaiva*	*Independent/ Santapanthī*	*Total*
Youthful Women and Girls				*88*
Girls 7–13	20	0	4	24
Adolescents 13–22	12	0	25	37
Young Women 23–39	17	3	7	27
Middle-aged and Elderly Women				*46*
middle-aged women 40–60	11	15	6	32
elderly women over 60	1	12	1	14
Total	61	30	43	134

both *nām* and *mantra dīkṣā*. They constitute the large Vaiṣṇava and independent community here, and are dispersed between the three sizable, exclusively female residences. Whether Vaiṣṇava or independent, their asceticism is essentially that of the celibate student, the *brahmacāriṇī*. With few exceptions, these young women and girls are Bengali and disciples of Anandamāyi Mā, Śobhā Mā, and Gaṅgā Mā.

The majority of younger female ascetics have not married at all. Most come from poor but high-caste families and residents of what is now Bangladesh. The East-West Pakistan War of 1971 caused many Hindus to flee, propertyless, across the border into India. Nearly four dozen such refugees have swollen the ranks of the female ascetic community in Varanasi over the past fifteen years. The single most important reason for the large number of young women in the conventlike *āśrams* of this city is that their families simply could not afford to maintain them. Most crucial, they are without dowries and thus cannot marry. The high-caste, traditional family's anxiety for its unwed daughters is a well-established theme, and it is one which has prompted the parents or guardians of such unfortunate girls to search for an institution that will protect them. Given their twice-born status, their orthodoxy, and the informal networks linking Bengali Śāktas to the *guru-mās* in Varanasi (who are all from East Bengal), the decision to send their daughters here is most appropriate. By entering *brahmacarya*, the girls and young women undertake a mode of asceticism that effectively guards their purity and assures them a ritual status far higher than that of the ordinary householder.

The young ascetics are free at any time to leave the ascetic life, and while some of the *brahmacāriṇīs* in Ānandamayī Mā's *kanyā gurukul* do leave and marry, very few of Gaṅgā Mā's disciples do.[21] The disciples of Śobhā Mā are usually older and have already decided against marriage, or else have left it, before taking initiation into asceticism. In terms of larger socioreligious values, this sector of the population, the Vaiṣṇava and independent *brahmacāriṇīs*, reflects the degree to which asceticism can attend to the cultural demand for purity by providing a context in which women can legitimately live outside of marriage and respectably pursue, for their own benefit, a religious ideal.

Such a large and visibly circumspect community of young girls and women in Varanasi obscures the presence of a smaller but altogether more traditional group of older ascetics. This remaining third of the population is spread more evenly across a larger range

of sectarian traditions: While the younger ascetics are found
in only two traditions, the older are found in eleven. They are
far more independent and individualistic. The majority are
sannyāsinīs.[22] but creative adaptation and idiosyncratic elabora-
tion typify their lifestyle, whether they are *sannyāsinīs*, Śāktas, or
bairāginīs. Moreover, most of them are closely integrated with the
larger male ascetic community, regularly participating in the com-
munal activities, both social and ritual, which characterize tradi-
tional ascetic society. In terms of geographical origins the older
ascetics are almost evenly divided between Bengal, Nepal, and the
rest of India, though very few are southerners. Unlike the young
women and girls, they have nearly all been married and widowed;
most were widowed in childhood.

One can clearly see that this older, mostly widowed population
shares a certain stigma with impoverished young women and girls,
and also, for that matter, with the very few women with physical
or other disabilities. They are all members of a category that may
be called "female persons who have been involuntarily excluded or
expelled form householdership." While this is a striking, and cer-
tainly compelling, datum of ascetic sociology, one should not forget
that other factors may figure in a woman's decision to undertake
asceticism, and that by treating only salient patterns in the data
one obscures the often far more interesting cases which depart
from the norm. Most of those who could and should have been
married, that is, all those past their mid-twenties (twenty-five years
being, even today, the upper limit for a girl from a respectable
family), are involuntarily without husbands: but some either re-
fused marriage or left their husbands. The most common circum-
stance of the former, the small but significant portion of middle-class
Bengalis, is that they have pursued academic studies, preferring
education to marriage. As just noted, Śobha Mā does not recruit
adolescents, but actively encourages well-educated young women to
join her *āśram*. The majority of women who have refused marriage
are articulate exponents of asceticism. They report having had a
call to the ascetic life, a visionary experience or a mystical craving
which at an early age decided them upon a religious career, often
with the encouragement of relatives or the family *guru*.

A small number of women have left their husbands. In only one
case had the husband and in-laws driven the woman out of her
home. It appears that a mixture of marital strife and the positive
attraction of a woman preceptor typically precipitates a woman's
decision to leave. The life histories of several women indicate that

ascetic residences offer a safe haven from physically or emotionally threatening men, and the head *mātājīs* in those *āśrams* or *maṭhs* to which troubled wives have come urgently counsel them to leave the householder life behind. Institutionalized asceticism offers both these women and those who refuse marriage the emotional and social security of an ascetic family, and the respectable ritual status and spiritual comfort that comes from a life oriented toward *mokṣa*.

CONCLUDING REMARKS

The female ascetic community in Varanasi comprises a collection of groups and individuals who exhibit a wide range of differences. They are found in more than a dozen different sectarian traditions; they follow several divergent lifestyles, live in a variety of establishments, and occupy many socioeconomic and ritual statuses. Vaiṣṇavas are numerically preponderant; together with the independents they form over two-thirds of the population and live in large, exclusively female establishments, following the rigorous but respected asceticism of celibate students. Alongside them, almost as a curiosity, exist the remainder, mainly Śaivas, who are altogether more diversified in their social and ritual relations and idiosyncratic in the interpretation and application of their asceticism. The female ascetics of Varanasi are almost exclusively high-caste, from orthodox or, at least, traditional families familiar with and respectful towards ascetic *gurus*. More than three-quarters of them are Bengali.

Several factors in the social and religious dynamics of the tradition as a whole and in the personal backgrounds of the women and girls contribute to their institutionalized asceticism. To examine the larger socioreligious processes it is useful to distinguish between beliefs and notions which legitimize female asceticism and social-structural pressures which precipitate it. As to the first, what underlies female asceticism and provides, as it were, its unconscious justification is the Śākta-tantric complex of ideas which elevates the feminine principle to the forefront in doctrine and practice. As to the second, the high valorization of wifehood and motherhood poses problems for those women and girls who through poverty, widowhood, or personal choice do not become or remain wives and mothers. These two factors interact so that, for example, while a woman or girl who for whatever reason does not marry can suffer greatly, her difficulties may be assuaged by adopting the

statuses available to her in the ascetic world. Undertaking a highly circumspect type of asceticism such as celibate studentship commands great respect, while entrance into any tradition which honors the feminine has its own attractions, though of a somewhat different sort. In terms of their personal features, the high-caste religiosity of a *guru*-oriented family makes asceticism familiar, and ascetic relatives can be most encouraging. Widowhood and poverty exercise considerable social pressure to seek a religiously secure status; and, finally, given the importance of Śākta and tantric idioms in Nepali and Bengali culture, it is no surprise that the majority of ascetic women and girls in Varanasi are from these areas.

Three concluing observations: First, the significance of the "Bengali factor" in female asceticism should not be underestimated as a social and religious force in the community. Not only do Bengali women predominate numerically; they also appear to excel as religious virtuosi, and they are the most articulate bearers of the Śākta tradition. In the past century the worship of living women as manifestations of the Holy Mother, the Great Goddess herself, has been strongest among Bengali Śāktas, foremost of these Śāktas being the ascetics Ramakrishna and Aurobindo. The case of Ramakrishna's "mother-wife," Śāradā Devī, is particularly important: One can see reflections and imitations of her hagiography in the biographies of two of the Bengali *gurumās* of Varanasi, Anandamāyi Mā and Śobhā Mā.[23] This fact is not lost on the sizable Bengali householder population in the city, many of whom adore one or more of their native holy women, speak with pride and awe of their *brahmacārinīs*, and contribute to the maintenance of their *āśrams*. But there is more to the Bengali factor than just the positive evaluation of the feminine as the Divine Mother. The majority of widows in Varanasi are Bengali, and the majority of Bengali female ascetics are widows. An historical inquiry into the time-honored Bengali practice of sending widows to Varanasi would prove valuable to the study of the female ascetic community there.

Second, with respect to the older, more traditional group of female ascetics it is evident that we need a good historical account, especially of the early modern period, to allow us fully to construct their profile. I have alluded to the relationship between women and the tantric branches of the community, notably the *akhārās*. Though recent research has expanded our knowledge of the role of the *akhārās* in the political and economic history of North India (Cohn 1964, Bayly 1983), their internal organization and ritual structure

are still imperfectly understood. Women appear to have achieved important statuses by means of their membership of them.

A third avenue for investigation is the strong ritual and social tie between certain sectors of the Nepalese population and the city of Varanasi. *Sannyāsinīs* and *sannyāsis* speak of a long-standing relationship between Nepali ascetics and the Nepali and Marwari householder settlements in Varanasi, describing, for example, how as recently as thirty years ago householders in the Nepali district used to regularly set up vats of cooked food such as lentils and rice, to which *sannyāsinīs* flocked in numbers. Several *sannyāsinīs* stated that there are only two true centers of *dharma*, Nepal and Kashi, albeit bemoaning the general decline of *dharma* in the latter. And as recently as 1977, after initiation at the great festival of ascetics, the Kumbha Melā in Allahabad, dozens of Nepali *sannyāsinīs* stopped off in Varanasi, on their way back to Nepal to participate in the communal feasts hosted by their mother *akhārā*, Juna. These are, indeed, intriguing facts that might well be amplified by further historical studies.

There are no doubt other topics for social-historical research that would contribute to the understanding of female asceticism in Varanasi. The three I have suggested lead to a final remark concerning the centrality of Varanasi to the entirety of asceticism. All ascetics in this city consider themselves blessed just to be here. The women's conversations are sprinkled with references to the glory of Kashi and to its appropriateness as an abode for ascetics. There are innumerable *dohā*s, rhymed couplets, which extol its praise (Saraswati 1975, 2), and I have heard many of the older women state that in their past lives they must have been particularly virtuous in order to be at this moment both in the *sannyāsāśrama* and in Kashi.

Mythologically, Varanasi is primarily the city of Śiva, but Vaiṣṇava ascetics also claim strong rights in this city and often list the names of Vaiṣṇava preceptors and saints who lived there, such as Rāmānanda and Tulasi Dās. Because nearly every sectarian tradition of ascetic Hinduism has a branch establishment or actual headquarters here nearly every ascetic who is also a *guru* to householders has a good reason to encourage his or her disciples to visit the city. In my research, I found that many female ascetics ended up in Varanasi because the family *guru* or ascetic acquaintance who had introduced them to asceticism was based here and had assured them that the pursuit of *mokṣa* was more effectively undertaken in this city. As one English-speaking ascetic put it, "If so

many *sādhus*, *sannyāsis*, and saints have done their ascetic practice here, how can the *galīs* (lanes) not be filled with their vibrations? Their *sādhanā* makes the atmosphere strong for us too." She continued by listing the names of various shrines, temples, and bathing spots that are powerful because great ascetics resided at or near them.

Apart from the fact that a rich tradition of asceticism in Varanasi renders it an especially strong place, there is the more frequently expressed and widely held belief that the city itself grants salvation. Varanasi is Kashi, the city of liberation: to die in this city is to gain immediate *mokṣa*. I found that even those women who entered asceticism after their arrival in Varanasi had come to the city in the first instance, so they said, because they wanted to die and achieve liberation here. Kashi and *mokṣa* are indissolubly linked. It is appropriate, then, that ascetics, whose only aim is liberation, should reside there. Though the female ascetic population of Varanasi is comparatively small, and only a few of its members are well-known, the householders living in the older and most sacred parts of the city are aware of these women and girls in their midst. For their part, female ascetics, like their male peers, are fully conscious of themselves as individuals who are not householders but rather ascetics and seekers of salvation. In the degree to which they perpetuate an ideal that is recognized as the highest for which a Hindu can strive, they are exemplary citizens of the city of liberation.

APPENDIX: ESTABLISHMENTS FOR YOUNG FEMALE ASCETICS

The majority of the female ascetics located in Benares live in three large establishments, which are, or contain within their *āśram* complex, convent-type institutions called *kanypīṭha*, from *kanyā*, virgin or unmarried girl, and *pīṭha*, seat. Ānandamayī Mā's *kanyāpīṭha* and Ananda Devī Matṛ's *kanyāpīṭha* shelter forty-five and forty girls respectively. Śobhā Mā's *āśram* houses fifteen permanent ascetics and its *kanyāpīṭha* serves 150 nonresident youngsters from householder families who have not been initiated. In all of these *āśram*s there are a few older women, the majority of whom have taken orthodox initiation, living as teachers and guardians of the girls. Each *āśram* has a Mother who is the *guru* of all the *brahmacāriṇī*s. Table 5.8 shows the age distribution of their ascetic disciples. It indicates that most of them are between the ages of

Table 5.8 Age distribution in the three āśrams discussed.

	5–12	12–25	25–40	over 40	Total
Ānandamayī Mā Kanyāpīṭha	10	20	10	5	45
Ānanda Devī Mātṛ Kanyāpīṭha	10	15	10	5	40
Śobhā Mā Āśram	0	8	12		20
Total	20	43	30	10	105

twelve and forty.[24] There are twenty prepubertal youngsters, and thirty-eight postpubertal women. The age of twenty-five is significant as I found it to be the accepted age in the householder community beyond which a girl should not remain unmarried;[25] and in fact it is frequently at this time that a young *brahmacāriṇī* makes the important decision to remain and pursue a full ascetic life, or else to leave. By and large, the thirty older girls and women in the age category of twenty-five to forty years are ones who entered the *kanyāpīṭha* at a young age, have known no other life, and have chosen to remain. Invariably they are well-educated and found the life of ascetic study preferable to a life-in-the-world.

Ānandamayī Mā Kanyāpīṭha

Until her death in 1982, Ānandamayī Mā was the most famous woman saint in India. Her *āśram* in Benares is a large complex, including a hospital, several temples, a *dharmaśāla* for pilgrims, living quarters for ten to fifteen permanent adult ascetics, and a separate set of buildings for the *kanyāpīṭha*. There are forty-five girls and women in all: thirty of these are young *brahmacāriṇīs,* ten are still very young girls, and five are older women *brahmacāriṇīs*. These five together with older girls act as teachers in the *kanyāpīṭha* and there is thus a high ratio of teachers to students in all subjects taught and a great degree of supervision in all matters of *āśram* life.

The forty-five residents of the *kanyāpīṭha* have all taken *mantra dīkṣā*. They are formally initiated into celibacy and are thus called *brahmacāriṇīs*. The *kanyāpīṭha* is strictly prohibited to outsiders, and the girls do not have unlimited access to all sections of the *āśram*. No visitors are allowed; the girls may not speak to men and rarely leave the *āśram* itself; they may only enter certain areas of the complex, such as the various temples in which

they have duties to perform. Their daily schedule is rigorous: Beginning before dawn, it includes: bathing, meditation, temple service, hymn-singing, washing, cleaning, cooking, and lengthy hours of study. Older *brahmacāriṇī* women told me that they conform to the rules concerning the four stages of life. The *kanyāpīṭha* life constitutes the first stage, *brahmacarya*, and of all the disciplines taught in this stage of life, the virtue of work or service, *sevā*, is considered the most important. This is relevant in light of the fact that the majority of these girls do leave to be married before the age of twenty.

The *kanyāpīṭha* is formally associated with the Benares San-skrit College and good students may take the *ācārya* Sanskrit degree (equivalent to a Master's). Sanskrit is compulsory in the *kanyāpīṭha*; philosophy, grammar, and logic are taught. The conscious model for the *kanyāpīṭha* is that of the *gurukula*, the classical Vedic in-stitution for the young male *brahmacāri* who had undergone the *upanayana* ceremony. Though I never heard anyone use that term for a young girl who undertakes such an initiation and thus em-barks on a stipulated period of study and ascetic control, there is an appropriate name for her: *brahmavādinī*. The *brahmavādinī* is the female counterpart of the *brahmacāri(n)*, and though, as dis-cussed in the first essay, the most authoritative law-maker, Manu, forbade the *brahmacarya āśrama* to girls (*Manusmṛti* II 67), some authors of classical texts do describe them (for example, *Harita* XXI 22; Altekar, 1973, 196–200). It is not surprising then, to dis-cover that those *brahmacāriṇīs* who evidence a love of study and intend to remain in the *āśram* are given the sacred thread; that is, they undergo the *upanayana* ceremony. Only Brahmin girls are so initiated and then, generally only those who will also be trained as ritual officiants for deity worship.

The *kanyāpīṭha* was founded in 1940 and originally most of its members came from Bengal. Today, nearly all the girls are from Bangladesh, and though the majority are Brahmins, none of their families are well-to-do. In fact, a girl's decision to remain in the *āśram* is largely a product of the family's willingness and ability to take her back This was clearly conveyed by one of the older women: "The family must want to take them back, which is not always the case if they cannot afford to marry them. And the girls must wish also." Only three or four of the girls in the *kanyāpīṭha* in 1977 could actually be supported by their parents. Perhaps to disguise this painful reality, the outsider is simply told: "The parents wish their daughters to have this type of education." Ānandamayī Mā

has no part in the formal education of the girls as she is illiterate, and though they have the opportunity to see her more frequently than lay devotees, they do not have intimate contact with her. Besides, she moves about, staying at different times in any of the nineteen *āśram*s that are part of her organization, the Srī Ānandamayī Sangha.

The *āśram* has no defined affiliation with any ascetic order, but there is a direct and overt association with Śākta tradition which is often attributed to the simple fact that she is Bengali. The Kṛṣṇa temple in the *āśram* complex is not as prominent as those which contain various forms of the goddess; and everywhere there are Śiva *linga*s together with portraits of Ānandamayī herself, located either beside or behind the various icons. Ānandamayī Mā is considered primarily a manifestation of Kālī, though others have seen her also as Durgā and even as Kṛṣṇa. The permanent ascetics are largely *sannyāsis* of the Śankarite Daśanāmi Order, and the *āśram* has distinct Śaiva and Śākta associations.[26] However, the *brahmacāriṇīs* are more closely identified with the Vaiṣṇava side and in fact, the Bāl-Kṛṣṇa temple (housing the child-form of Kṛṣṇa) is their main responsibility. The forehead marking worn by the *brahmacāriṇīs* consists of vertically placed lines of sandalwood paste characteristic of Vaiṣṇava orders, but there is a difference: The simultaneous presence of Śākta influence and the vow of celibacy are indicated by two additional markings; a red dot, signifying *śakti* (the power of the goddess), is applied above the bridge of the nose, and above this is placed a white dot of *candan* (sandalwood paste), in order to signify *brahmacarya* (chastity).

Ānanda Devī Mātṛ Kanyāpīṭha

This establishment is under the care of Gangā Mā, a former principal of Ānandamāyī Mā's school who left because she wished to take care of girls from destitute families. It is named after the woman who was wife to her *guru*, Santodās Bābājī, a Nimbārki ascetic whose renown has spread throughout the north of India. He was an initiated *sādhu*, but he wore the white robes of Vaiṣṇava renunciation, as does Gangā Mā, who has also undergone *sannyāsa*. In contrast to other conventlike places in Benares, this one is modest in size, occupying an old building with a garden and a cowshed in a large central courtyard. There are forty residents; thirty-five of these are girls of whom fifteen have had *mantra dīkṣā* and are thus *brahmacāriṇīs*. In addition, three of them have taken *sannyāsa*

initiation. There are about ten very young girls (five to twelve years of age), and five older women who are all widows. When the young girls first arrive, their heads are shaven and they are given their first initiation and a new name. Their hair remains cropped like that of a young boy until puberty, at which time, if they so desire, they may choose to join Gaṅgā Mā's sect, the Vaiṣṇava Nimbārki Sampradāya. They are then given a *mantra*, which marks their entry into *brahmacarya*. Brahmin girls with a serious inclination to study are invested with the sacred thread, because, "only those who have undergone *upanayana* may study the Vedas." These same girls will be able to act as *pūjārīs* in the temple, and, it is also likely that they will have an inclination to take *sannyāsa*.

Gaṅgā Mā has instituted her own *sannyāsa* ritual. Unlike Śaiva ascetics, Vaiṣṇavas do not undergo *sannyāsa dīkṣā* in the normal course of entry into ascetic life.[27] Gaṅgā Mā sees that some girls desire marriage more than others, and her *sannyāsa* initiation consists of an orthodox, formal ceremony of marriage to Kṛṣṇa, the tutelary deity of all Nimbārkis. The temple icon of the god is the groom and a *purohit* officiates. The initiation is given at the age of eighteen or so, the legal age of marriage. (At the time of my research, three girls were *sannyāsinīs*, in this sense.)[28]

The girls here lead an exceedingly austere life, rising at 3:30 or 4:00 in the morning, following the daily schedule outlined above for Ānandamayī Mā's āśramites, but Gaṅgā Mā's girls must also attend to the garden and their cows. However, by far the most important pursuit in this *āśram* is study; Gaṅgā Mā is herself a highly accomplished Sanskrit scholar and she supervises the education of the older girls, engaging in lengthy hours of discussion of topics in Nimbārki philosophy and theology. She is the most respected woman scholar within the Benares ascetic community and has an arrangement with one of the Daśanāmi *sannyāsis* to prepare her advanced students for Sanskrit College exams. He is one of the only two men who frequent the *kanyāpīṭha*, the other being an elderly man called "mother's elder brother," who is manager-trustee of the *āśram*. The ethos of the *kanyāpīṭha* is dominated by a high valuation of scholarship: The young girls are always running about with books in hand, sitting down to write or to discuss philosophy.

It is a peculiarity of Gaṅgā Mā that she accepts all castes, but is fastidious in matters of purity and pollution. In her *āśram* I was made aware of a *kayastha* girl who had been delegated separate duties.[29] This liberality, I suggest, is partly a product of the exigen-

cies of destitution: The majority of girls come from families who arrived in Calcutta in the aftermath of war between East and West Pakistan. Though in the main they are high-caste Bangladeshis, some of the girls are orphans and thus their exact caste is not necessarily known; such children, together with those from families who arrived six or seven years ago in Bengal without land or money, simply have no marriage possibilities. Not only are their families poor, they are presently incapable of even feeding their daughters. In addition, prospects are slim of accumulating enough property and money to provide a reasonable dowry so that the young girls will not have to suffer the distress and ignominy of a bad marriage. One lay devotee of Gaṅgā Mā explained sadly to me that girls are often sent here by impoverished parents, but after staying a few weeks or months, unable to bear the discipline of the ascetic life, they leave. "Such girls would rather live in poverty with their family and have to go out to work as cooks and perhaps never make a good marriage than stay in the kanyāpīṭha." Behind this lies an implicit recognition that such girls might become second wives to some high-caste man, or worse, fall into prostitution. A common attitude to such a community of pre- and postpubertal un-wed girls is seen in the comment of my research assistant, a young student from Benares Hindu University, from a kṣatriya caste, whose wealthy parents were then engaged in securing a husband for her. About the girls in the kanyāpīṭha, she volunteered, "Such children are surely not from good families because a well-to-do family would never send their girls away from them for so long."

Rules controlling the possibility of contamination are extensive. No householder may ever touch Gaṅgā Mā, except her feet, which is why she frequently steps back when people approach her. In fact she dislikes rituals of abasement, and usually discourages a devotee who would touch her feet; rather she simply raises her hand in acknowledgment of their motion of respect. The āśramites alone may touch her and then, only if they are wearing silk or wool. Certain seats are set aside specifically for outsiders and no resident will ever sit on them. I noticed that these light, basket-type stools were usually picked up and moved from one place to another by the girls using the left hand. No menstruating girl or woman should enter the kanyāpīṭha: to touch a householder in this condition would necessitate bathing immediately. As with the other two āśrams investigated here, only certain foods, such as fruit, may be accepted from outsiders, and only pure (sattvik) food may be eaten by the initiates.

After *sannyāsa* the ascetic life is irreversible; but to leave in *brahmacarya*-hood is possible. Like the girls from Ānandamayī Mā's *kanyāpīṭha*, prospective brides can assure the parents of an eligible boy that they will have an orthodox, educated daughter-in-law, one who will fulfill the norms of *strīdharma* to perfection. It seems likely that in lieu of adequate money and property the impoverished high-caste parents of *brahmacāriṇīs* can offer a young man's family a substitute for elaborate dowry: a well-educated girl, familiar with all the implications of *varṇāśramadharma*, and one whose chastity and purity are beyond question.

The meticulous observance of pollution conventions extends across the field of Vaiṣṇava asceticism itself, so that Gaṅgā Mā, her girls, and other Nimbārkis refuse to accept food from certain Vaiṣṇavas of different sects. Yet, despite the extreme inculcation of purity-pollution conventions and the ritually defined patterns for the control of sexuality, Gaṅgā Mā is possessed of a personal warmth and tenderness that I have found in few other female ascetics. The intimacy of her relationship with the girls is such that informality exists in matters of coming and going, she will discuss at any time any question with which a young *brahmacāriṇī* might be struggling, and the very young ones are free to sleep with her at night if they feel afraid. This is quite unlike the relationship between mother and disciple found in both Ānandamayī Mā and Śobhā Mā's *kanyāpīṭha*s. In contrast with Ānandamayī Mā, Gaṅgā Mā's establishment has an atmosphere of renunciation, yet also of emotional warmth. Even the modest quality and untidiness of their clothing evidences a different attachment to householder notions of propriety, and indicates, I suggest, a correspondingly different evaluation of the *gṛhastha* life: While Gaṅgā Mā positively devalues *gṛhastha* *āśrama*, encouraging her girls, and even young lay devotees, to take *mantra dīkṣā* and commit themselves to a life of renunciation, Ānandamayī Mā actually encourages her staff to be aware of prospective and appropriate marriage arrangements for some of her girls. Accordingly, the discipline imposed on the girls in Ānandamayī Mā's *kanyāpīṭha* emphasizes duty: A young girl who has learned how to serve the deity well must necessarily be well-equipped to serve her husband. Gaṅgā Mā's interpretation of the essence of *brahmacarya* on the other hand, with its inculcation of the classical *brahmavādinī* ideal, accords well with her preference for the renunciatory life. Her institutional mechanism for the control of adolescent sexuality—marriage to the god—overtly recognizes the need for an appropriate channeling of this otherwise disruptive force.

Srī 108 Śobhā Mā Sant Āśram

This *āśram* has the affluence of Ānandamayī Mā's *āśram* and the intense devotion to the mother observed in Gaṅgā Mā's *kanyāpīṭha*. There are twenty residents, twelve of whom are *brahmacāriṇīs*; the remaining eight lead the *āśram* life and have taken *nām dīkṣā*, but are not initiated into *brahmacarya*. The *āśram* was founded recently, in 1950, and its school serves approximately 150 children from the district whose parents are "very pleased that their children should receive this kind of education from the *brahmacāriṇīs* under Mā's instruction." Śobhā is herself of the same order as Gaṅgā Mā. They are in fact *guru-bahan*, sisters-in-the-same-*guru*, and among lay followers there is a degree of rivalry. It is frequently said that Śobhā Mā is "too showy," as compared with Gaṅgā Mā; on the other side, it is pointed out that Gaṅgā Mā is not as strict as Śobhā, and above all, that Śobha often enters elevated states of *samādhi*, and, by implication, is of higher spiritual status.

The *āśram* is notable for a well appointed and modern, though relatively small, Kṛṣṇa-Rādhā temple, which attracts local householders to most of its daily worship services. Built by her wealthy and devoted lay disciples, the *āśram* with its attached *kanyāpīṭha* is well known in the locality itself, unlike the *kanyāpīṭha* of Gaṅgā Mā, whose self-effacing and unostentatious manner do not advertise her spirituality. The *brahmacāriṇīs* in Śobhā Mā's *āśram* are all postpubertal, ranging in age from about fifteen to thirty-five years. Many residents appear to be unmarriageable, owing to factors like age, physical unattractiveness, or a disreputable family situation: one girl's mother is mad, and thus by extension, her sanity is questioned. The majority of those who are too old are very well educated, possessing one or even two university degrees; the course of their studies has left them at the extreme edge of the acceptable age for marriage. Several of the noninitiated women, who will eventually take *mantra dīkṣā*, have either left or been sent away from their husbands. In some of these cases, barrenness is a possible contributing factor. The daily schedule here is somewhat less rigorous. In fact, by comparison, the women live in relative ease; for example, servants clean the school, courtyard, and latrines. Except for those educated *brahmacāriṇīs*, one of whom has a BA in English, an MA in Political Science, and also a Bachelor of Education degree, the majority do not evince an attitude of scholarship.

The *āśram*'s popular Kṛṣṇa temple attracts a large number of lay followers and *swamis* from the nearby Ramakrishna Mission,

and thus *āśram* residents at first appear freer than other *brahmacāriṇīs*, in that interaction between themselves and the householder community is wider. They are, however, restricted in a more private and ritualized sense. Śobha Mā is considered divine by her devotees and many of the *brahmacāriṇīs* with whom I spoke claim to have seen her manifest in divine form, occasionally as a goddess, but most frequently as Kṛṣṇa. Recognition of her divinity is evident in numerous rituals of deference and purity acquisition. Thus Śobhā Mā's arrival and departure are marked by a complete disruption of activities such as reading, letter writing, or knitting, in order that all the women and girls might spatially reorient themselves toward her. When she moves, the *brahmacāriṇīs* (but not the uninitiated women) touch the space where she has sat and then touch their own forehead; whenever a *brahmacariṇī* seated in the Mother's presence must perform some task or other, she moves to Śobha Mā's sitting place, bows down and touches her feet before departure; and in matters great and small, one constantly hears, "I must first request of Mā (Mother). . . . " Constraints are evident in such minutely specified rituals and counterbalance the seeming openness of the *āśram*.

Śobhā Mā is liberal with regard to the background of potential ascetic devotees and has even accepted foreigners into her *āśram*. However, once vows of *brahmacarya* have been undertaken, she does not countenance return to the householder life. Her dramatic manifestations of divinity, as when during the ritual of *guru* worship she is clothed, adorned, and worshiped as Kṛṣṇa the youthful flute player, the elaborate and time-consuming rituals that continually reestablish bonds between herself and her *brahmacāriṇīs*, and the designation of specific times when she sits and converses only with her ascetic devotees, all contribute to a sense of being special, and to the perpetuation of a tightly organized conventlike structure in which there is little motivating a young woman to leave.

Let me sum up the features of ritual, belief, and sociocultural background common to these establishments for young women and girls. All three institutions are headed by a female ascetic who has undergone the ritual of *sannyāsa* and who acts as spiritual preceptor to large numbers of young women or girls who have taken vows themselves.[30] A few of these have also taken an unorthodox form of *sannyāsa*. Prepubertal girls and even some older women who have not long been resident in the *kanyāpīṭha* have simply taken a new name in *nām dīkṣā*, but fully participate in most activities of *āśram*

life. And the large majority of inhabitants have taken formal *brahmacarya* vows through the process of *mantra dīkṣā*. In addition, to those who will pursue serious scholarship and who may act as ritual officiants at the deity worship ceremonies in their respective temples, the sacred thread investiture (*upanayana*) is allowed. Daily life is austere and the routine is strict; by and large contact with outsiders is curtailed and in Ānandamayī Mā's *kanyāpīṭha*, conversation with men is strictly prohibited. In all cases, there is meticulous adherence to rules governing purity and pollution in matters of physical contact, food, and general association with householders.

In two of the *āśrams*, there is approbation of and adherence to the classical system of the four stages and four classes of life, *varṇāśramadharma*. All residents and associated officials immediately assert with pride that they follow "only what is written in the *śāstras*," asserting their orthodoxy. It is almost a compensatory response to this effect: "Though we shelter young, unmarried girls, their purity may in no way be questioned because our adherence to the laws regulating chastity and pollution is exacting and thorough." The outward signs of their celibacy and austerity inspire awe among the householder community: the young, prepubertal girls' wearing their hair cropped very short, like a young boy's; the shapeless, cream-colored or white dresses which fall to the knee. After initiation the *brahmacāriṇī*s all wear plain white saris with a very fine, perhaps three-quarter inch red trim. These young *brahmacāriṇī*s wear their hair cut to about one inch below the ear lobe and always well oiled: "so they do not have to part it" and thereby focus on their appearance. Any *brahmacāriṇī* who has made a decision to reside permanently in the ascetic community will don a solid white or pale cream sari without any markings or embroidery. The older *brahmacāriṇī*s, who are well past acceptable marriageable age and who wear white, keep their hair cropped regularly. They bear all the visible discriminants of widowhood.

Except for Śobha Mā's *āśram*, all contain prepubertal girls. But overall, the population is dominated by postpubertal, unmarried, or unmarriageable young women and girls. For one reason or another, all have experienced problems with regard to marriage: Among the sample of cloistered female ascetics examined here, few have entered the ascetic world out of an entirely free choice. The majority stand in an ambiguous position with regard to wifehood: (i) most have been placed here by impoverished, high-caste families unable to provide a dowry for them, (ii) some have been sent by relatives

unable to feed and clothe an orphaned child, (iii) some have parents who simply desire an orthodox education and protection for them, (iv) a few appear to have either been rejected by their husbands or else to have left them, perhaps owing to barrenness, and (v) some are unable to compete in the marriage market because of physical disability or unattractiveness, suspicions about mental or emotional capacity, or relatively advanced age.

6

Sainthood, Society, and Transcendence

Legends and Poetry of Women Saints

LEGEND AND SOCIETY

The Hindu tradition abounds in spiritual heroines. Popular characters such as Sītā, Sāvitrī, and Santoṣi Mā, who serve as models for appropriate behavior in the world, have received the attention of scholars. But those whose lives are lived in struggle with the world

[Note: Earlier chapters in this book looked at different lifestyles for women. First is the ideal woman of orthodox sociolegal texts, submissive to her husband, indeed vowing to serve him—observing *pativrata*—and scrupulously adhering to the rules of purity, social class, and stage of life. Then there are three ascetic ways of living outside this paradigm, available to women who have either chosen or been forced to abandon the life of the married householder: those of the celibate student (*brahmacāriṇī*), the renouncer (*sannyāsinī*), and the extra, even anti-social tantric. They illustrate these life-styles with data from Varanasi, primarily of a sociological kind. It is clear that LTD intended to supplement this with more ethnography of actual people and places. Fragments of this appear in the previous essays, but nothing remains in her papers that could be reconstructed into a complete chapter. In this last chapter, written as a freestanding article in 1984, she considers data from texts. In the earlier version of it she wrote in a note that she had also "collected the life histories of four contemporary women saints and observed the transformation of biography into hagiography, life history into legend." It would have been fascinating to have had biographical data for these individuals to enrich the formal and sociological analyses she gives, and to have had what would certainly have been thought-provoking remarks on the kinds of relation she perceived between texts about contemporary saints and behavioral-sociological realities as she saw them. But at least we have this chapter to set her analyses of womens' lifestyles, ascetic and not, in the context of individual personalities, albeit mostly legendary—S.C.]

of normal social relations and, quite often, with themselves, remain largely unexamined. The heroines I refer to are mystics, ascetics and saints whose lives are rarely considered exemplary. Rather, they are evidential: evidence that *mokṣa* is possible.

This chapter takes material from legendary accounts of a number of women saints in order to discuss the relationship between sainthood, society, and spiritual liberation.[1] In the large stock of legends, folktales, and biographies of women saints available to us, one is struck by their extreme personalization, their dissimilarities, their precious eccentricities. If one relies on legend alone, their lives appear quixotic and contradictory. Sainthood emerges in varied circumstances, ranging from that of the widow who voluntarily subjects herself to starvation, to the sensuous obsessions of the young girl who marries her beloved deity, to the intellectual mysticism of the homeless and naked female ascetic. All symbolic action described in legend is perfectly real behavior. The tragedies of miserable marriage, widowhood, and physical unattractiveness may be reinterpreted and presented in texts in such a manner as to divest them of their personal significance and pain, but such symbolic acts are quite real. All forms of religion in South Asia have precise behavioral specifications governing social interaction. Social existence is the arbiter, avenue, and evidence of spirituality. By clarifying the overall structure of Hindu society and of the possible ways of being religious, legend becomes sensible. So my perspective is both literary and sociological, that is, I apply the logic of social analysis to legend.

The data are literary in two senses. First, and most fortunately for us, a large number of women saints were also writers and poets, and we have the verbal testimonies of their spiritual struggles and, sometimes quite explicitly, of their struggles with society. Second, and as already stated, the literature is legendary. I am well aware of the mythical character of legendary biographies and have no doubt that there exists for female saints something analogous to the myth of the magus. These women are indeed ritual heroines, more specifically, spiritual ones, and a comprehensive study of their lives would reveal certain stock features (Butler 1979, 1–2). But here we focus on cultural specificity and thus on their Hinduness. In addition to their universal or archetypal quality, hagiographies select and elaborate essential religious themes as defined by the specific society of a saint. The term *saint,* which has no indigenous equivalent,[2] refers to someone who is recognized as having attained the highest state of spiritual accomplishment ap-

propriate to her form of religiosity. It is analogous to the Christian notion of a person of extraordinary holiness of life, but this holiness admits of a rather different relationship with divinity than in the Christian world: Hindu saints are themselves divine. Saints are believed to have attained liberation either in the course of their life, often at a very young age, or at death. It is the moment when, as one of my female ascetic friends graphically phrased it, "they get union with God," and thus are not subject to rebirth. Saintliness may be demonstrated in forms of behavior that we would consider paradoxical, irrational, outrageous, or intransigent. It is invariably indicated by *samādhi*. Its inner content is described in terms that incline us to identify it with mystical experience, and in this sense, saints are mystics.

I suggest it is possible to distinguish several types of female sainthood and that these are located at specific places within the socioreligious structure of Hinduism. There is a social dimension, expressed in the mode of asceticism or type of ascetic lifestyle pursued by the saint, and a religious dimension, evident in the path or approach (*marga*) to spiritual liberation and/or mystical experience that she chooses. The social and the more properly spiritual dimensions intersect and there is a correlation between the degree of social externality of a saint and the type of religious path chosen. With respect to the social dimension of sainthood, there are recognizable degrees of asceticism, moving from a point located within the ordinary social world, to one that rejects the world, to one that is entirely beyond the strictures of society. This entails the successive renunciation of that which has been previously affirmed: husband, society, deity, self. The more specifically religious dimension consists in a renunciation of the type of spiritual approach that has been previously affirmed. This includes the successive renunciation of ideal wifehood, learning, devotionalism, gnosis, and then abandonment of even this last in recognition that one no longer strives for liberation at all, but has attained it.

This chapter has three parts. The first concentrates on those saints whose asceticism is pursued in-the-world, that is, worldly asceticism, the second on those who pursue renunciatory asceticism, and the last on those whose asceticism is antisocial or extrasocietal. In each part I describe the social reality for a woman in that particular status, discuss the forms of spirituality available to her, and present selections from both the legendary biographies of women saints and, where possible, their poetry or prose. All saints struggle with society and for women saints this is primarily

evident in their relations with men; but all saints also struggle with themselves and for women saints this is evident in the markedly passionate quality of both their emotional and intellectual approaches to the divine.

The typology is not intended to be evaluative. I do not wish to imply that the emotional mysticism of a saint-in-the-world such as Mīra Baī is lower than the mystical gnosis of a Mahadevī, or the fierce asceticism of the woman-turned-ghost Ammaiyār. Rather, the typology is useful in the interpretation of legend and also, perhaps, in understanding contemporary religious and political saints. The behavior of saints is often bizarre, but it is never entirely arbitrary and never without meaning. By locating a saint in a certain type of sainthood we gain entry into the quality of her religious struggle, for the ground of religious experience, mystical or otherwise, is laid by the circumstances of birth and accident, and Hindu society has precise social structures that attend to these.

WORLDLY ASCETIC SAINTS

Ideal Wifehood and Devotionalism: Bahiṇā Baī

The point of departure for this-worldly sainthood is the renunciation of wifehood. There appear to be two types of sainthood while remaining in-the-world. Both reject the husband as the central object of concern but each selects a different focus in his stead: the first selects society as a totality and is directed toward wisdom; the second selects a male deity as the fundamental object of ritual or devotional concern and is directed toward mystical union with him. In the latter stance a woman has the option of maintaining, rejecting, or simply ignoring a relationship with the conventional social order. Thus there are several possible ways of combining devotional sentiment with social reality. But the starting point remains that of wifehood, and since it is the first role renounced by a woman saint it deserves attention. As discussed in chapter 1, the texts on *strīdharma* were written by men, and it is rare to find its ideals articulated by an other than purely mythical woman. There is one historical woman who has done so, the seventeenth-century saint of Maharashtra, Bahiṇā Baī. She is considered a saint not by virtue of her wifehood however, but owing to her inspirational role in a certain Maharashtrian sectarian devotionalist movement. Bahiṇā had taken a low-caste man, Tukārām, as guru and persisted in

attending devotionalist gatherings. She encountered resistance from her husband, a poor but orthodox *paṇḍit*. She continued in devotion to her chosen deity, Pandurang, a form of Viṣṇu, and in associating with other devotionalists, and generally behaved in such a manner as to discredit her husband's authority. When he threatened to take *sannyāsa*, Bahiṇā capitulated to the requirements of wifehood. She was a prolific poet and one entire set of her works is devoted to the description of orthodox *strīdharma*. She writes (Feldhaus 1982, 597):

> Keeping my proper duties in mind,
> I'll reach God by listening to the scriptures.
> I'll serve my husband—he's my god.
> My husband is the supreme Brahman itself.
> The holy water that has washed my husband's feet
> combines all holy waters in one.
> Without that water, nothing is of worth.
> The goal is in serving my husband.
> In my husband alone is all my aim.
> If I have any other god but my husband,
> It will be as bad as killing a Brahman.
> My husband's my guru; my husband's my way—
> This is my heart's true resolve.
> If my husband goes off renouncing the world,
> Pandurang, what good will it do me to live among men?
> What beauty has flesh without breath
> or moonlight without the night?
> My husband's the soul; I am the body.
> My husband is all my good . . .

Shortly before her death, Bahiṇā composed a set of poems in which she recalled her previous twelve births. She depicts her successive incarnations as a progression upward on the scale of *varṇa*, and on the scale of appropriate marital statuses, so that in her first few lives she was unmarried or widowed and of Vaiśya or Kṣatriya classes, while in her last four lives she was a married *brāhmiṇī*, devoted to her husband.

She was not only a poet but also a rather clever metaphysician and, indeed, a devotionalist saint. Surely in no woman saint's life has the battle between the orthodoxy of the Vedas and the relativization of the "lowly" devotionalist cults been played out with such drama as in that of Bahiṇā Bāī.[3] That she remained as wife

to her husband is largely due to the fact that, while he managed
to convert her to the ideals of *pativrata*, she converted him to the
ideals of *bhakti*. Bahiṇā, whose spiritual passion was formidable,
bitterly encapsulates Vedic orthodoxy (Feldhaus 1982, 594):

> The Vedas cry, the Purāṇas shout
> that no good can come of a woman.
> I was born with a woman's body—
> how am I, now, to attain the Goal?
> They're foolish, selfish, seductive, deceptive,
> any link with a woman brings harm.
> Bahiṇā says, "If a woman's body's so harmful,
> how in this world will I reach the goal?"
> . . .
> I haven't the right to hear the Vedas.
> The Brahmans keep secret the Gāyatrī mantra.
> I may not say "Oṃ,"
> I may not hear mantra's names.
> I must not speak of these things with another.

In contrast, sectarian texts such as the *Bhagavadgītā*, devoted to the
god Kṛṣṇa, may be read by all, and one of the central religious acts
of devotionalism is the repetition of God's name. Bahiṇā depicts the
hostility of her husband to such theistic expressions (*Ibid.*, 595)

> My husband earned a living working with the Vedas—
> where is God in that?
> though he recited the Vedas,
> he cared not at all for devotion.
> God's name brought pollution in our house.
> To our family, the Gītā and scriptures were foes.

That the larger social battle of sectarianism versus orthodoxy was
played out in Bahiṇā's personal struggle with her husband is quite
evident in the plea to her preferred deity, Pandurang (*Ibid.*, 594–95):

> You alone are my friend, Hari, sibling. You stand
> up, Pandurang, for the lowly.
> You must believe, Meghaśyām,
> that devotion to you allows for wifely duty,
> that the Goal is not opposed to the Vedas.
> So think of my need.

Bahiṇā says, "Think quickly, Hari.
of a way to let both things happen."

But Bahiṇā did not wait for Hari (Viṣṇu) to do the thinking for her. She pursued the problem by intellectualizing it and converting her emotional trauma into an ideational one. She translates the conflict between the duty to her husband and her own desire for withdrawal into emotion for the deity into a conflict between *pravṛtti* (activity) and *nivṛtti* (resignation, quiescence). These two concepts are of central concern to the Hindu religious tradition as a whole and Bahiṇā's treatment of them is skillful. She hypostasizes them as the two wives of mind, and in an allegorical poem describes how each asserts her superiority to her cowife, and each tries the other out. In the end, the two are reconciled, and both of them together bring the mind to its ultimate goal (*Ibid.*, 599):

> The two wives became one through their quarrel.
> Let go of the root of ignorance:
> difference goes off of itself;
> doubt breaks up on its own.
> What difference can remain there?
> the two wives are one.
> The mind is in mindfulness.

I cannot do justice here to the remarkable, if tortured, complexity of this woman saint. She is as a devotionalist who affirms husband and deity at the center of her life and pursues celibacy after his death. Perhaps this is why legend depicts her as attaining *mukti* on the occasion of her death (Anandkar 1955, 71) rather than during the course of her life.

The Sainthood of Learning (*vidvattā*): Avvaiyār

We are told that in the first or second century BCE there lived a Brahmiṇī, Avvaiyār by name, who was so intellectually inclined that she preferred to dedicate herself to Sarasvatī, goddess of learning, rather than to any mortal man. She escaped the clutches of marriage by praying to God that he might divest her of her beauty, whereupon she became "an old woman with a common appearance." This, the chronicler continues, "relieved her from further proposals of marriage . . ." (Avinashilingam 1955, 10). Although we do not know if she took renunciatory vows, she is reported to have

advised others of its worth. She was a counselor to the kings of
Tamilnadu, yet herself lived an unostentatious life: she expounded
words of wisdom to the common folk, but was highly literate and
is recognized as the author of at least nine major ethical works in
classical Tamil literature.

Her writings pay careful attention to the pragmatic ethics of
everyday life (*Ibid.*, 12):

Big is the frond of the palm but scentless; sweet is the tiny
magizha flower. Judge not men therefore from size merely.

Harsh words do not conquer soft ones; . . . the rock that is
not split with the long iron crowbar, splits when the roots
of a tender shrub enter it.

But she was above all concerned with the duty of those who govern
and the virtues of nobility and wisdom. Thus (*Ibid.*, 13),

The justice of the King consists in not being content with
the information of spies but endeavoring to ascertain the
truth in person . . . ; and in hesitating to act before mature
deliberation.

True ministers fail not to approach the King and rouse him
to the call of reason, assailing his ears with their good
counsels undeterred by fear of his anger.

That she gave advice about renunciation to a man (*Ibid.*, 11) is
no more remarkable than that she counseled kings, because we
find combined in Avvaiyār the woman referred to in literature as
"Brahmin" nun and "Brahman lady scholar." She was certainly
celibate and seems to have held renunciatory asceticism in high
regard, advocating it as an escape from unhappy marriage. As for
her scholarship, apart from her own writings that testify to her
erudition, there is her legendary association with Sarasvatī, the
goddess of learning. One recalls Ubhay Bhārati, the eighth-century
brahminī who surpassed men in learning and acted as arbiter of
scholarly debates. She was held to be an incarnation of Sarasvati.[4]

Avvaiyār's sainthood is clarified by recognizing the social dy-
namics of her type of asceticism. Hindu socioreligious order is gov-
erned by the persons of the Brahmin, who possesses the authority of
tradition, and the king, who exercises the obligations of power. It is

the former's duty to articulate *dharma* and the latter's to ensure its fulfillment. Avvaiyār herself is the very model of the Brahmin minister to kings, and nothing she wrote threatens the specifically Hindu solution to the delicate problem of power versus authority. Because the specifications for right behavior are codified in canonical literature, erudition is held in high regard. But to arrive at dispassionate wisdom, learning should be pursued in celibacy. This allows one to articulate ideal *sanātanadharma*. By rejecting man as husband a woman may expand her compassion and insight and take mankind at large, society as a whole, as the object of her concern.[5] Without taking renunciatory vows she remains physically inside society but emotionally and intellectually outside.

Avvaiyār demonstrates the type of worldly saint who renounces a husband for learning. The object of her concern is society as a whole and she clarifies ideal socioreligious order, *sanātanadharma*. The relationship she has with society is that of a wise elder. It is no accident that she is known as "the universal grandmother" (*Ibid.*, 12).

Rejection of Wifehood and Affirmation of Orthodox Society: Kurūr Amma and Chanikrottu Amma

In late sixteenth-century Kerala we meet with the woman Kurūr Amma, who was born of a respectable Brahmin family and whose love for the god Viṣṇu vas so elevated that she dared adopt the attitude of mother toward him;[6] it is said that while performing *pūjā* to him as the boy-child Kṛṣṇa (Bāl Kṛṣṇa), the godling himself sat on her lap, clambered over her back and played his usual inventory of childish pranks. Coexistent with Kurūr's devotionalism was a thoroughgoing orthodoxy: she adhered firmly to the laws regarding seclusion of women (*pardah*). On one occasion an elderly Brahmin beggar appeared at her door. How could she resolve the duty incumbent upon her of feeding the Brahmin with the observance of *pardah*? Her combination of steadfast devotion for the deity and virtuous preservation of modesty was resolved by the appearance of the god Viṣṇu himself in the form of a celibate youth, who then graciously served the guest.

Then too, there is the fourth-century saint, Chanikrottu Amma, who was also a devotee of Viṣṇu and scrupulous in the performance of one especially important Vaiṣṇavite fast: *ekādaśī*. During this fast neither food nor water can be taken for one full day and a night, and on the following morning, having bathed and prepared

food, one may eat only after first feeding a Brahmin. Chanikrottu followed this fast into her old age, but on one occasion she could find no Brahmin to feed. She vowed to fast to death rather than violate the specifications of *ekādaśī*. It is said that Viṣṇu, moved by her faith, appeared in the form of a *brahmacāri*. She fed him and he blessed her with liberation at once. A temple has been built in Tiruvella, Kerala, on the site of her ascension.

These women saints satisfactorily combine devotionalism and orthodoxy. From the perspective of belief, they blend the religion of a personal theism with that of Vedic orthodoxy. Consider the special prayer attributed to Kurūr Amma and still popular today:

> May this dark-complexioned boy [Kṛṣṇa] who is really the Supreme Brahman known by the Vedas, deign to appear before me, sounding his sweet flute

From the social perspective, they combine devotionalism with a sort of asceticism that demonstrates full recognition and internalization of the norms of conventional society, as for example in the performance of *vratas* and observance of *pardah*. That legend should associate both Kurūr and Chanikrottu with celibate youths is appropriate, for they were themselves practitioners of lifelong celibacy. Such women have rejected wifehood and chosen devotionalism, but continue to affirm society and the socioreligious order. They are exemplary saints, favored by the orthodox, and are perhaps the most common of all women saints in India.

Rejection of Wifehood and Indifference to Society
Aṇṭal, Gaurī Bāī, and Mīrā Bāī

There are women saints who reject wifehood and appear utterly indifferent to society. The means by which they accomplish this, or are reported to have accomplished this, vary. Released from relationships of either the societal or wifely sort, it is at this point that passion truly enters a woman's devotionalism.

In seventh-century CE Madurai we encounter the poet Aṇṭal.[7] We are told she was not born at all, but that a gentle, illiterate poet-mystic found her in a field of basil (*tulasi*), cultivated as an act of worship to the god Kṛṣṇa for whom *tulasi* is sacred, who raised her as his daughter. His devotionalism was contagious and even before the appropriate age for her marriage Aṇṭal fantasized Kṛṣṇa as her lover, indulging in dalliances as his favorite pastoral nymph.

She wrote an autobiography of the spirit and poetry of such erotic and mystical desire (*prema*) for union with Kṛṣṇa that she has been called "the eternal Divine Queen of *prema*" and "the star of bridal mysticism" (Paramatmananda 1955, 23). When she declared her intent to marry only this divine lover, her father wisely ascertained the form of Kṛṣṇa that most suited her—that of Raṅganāth—and took the lovesick girl to the Śrī Raṅgam temple. At the sight of her object of desire, Aṇṭal is reported to have walked straight to his side, and then to have vanished. Today she is worshiped as his consort, and as a model of single-minded devotion for the deity. She depicts herself as crushed under the feet of Kṛṣṇa in total submission and penned lines such as these (*Ibid.*, 29),

> Fetch me the dust of the place trodden by that brazen-faced Youth, and smear my body with it; for then alone my life will not depart . . .

Many of Aṇṭal's poems are sung daily in Vaiṣṇava temples across the south of India today.

Then there is the eighteenth-century Gujerati saint, Gaurī Bāī, who was widowed at a very young age. Appropriate to her high-caste status, she pursued the irreproachable way of life expected of a widow, which is entirely religious, requiring serious fasting, performance of *pūjā*, and singing of devotional songs. A scholarly Vaiṣṇava ascetic recognized her talents and gave her learned instruction in Vedāntic (monistic) doctrine and she began to demonstrate the signs of spiritual elevation, remaining in trance for periods of time longer than a week. Since her death in 1809 she has been compared to the river Ganges, "which purifies all those who are devoted to her" (Mehta 1955, 79).

Finally, there is the very well-known woman of sixteenth-century North India, Mīrā Bāī, in whom "we have a poetess who is universally admitted to have been among the greatest saints of India" (Madan 1955, 51). Widowed at a young age, she refused to become a *satī*. Instead, she decided to marry the object of her religious devotion, the god Kṛṣṇa. This bittersweet poem describes her experience (Nandy 1975, 42):

> Śyam, the native of Braj is mine.
> mortal marriages are short-lived:
> They break so often, so easily.
> But my husband is immortal:

> even the serpent of death
> cannot kill him.
> My love resides in my heart.
> He is my complete joy.
> I find solace at his feet
> for I am his slave.

Mīrā's in-laws protested her ecstatic behavior because she dared go to a public temple of the god Kṛṣṇa, sing and dance before the image, and go into *samādhi*. However, she gained the recognition of other saints, scholars, and her own family (Madan 1955, 56):

> I am true to my Lord. Why should I feel abashed now since I even danced (for the Beloved) in public? I lost all appetite in the day, and rest and sleep at night. Now the arrow (of love) has pierced me and come out the Other side, and I have begun singing of Knowledge divine: (so) family and relatives have all come and are sitting (round me) like bees sipping honey.

As with Aṇṭal, Mīrā imagined herself a pastoral nymph of Kṛṣṇa:

> . . . The sight of him entices me.
> At nightfall I go to join him,
> At daybreak I depart.
> Both night and day I sport with him.

and certain of her poems extol his physical beauty (Madan 1955, 57):

> Dwell in my eyes, O Son of Nanda; enchanting is your figure, dusky your complexion, large are your eyes. So beautiful looks the flute on your nectar-like-lips; on your chest is the garland of *vaijanti* (forest weeds). The belt of little bells round your waist and the trinkets on Your ankles look charming and tinkle sweetly.

Mīrā Bāī wrote in the vernacular languages of North India and her several hundred poems are extremely well-known. The quality of her poetry reveals a very humanly conceived deity; it is passionate and personal yet it is consistently rendered by commentators as expressive of the mystical union of the individual self with the

Supreme Self. For instance, we are given the following poem as an example "in soul-stirring words of the suffering of Mīrā's soul, separated from the Universal Soul" (*Ibid.*, 56–57):

> ... my bed is laid on a guillotine, how can I possibly sleep? The bed of my Beloved is in heaven, what chance have I of meeting (Him)? Smitten with pain, from forest to forest I roam. No physician have I found. Mīrā's pain will vanish only when the Beloved (God) Himself becomes the physician.

Whatever the context of her mysticism, Mīrā Bāī is the quintessential ecstatic yet worldly mystic and she remained throughout her life patronized and protected by those around her.

There are two types of worldly sainthood open to women. Both pursue celibacy and reject wifehood. One has learning as its major path and society at large as its object of concern. The saint who pursues this route is seen to be a wise and legitimate articulator of *dharma*. Such is Avvaiyār, the Universal Grandmother. The other chooses devotionalism as its mode of spirituality and affirms a specific deity as central to religiosity. Within the devotionalist framework there are three possibilities: embracing orthodox conceptions of socioreligious order, as did Kurūr and Chanikrottu Amma; effecting a reconciliation of devotionalism and orthodox conceptions of both society and wifehood, as did Bahiṇā Bāī (though she practiced celibacy only as a widow); or ignoring society entirely. The disposition of indifference is commonly conveyed in legend by simply denying normal birth to a saint, as in the case of Aṇṭal. It prevents the saint from having any *varṇa* status in the first instance, a fact which releases her from the prerequisites of a social duty decreed by birth. In practice, indifference to society is more frequently a product of the saint's religious experience itself: A large number of saints remain quite disengaged from society by virtue of the frequency and intensity of their trance states. Gaurī Bāī and Mīrā Bāī are two instances we have noted.

Dealing with celibacy while remaining in society is another matter, which can be done only by adopting one of several roles towards the deity, for example that of mother (Kurūr Amma) or wife (Aṇṭal, Mīrā Bāī). As has been seen, ritual marriage to a god, using his image for the ceremony, is found in female, notably Vaiṣṇavite, ascetic orders today. It is a persistent theme and practice in both North and South India and solves the central dilemma

of worldly ascetic devotionalism for a woman. She remains in the world, yet subjected only to the authority and control of a divine husband. In spiritual terms, *bhakti* that is pursued in-the-world is always controlled. If a woman retains any vestige of social dependence, even her extreme devotional sentiment remains within the bounds of modesty. One can enter ecstasy, but one cannot abandon oneself to it entirely because there is always a sense of responsibility to others, the interdependent social relations of life-in-the-world.[8] If one's hair gets disheveled or *sārī* falls loose, there are those around who rush to restore propriety. Women saints who remain in the world exist as mothers, grandmothers, or daughters to the society in which they live. To take the pursuit of knowledge or of devotionalism so far as to overthrow, in addition to *pativrata*, all conventional social relationships defined by kinship and caste is to become a woman outside-the-world. This is renunciation and here the saint becomes unequivocal evidence of transcendence.

THE SAINTHOOD OF RENUNCIATORY ASCETICISM

The saints of this category are outside the world of normal social relations, that is, they have renounced not only *pativrata* but *saṃsāra* as well. Legend does not always identify them as *sannyāsinīs*, but it often speaks of them in terms of specific types of renouncer, for example, as *yoginīs*, and features of their lifestyle conveyed in legend are made sensible by reference to renunciation, whether as practice or metaphor. Even within renunciatory asceticism there still continues a ladder of transcendence: Having renounced the world, what remains is to renounce that which has been previously affirmed, the emotional, ritual, and intellectual ties that bind one to the quest for *mokṣa* itself.

 There appear to be two types of renunciatory sainthood. In one, the saint is still a passionate *bhaktā*. The deity she worships is real and her love for him quite carnal. In the other, the metaphor of transcendence strains to identify the divine as something less real, and though the notion of deity may remain, it is without attributes, and the mystic speaks of it or him as a principle, often as the self. This is accompanied by a shift in ritual practice, from an externally performed ritual action to one that is performed internally or mentally. In its most austere form, devotionalism is transcended

and the realization of unity with this ultimate principle consists in a sort of gnosis, an experience precipitated by an intellectual and intuitive flash of insight.

The Devotional Mystic, Mahādevī

In twelfth-century Mysore there was a woman, Mahādevī, whose surpassing beauty so captivated a local prince that he demanded her in marriage. She was a *bhaktā*, a member of the devotionalist Vīraśaiva sect who honor the God Śiva in his aniconic and phallic form, the *liṅga*. Her husband was a *bhavi*[9], a man without spiritual inclination, motivated only by worldly desires. Mahādevī is depicted as dealing with her marriage to this infidel rather skillfully: she survived their union only by observing the entire affair from the perspective of a passive witness. On the other hand, it is said that she sat for hours with the *liṅga* in her hands, gazing upon it, performing all the rites of worship, pressing it to her heart, singing songs expressing her devotion, and praying "for release from the bonds which bound her to a *bhavi*."

Other accounts suggest that when her husband forced himself upon her, she just got up and left. She considered the god Śiva, in the sensuous form of Cenna Mallikārjuna (The Lord, White as Jasmine), to be her paramour. Her husband's demands, though perfectly legitimate from the perspective of *strīdharma*, violated her commitment to her true Lord. The question of Mahādevī's virginity is hotly debated (Ramanujan 1973, iii), but in any event she left her husband, family, and clothes behind. The popular lithographs found in South Indian bazaars today represent her as a supremely beautiful woman, with lustrous black hair falling over her shoulders, covering her otherwise naked body.[10] Her nakedness did not remain unchallenged; she appeared before a council of the senior elders of her sect and her poems testify to the verbal debates she held on this and other topics.

Besides debating, Mahādevī wandered, begged, lived in caves, moving in and out of society at will; and she wrote exquisite poetry. Her poems are at times almost vulgar, at others, intellectually sublime. They convey as much about her struggle with meddlesome in-laws, an ungodly husband, and molesting male detractors as they do a fondness for her mother, an adoration of nature and, above all, the erotic longing for mystical intercourse with her divine lover. She confided in her mother (*Ibid.*, 121):

> O mother, I burned
> in a flameless fire
> O mother I suffered
> A bloodless wound
> Mother I tossed
> without a pleasure:
> loving my lord white as jasmine
> I wandered through unlikely worlds.

In one poem her mother teasingly suggests that perhaps she might go too far (*Ibid.*, 126)

> When one's heart touches
> and feels another
> won't feeling weigh over all,
> can it stand any decencies then?
> O mother, you must be crazy,
> I fell for my lord
> white as jasmine.
> I've given in utterly.
>
> Go, go, I'll have nothing
> of your mother-and-daughter stuff.
> You go now.

Mahādevī's saintly Vīraśaiva male contemporaries recognized her poetry as superior to their own and for many she is still the superlative poetic artist of the Kannada language. From our perspective it is significant not only for its beauty but for the manner in which a graphic notion of the divine coexists with a monistic understanding of the attributeless nature of the ultimate mystical experience. Mahādevī describes Cenna Mallikārjuna, her lord white as jasmine, in his form as the compellingly erotic ascetic (*Ibid.*, 124):

> Listen, sister, listen,
> I had a dream
>
> I saw rice, betel, palmleaf
> and coconut,
> I saw an ascetic come to beg,
> white teeth and small matted curls.

I followed on his heels
and held his hand,
he who goes breaking
all bounds and beyond.

I saw the lord, white as jasmine,
And woke wide open.

But this same poet writes of her devotion as a gnosis (*Ibid., 126*):

Till you've earned
Knowledge of good and evil
 it is
 lust's body
 site of rage,
 ambush of greed,
 house of passion,
 fence of pride
 mask of envy.
Till you know and lose this knowing
You've no way
Of knowing.
My lord, white as jasmine.

or again (*Ibid.,* 119):

When I didn't know myself
Where were you?
Like the color in the gold,
You were in me.
I saw in you,
lord, white as jasmine,
the paradox of your being
in me
without showing a limb.

Furthermore, Mahādevī appears thoroughly acquainted with the classical use of negation to describe the mystical experience of union. Here she employs the aniconic metaphor of Śiva, the *liṅga*, to assert that the ultimate is formless and unqualified and, moreover, that the experience itself is ultimately incommunicable:

I do not say it is the Liṅga,
I do not say it is oneness with the Liṅga,
I do not say it is union,
I do not say it is harmony,
I do not say it has occurred,
I do not say it is You,
I do not say it is I,
After becoming one with the Liṅga
 in Cenna Mallikārjuna,
I say nothing whatever.

One consistent feature in the telling of Mahādevī's life story is that when she sought guidance from her *gurus*, they found her level of spiritual achievement to be far in advance of their own, and were disinclined to interrupt her states of ecstatic trance. She died young, in her twenties, and is invariably depicted as having achieved liberation shortly before her death. As one chronicler puts it, when she prayed to Śiva 'for release from the body which had been polluted by contact with a *bhavi*, [i.e., her infidel husband], Śiva granted her request and she went to his heaven (Kailas) in a new divine body.

EXTRA-SOCIETAL SAINTHOOD

The Tantric Mystic, Lalla

The Kashmiri poet Lāl Ded, commonly known as Lalla, lived in the fourteenth century. Maltreatment by her in-laws and the indifference of her husband led her, at about the age of twenty-four, to leave married life and home (Kaul 1973; Handoo 1955). She took initiation from a *guru* of the Kashmiri Śaivite tradition. We know that she combined the very intellectual devotionalism characteristic of that school with the esotericism of tantric *yoga*, because in her poems she employs the technical language of monistic Vedanta with that of tantric philosophy. We know that, like Mahādevī, she became a mendicant, homeless beggar and also dispensed with her clothes. It is believed that she attained *mokṣa* early in her career, just after winning an intellectual battle over the subject of her nudity. It was at this point that she started roaming about Kashmir, "singing and dancing in divine ecstasy" (Handoo 1955, 45). Legend has it that she excelled her *gurus* in verbal debate and spiritual accomplishment and that they, in fact, learned from her.

Lalla's behavior was ecstatic and, as with Mahādevī, her nudity was challenged. She replies to the objections poetically (Handoo 1955, 46):

> Dance then, Lalla, clothed, but by the air:
> Sing then, Lalla, clad but in the sky.
> Air and sky—what garment is more fair?
> "cloth," saith custom—doth that sanctify?

Lalla is quite removed from the world of *bhakti* sentiment. Her descriptions of mystical experience contrast wih those of Mahādevī. Lāleśvarī, one feels, unites not with a deity, but with an unqualifiable Principle, and achieves pure identity with it (*Ibid.*, 47):

> Self of my Self, for Thou art but I,
> Self of my Self, for I am but Thou,
> Twain of us in one shall never die,
> What do they matter—the why and how?

Like Avvaiyār, she was advisor to rulers on the one hand and heroine to commoners on the other. She is one of the most important personages of Kashmiri folklore and it is estimated that more than one-third of all Kashmiri proverbs come from her.[11] Lalla had attained *mokṣa* in her youth and when she died at an advanced age, it is said that her soul "buoyed up like a flame of light in the air and then disappeared" (Kaul 1973, 308).

Lāl Ded and Mahādevī are both renunciatory and mystical female ascetics, of who there have been hundreds in Indian history. Few of them are known to us. Unlike the ascetic mystics who remain in-the-world and, accordingly, preserve ties with a community, usually a community of devotees, renunciatory mystics remain largely the property of the ascetic community alone, unless by chance they produce sayings, poems, or oral literature of such a quality and quantity as to deposit themselves in the memory of society at large. Lalla and Mahādevī are both part of a lengthy ascetic and mystical tradition that has its own social institutions, and I suggest that the legends of these saints and their religious experiences can be clarified by reference to these institutions.

First, on the sociological side of this inquiry, both these women are members of the oldest ascetic tradition in India, the Śaivite. Both of them are *yoginī*s, that is, female practitioners of *tantrik yoga*. With this in mind we may unravel some of their behaviors.

First of all, on the topic of their nudity, we must note that naked-
ness is sanctioned, even required by ascetic tradition in precisely
those orders who follow *tantrik* ideology and who take the physical
body as a microcosm of the universe. The body is something to be
used in the process of attaining liberation and this has implications
for mystical practice. Nudity is thus neither exhibitionistic nor
vulgar: it is a very severe austerity. To go without clothes in the
cold of a North Indian winter or the heat of a South Indian summer
is an austerity of the highest order and it commands respect. Nudity
is institutionalized in the renunciatory tradition; there are subor-
ders of ascetics for whom complete or partial nudity is requisite.[12]
There is a good deal of literary and circumstantial evidence to the
effect that women of *tantrik* persuasion in both Śaivite and
Vaiṣṇavite ascetic orders also undertook nudity, and I am person-
ally familiar with its practice.[13] Even relatively recent historians of
ascetics or mystics (Oman 1905, 226) have recorded it, literary
dramas depict it (Ghurye 1964, 122ff.), and it is a frequent theme
in tantric art (Mookerjee 1967, 1971).

Lalla and Mahādṅvi are early representatives of those women
who in contemporary Śaivite asceticism are known as *avadhūtanīs*.[14]
I suggest that these saints were not only socially free in that they
were renouncers, but, also that they were not celibate, that they
both were ritual practitioners of *tantrik yoga* and that they chose,
if and when they wished, a male partner.[15] For Ramanujan,
Mahādevī's sayings have "an occult glossary . . . drawn from yogic
psychology and tantric philosophy" (1973, 49). Her poetry is so
graphic that one hesitates to concur with Ramanujan's assertion
that her nakedness is primarily and nothing more than an act of
social protest. It most certainly is that. But it is far more.

Lāl Ded is specifically identified as a *yoginī*: every legend states
this and one of her names is Lalla Yogeśvarī, which means some-
thing like "the Queen of Yoginīs." In her poetry she uses the vocabu-
lary and metaphor of *kuṇḍalinī yoga*.[16] However, she proceeds to a
point beyond the ritual practice of sexual *yoga* to a symbolic one. In
her life Lalla expresses the ideal method by which to pursue mysti-
cal experience, a method that nearly all Śaivite and some Vaiṣṇavite
ascetics today affirm: One should move from external to internal
practice, but the internal mode is arrived at only after having gone
through its external form.[17] It is a movement from physical ritual
practice into a perpetual communion with the divine.

I further suggest that the reported differences in the physical
appearances of women saints correspond to differences in their

mystical-ascetic practice. In the case of Lāleśvarī, nudity is the evidence that she has attained *mokṣa*. For her, the ultimate experience is unitary, and thus sartorial finery and nakedness are both alike. She was beyond sensual desire and external ritual practice. All the stories I was told about Lalla describe her as a naked, but older, woman, singing and dancing with just an ochre cloth thrown over her shoulder.[18] She herself describes her nudity in terms that make it evidence of her state of spirituality, that she had shifted the focus of her vision from the external world to the interiorized mystical quest (Kaul 1973, 12):

> My guru gave me but one precept:
> "From without withdraw your gaze within,
> And fix it on the inmost Self."
> I, Lalla, took to heart this one precept,
> And therefore naked I began to dance.

Mahādevī, on the other hand, was *clothed* in her *hair*. This is important, because long, free, and flowing hair is a visible and alluring representation of *māyā* (illusion). *Māyā* is a magic show or play, the powerful force that binds one to the world. In *tantrik*, as opposed to orthodox Vedāntic systems, *māyā* is nonetheless a force to be reckoned with and creatively used. Mahādevī's nudity is instrumental and her hair cloak (McCormack, 1973, 176) a sign of engagement with the senses. In the following poem (which incidentally refers also to the practice of ritual tantric intercourse), Mahādevī fully recognizes the entrapment of *māyā* and craves for release from its clutches:

> O Lord, your Māyā does not give me up even when I have given it up. In spite of my resistance it clings to me and follows me.

> Your Māyā becomes a yoginī to the yogin. It becomes a nun to the monk, it becomes a herald to the saint. It adapts itself to each according to his nature . . .

In fact, the most famous dialogue of Mahādevī's career turns on her nakedness and its significance. The elders demanded, "Why take off your clothes as if by that gesture you could peel off illusions? And yet robe yourself in tresses of hair? If so free and pure of heart, why replace a sari with a covering of tresses?" Mahādevī

was aware of her attachment to *māyā* and with utter honesty re-
plied (Ramanujan 1973, 112):

> Till the fruit is ripe inside
> the shell will not fall off.
> I'd a feeling it would hurt you
> If I displayed the body's seals of love.
> O brother, don't tease me
> needlessly. I'm given entire
> into the hands of my lord
> white as jasmine.

In those lines—till the fruit is ripe inside/the shell will not fall
off—Mahādevī expresses her continued but eventually liberating
engagement with *māyā*.

Turning to the mystical experiences of these women, I think
it is reasonable to delineate differences in terms of their degree
and type of renunciation, but here it is affairs of the heart or
senses or mind that are renounced. Lalla and Mahādevī are both
individuals-outside-the-world who have renounced, in fact actively
rejected, all the worldly things that a woman should have, hus-
band, family, ornaments, and home, as have many of the ascetic-
saints-in-the-world noted above. But the majority of these latter
still cling to a deity. Mahādevī's intoxication with a qualified
(*saguṇa*) deity is transmuted into a pervasive sensuous mon-
ism, a most sublimely elevated pantheism. In fact, some hold
Mahādevī's ecstatic communion with nature to be a form of insan-
ity.[19] As Ramanujan says, she involved all of nature in her mys-
tical ascent (1973, 123):

> Would a circling surface vulture
> know such depths of sky
> as the moon would know?

> Would a weed on the riverbank
> know such depths of water
> as the lotus would know?

> Would a fly darting nearby
> know the smell of flowers
> as the bee would know?

> O Lord white as jasmine
> only you would know
> the way to your devotees:
> how would these
> mosquitoes
> on the buffalo's hide.

or again:

> All the forest is You
> All the glorious trees of the forest are You,
> All the buds and beasts that move
> among the trees are you.
> O Cenna Mallikārjuna, reveal to me Your face,
> pervading everything.

Mahādevī's vision of the divine is one that is mediated by sense experience and strives for release. Lalla's vision is of quite another sort. Painfully aware of transience, how different from the ecstatic absorption of Mahādevī it is (Handoo 1955, 47):

> Just for a moment a flower grows,
> Bright and brilliant on a green-clad tree:
> Just for a moment a cold wind blows
> through the bare thorns of a thicket free.

Lāl Ded speaks of Śiva as the universal "Thou" and poems such as the following could have emerged from the mouth of an Upaniṣadic mystic (*Ibid.*, 47):

> Thou art the heavens, and thou the earth:
> Thou alone art day and night and air:
> Thou thyself art all things that have birth,
> Even the offerings of flowers fair.

She has renounced *deity* entirely, having obtained an unmediated vision of the divine.

A final note on the spiritual struggles of these women. Mahādevī and Lāl Ded both employ the most "homely" metaphors. They speak of silkworms, cotton blooms, spinning wheels, and looms. Surely this poetic description by Mahādevī if nothing else demonstrates

her struggle with the oppressiveness of *māyā* (illusion), its skill-fully, lovingly self-woven threads leading ultimately to the destruc-tion of ego. (Ramanujan 1973, 116):

> Like a silkworm weaving
> her house with love
> from her marrow,
> and dying
> in her body's threads
> winding tight round
> and round,
> I burn
> desiring what the heart desires.
>
> Cut through, O lord,
> my heart's greed,
> and show me
> your way out.
>
> O lord white as jasmine.

Mahādevī struggles to use *māyā* to escape *māyā*, aware of its op-pression; Lalla struggles to escape from the intellectual burden of *saṃsāra*. The following poem shows her perception of the totality of the world as a cycle of painful rebirths that everyone must live out in the physical body and escape only by the recognition that it is so. It is a gnosis, a recognition that she refers to at one point as "the moonlight of knowledge bright" (Handoo 1955, 48):

> First I, Lalla, as a cotton bloom,
> Blithely set forth on the path of life.
> Next came the knock's of the cleanser's room,
> and the hard blows of the larder's wife.
>
> Gossamer from me a woman spun,
> Twisting me about upon her wheel.
> Then on a loom was I left undone,
> . . .
>
> Cloth now become, on the washing stone,
> Washermen dashed me to their content.

Whitened by earth and skin and bone
Cleaned they with soaps to my wonderment.

Tailors then their scissors worked on me:
Cut me and finished me, piece by piece.
Garment at last, as a soul set free
Found I the Self and obtained Release.

These metaphors remind us of one of the earliest religious women figures in India, Gārgī Vācaknavī of the *Bṛhadāraṇyaka Upaniṣad*. She pushes us to the edge of the universe, to the very limits of our imaginative capacity. Gārgī no longer deals with notions of deity or of self. There is at the end of her thought only pure unqualified existence. She begins by asking what it is that time is woven across:

... that which the people call the past, the present and the future, across what is that woven, like warp and woof? (BAU III 8.3)

When Yājñavalkya replies that time is woven across space, she concurs; but when she indicated that she wishes to know what it is that space is then woven across "like warp and woof," he is caught by the challenge and her question precipitates a famous statement about the indescribable nature of the ultimate: that it is unseen but is the seer, is unheard but is the hearer, unthought but is the thinker, unknown but is the knower (BAU III 8.11).

Ghost and Aghoriṇī: Kāraikkāl Ammaiyār

Somewhere between 400 and 600 CE there lived in Tamilnadu a woman now known as Kāraikkāl Ammaiyār. Just over sixty persons are included in the traditional list of Tamil Śaivite saints of whom three are women. One was wife to a saint and the other a saint's mother, but Ammaiyār was simply the daughter of a very rich but upright merchant. She is described as being extraordinarily beautiful. At a very young age a perfectly suitable marriage was arranged for her to a man who was not, however, a devotee of Śiva. But we are told that she loved her husband and "served him to keep him happy, as all dutiful wives of cultured families do" (Pillai 1955, 16).

Simultaneously, Ammaiyār's devotional intensity for Śiva increased. If as a child she "lisped the holy name of Lord Śiva with

love and delight," as an adult she associated with his devotees and gave them her wealth. Her devotional fervor engendered occult powers, which she demonstrated by replacing one of her husband's succulent mangoes that she had respectfully given to a Śaiva ascetic, by the force of her mental concentration on Śiva. At this, her terrified husband took flight, moved to another city, and married someone else. Ammaiyār continued in faithful wifehood. When the family eventually confronted him with his desertion, the husband prostrated himself before her and declared she was no mortal human being, but a goddess. On recognizing her husband's attitude, Ammaiyār made her famous request of Śiva (*Ibid., eighteen*):

So I pray to thee that the flesh of my body, which has been sustaining beauty for his sake, may now be removed from my physical frame and I may be granted the form of a ghost to dance round thee with devotion.

Her beauty fell away at once, her body transformed into that of a ghost, and at this point she commenced singing songs of praise to Śiva.

Ammaiyār headed north to the Himalayas, the place of Śiva, and so hideous was she that the people she passed were terrified. She converted their abhorrence to praise. En route, an inexplicable feeling came over her, she turned herself upside down and proceeded, head downward, to meet Śiva. When she arrived, the great God greeted her as his mother. She fell before him, calling him father and was granted her most urgent request, to be allowed to witness his eternal cosmic dance of fire (*Ibid.*, 20). She returned home, moving as before, upside down, and she remains to this day in the temple of Tiruvalangadu.[20]

The legend of Ammaiyār rests firmly on a notorious, if obscure, ascetic tradition. This "worshipful ghost of skin and bone, a form loathsome to the mortal eye" (*Ibid.*, 19) is the prototypical *aghorinī*, a female member of the most radical tantric tradition, the Aghoris.[21] The Aghoris identify themselves with the terrifying, cremation-ground-haunting aspects of Śiva. The *aghorinī* is a human form of Bhairavī, the female counterpart to Bhairava, Śiva as ghoul. Aghori ascetics are those who live on or near a cremation ground that provides the entirety of their necessities, from food to garments. In one of her poems Ammaiyār speaks of the dilemma of the mystical ghoul (*Ibid.*, 21):

They who are incapable of understanding his real nature make fun of Him. They see only his fine form besmeared with ashes and bedecked with a garland of bones like a ghost.

The Aghoris turn the entire social and ideological system on its head and violate its most stringent norms, so as actively to express transcendence. As Parry writes (1984, 25), "the genuine Aghori, it is acknowledged, is—almost by definition—likely to seem demented to ordinary mortals . . . this is merely evidence of his divine nature and of the fact that he has succeeded in homologizing himself with Śiva, who is himself somewhat touched, and with Lord Bhairava . . ." The same holds true for the *aghorinī* who is Queen Bhairavī.

In theological terms, the relationship between the cremation ground and Śiva's dance is more subtle. As forcefully argued by Parry the cremation ground is the seat of every human's final sacrifice, the consignment of their own body to the sacrificial fire of the funeral pyre. In her poetry, Ammaiyār makes continual reference to the flaming fire of Śiva's cosmic dance. He is "my Lord who dances with fire in hand and a garland of bones . . . " (Pillai 1955, 21). Śiva's dance is the dance of destruction and simultaneous creation by fire, the most aesthetically vigorous representation of sacrifice.

The *aghorinū*, who is the walking but utterly divine ghost, does not die. She has already attained *mokṣa*, which can be demonstrated in several ways, one of which is that having attained occult powers demonstrating them is scorned. This is precisely the course of events depicted in the legend of Ammaiyār. And she does not die. The ghost has escaped the normal consequences of death. Thus, Ammaiyār's *samādhi* (here *samādhi* means "mystical trance," "death," and the earthly moment of that liberation) remains enshrined in stone in the temple of the deity who is the cremation ground Master of the dance of destruction, death, and creation by fire.

We have come a long way from the sainthood of life-in-the-world. There are hundreds of women saints, spiritual heroines, in the Hindu tradition; and only a few have been considered here. Those whose legends and poems furnish us with evidence of their journey provide substance to the sociological exploration of sainthood. In recognition of both the ascetic and mystical dimensions of saintliness, I have suggested that a framework for analysis that

takes into account both social and spiritual realities is valuable. As-
ceticism has three main social expressions—worldly, renunciatory, and
extrasocietal; spirituality, or religiosity, admits of a variety of paths to
the specific goal of liberation. These features, combined together, con-
stitute several embracing paths to sainthood, ascetic-cum-mystic dis-
ciplines, which fall into a small number of recognized types.

Celibacy is an essential criterion of this-worldly asceticism. It
requires renunciation of wifehood and the pursuit of wisdom or of
devotional union with a deity. Mendicancy is the essential criterion
of renunciatory asceticism. It requires abandonment of all social
identities and renunciation of the world. Here, whether by means
of the body and senses or the imagination and intellect, the pursuit
of transcendence strains for release from the notion of deity and
strives toward an attributeless expression of the ultimate. In
extrasocietal asceticism one physically incarnates and lives out the
mythology of antisocial divinity.

There are valid objections of the assertion that each of the
women saints we have considered are or rather were fully initiated
ascetics of specific types. If, however, reference to the socioreligious
practices outlined above are of any aid in the interpretation of
legend, and if legend itself thus becomes useful in the elaboration
of sociologically observed practice, then, the typology is of some
worth. It shows that Hinduism is a socioreligious system of far
greater complexity than is often admitted. The mystical goal is so
diversely conceived and so variously approached that one tends to
forget that there have been and still are carefully articulated and
socially institutionalized mechanisms for its pursuit. Moreover, the
appropriation by women of the social and religious structures of
Hindu society requires exposition. Sociology can provide a basis for
the interpretation of what appears on the surface as the purely
religious or spiritual phenomenon of mystic sainthood. Attention to
the social dimension can indicate the sources of potentially insuf-
ferable life experience, of the personal tragedies that may befall a
woman in life, tensions and conflicts engendered by society itself.
Combining sociological insights and legend with sympathetic imagi-
nation, one arrives at the social and personal roots of religiosity.
Then, finally, the eloquent words and poetry of a saint provide
insights into the manner in which she may consciously decide to
renounce one goal for another, one structure for another. She may
take a variety of social institutions, of ideologies, or of philosophies,
and by means of intense physical, emotional, or intellectual struggle,
make them her own, and in the process transcend them.

 Notes

INTRODUCTION

1. Patrick Olivelle provides the most extensive survey yet of the literature on the *āśramas* (1977, 22ff), on the place of *saṃnyāsa* within *āśrama* ideology (1974, 27–35), and on the semantic history of the term *saṃnyāsa* itself (1981). [See now Olivelle 1993—S.C.]

2. The most succinct, much quoted textual exposition of this is found in *Manusmṛti* IV.1, VI.1,2, and VI.33,34.

3. In addition, up until 1989, regular correspondence with my primary research assistant, a Benares-based ascetic himself, has allowed me to monitor the state of affairs of the female ascetic community and to note changes, of which (with the exception of several deaths among the older population) there have been remarkably few.

4. Diana Eck's *Banaras: City of Light* (1982) is an inquiry into the *śāstrik* conception and definition of the city. Two interesting earlier works are those by Havell (1905) and Saraswati (1975); see also Vidyarti et al. (1979) and R. Singh (1987a, 1987b, 1988), who deal specifically with the city's sacred geography.

5. This constitutes the strength of B. D. Tripathi's work (1978); he took initiation successively and with impunity in first a Vaiṣṇava, and then a Śaiva ascetic order. Two other anthropologists who base their analyses of Hindu asceticism on their experiences as initiated ascetics, Agehananda Bharati (1980) and R. L. Gross (1979), provide accounts especially rich in ritual detail and personal reflection.

6. In the past, *hijṛā*s (or eunuchs) most commonly identified themselves with Rādhā in the Rādhā-Kṛṣṇa cycle of myths. At weddings they entertained family and guests by singing and dancing the roles of Rādhā and the other milkmaids in love with the god Kṛṣṇa; today they are more likely to sing and dance to popular film songs. Less well known is the fact

167

that many people fear them as "kidnappers," it having been their custom
to appear at the birth of a child who they examined for genital defects.
Should the child prove to be of indeterminate sex, the *hijrās* supposedly
had the right to claim the child as their own and whisk it away. Even
today many people believe that the community gains new members in this
manner, though my limited data suggest otherwise. There still is an India-
wide network of transsexual sects, many of whose members have chosen
in adolescence or early adulthood to undergo rituals of initiation which, in
some instances, entail castration.

　　7. The same is noted by Makhan Jha (1972, 141) who records that
the Vaiṣṇava transvestites whom he met in Janakpur, Nepal, avoid public
exposure.

　　8. V. Das (1979, 98ff) and K. David (1980, 98ff) both pursue thought-
ful structural analyses of the similarity between the norms of widowhood
and the norms of asceticism.

1. THE RELIGIOUS LIFE OF WOMAN-AS-HOUSEHOLDER

　　1. One of the few proscriptive passages is noted by Kane (1941b,
942): "Yāma quoted in the [*Smṛti Candrika*] . . . declares 'neither in the
Vedas nor in the *Dharmaśāstras* is *pravrajyā* [mendicancy] enjoined for
women; (procreation and care of) progeny from a male of the same *varṇa*
as herself is her proper *dharma*, this is the established rule.' " Another is
found in the *Arthaśāstra* (II.1.48) where Kauṭilya prescribes "punishment
with the first amercement for any person who converts a woman to asceti-
cism" (Chakraborti 1973, 96). Discouragement, rather than proscription, is
the usual case; for example, the *Strīdharmapaddhati* follows *Atri Samhitā*
(136, 137) in listing *pravrajyā* as one of the things "that cause women and
śūdras to fall" (Leslie 1989, 171).

　　2. Scholars have used "female ascetic" to translate a number of words:
Pāṇini (II.1.70) refers to *śramaṇā, pravrajitā,* and *tāpasī;* Kauṭilya speaks
of *parivrājikā* (I.XII.20) and *bhikṣukī* (I.XI.18); in his commentary on
Yājñavalkya, (*Yājñavalkya Mitākṣara* III.58), the twelfth-century
Vijñānesvar uses the word *sannyāsinī,* and quotes a much earlier author-
ity, Baudhāyana (500–200 BCE), as allowing renunciation to women. This
last reference is of special importance: Bühler (1886, 317 n.363) notes that
it is cited by the commentators Govindarāga and Nārāyaṇa as well, and
a lengthy tradition of Daśanāmi writers on renunciation followed
Baudhāyana's lead (Olivelle 1977, 34). In the epics, especially the
Mahābhārata, female ascetics appear, variously designated as adepts in
yoga (*yogasiddhā*), silent ascetics (*munivratā*), lifelong celibates
(*brahmacāriṇī*), and Brahmanical renouncers (*sannyāsinī*). See H. D.
Sharma 1939, 63–64; Kane 1941b, 942–46; Chakraborti 1973, 95–97; and
Olivelle 1977, 34 n.21. The many passages in *dharma* literature that dis-
parage female ascetics make sense only if one assumes that ascetic women

did indeed exist. They are most often treated as one of the categories of people the upright should avoid (e.g., Manu VIII.363). A late medieval text on women's duties states that women should not talk with *pravrajitās* or *śramaṇās* (Leslie 1989, 171); and in several places female ascetics are associated with erotic arts and the harem (e.g., *Kāma Sūtra* III.15 and *Kauṭilya* I.IX.18, I.XII.20).

3. Written c. 1719 by Tryambaka, minister to Ekoji, King of Tanjore. Leslie has translated parts of this text; she presents them together with commentary in Leslie *(1989)*.

4. The largest section, "Daily Duties" (Leslie 1989, 244–45), meticulously outlines a woman's daily routine, what she should do from dawn to dusk, and how she should do these things (e.g., arising, bodily cleansing, preparation of the domestic fire). "Duties Common to All Women" *(ibid., 273–304)*, though shorter, is also important; it discusses topics such as menstruation, pregnancy, how to behave when one's husband is away, and the rules for widowhood.

5. Leslie (1989, 251–52) lists several texts that compare women with "other creatures whose only common quality is impurity." A comprehensive survey of the ethnographic literature on women's impurity is found in J. Krygier's piece on caste and female pollution (1982).

6. *Sdhp* 12 v. 5–8 Leslie (1989, 178–80) describes the wife's role in the daily household image worship *(devapūjā)* as a strictly ancillary one (e.g., it is she who prepares all the items offered in worship). This compares with E. B. Harper's observations: In his discussion of women's allocation to *śūdra* status he notes, "Brahmin women, like most non-Brahmins, cannot directly do *pūjā* to most of the Sanskritic gods—instead they do it through their husbands" (1964, 173).

7. Married women are also *sahadharmaṇī*, partners in *dharma* (V. Das 1979, 94). Moreover, there is a technical term for "those rulings in which the wife assists the husband in his ritual obligations" *(pativratabhāginī)* (Leslie 1989, 50). See also Abbott 1984, 190; Dumont 1961, 82; Madan 1965, 102; and Srinivas 1978, 20.

8. A. Hejib (1980) has explored the *Mīmāṃsā* logic underlying this division of ritual labor. In the earliest Vedic period, women were required to recite crucial *mantras* as part of their role in at least one type of ritual, the *śrauta*; see Smith (1991, 30, 31, 37) for examples of such *mantras*.

9. For example, Leela Dube (1979) takes issue with the notions of *ardhāṅganī*, arguing that the term expresses neither integrity or equality; rather, it means that woman is encompassed by and "contained within one half of the man." See also Srinivas (1978, 230) and V. Das (1979, 94).

10. In this context I have noted that Brahmin male ritual specialists are not as enthusiastic as male family members.

11. Mary McGee, whose 1987 study of women's *vratas* is the most comprehensive to date, translates *vrata* as "votive rite." Because there are votive rites for women other than *vratas* and because the common translation "fast" inadequately captures the several dimensions and types of

ritual involved, I prefer to leave it untranslated while describing it as a religious observance or vow whose central feature is the fast.

12. Cf. McGee (1991, 78), "In many ways the life of the *pativrata* is the *vrata par excellence* of women. It is through fulfilling this *vrata* of service and devotion to the husband that a woman is rewarded in this world and the next."

13. Women worship deities on occasions other than *vratas* and in contexts other than exclusively female festivals. Unfortunately, few of the currently available studies describe deity worship as practiced by the average woman householder. K. Erndl (1993) describes a number of women who, though married, are professional *religieuses* rather than typical housewives. It is presently difficult to characterize women's daily *pūjā* to their favored deities (*iṣṭadevatā*), except to note that it is devotional in tone and, as Altekar (1973, 206) observed, essentially "Pauranik," that is, based on the *Purāṇas*. In the case of orthodox families today, Leslie writes that "the woman usually does everything except the crucial part of the ritual reserved for her husband; he does that and then goes to the office. She may also touch her husband's arm during the ceremony in order to earn her share of his merit" (1989, 180). Leslie also notes that the *mantras* such a woman uses are liable to be *paurāṇik* ones.

14. One should not conclude, however, that such women's religiosity is without a spiritual element. As McGee discovered on questioning Maharashtrian women about their motivation for observing *vratas*, many responded that devotion to God is important (1991, 84), and some spoke directly of establishing "a spiritual relationship with God." But, McGee stresses, this is the closest they came to "articulating any goal resembling liberation (*mokṣa*)" (*Ibid.*, 85).

15. Until recently there were few discussions of the auspicious-inauspicious scale of value as a principle central to Hindu life and thought. Srinivas (1952) and Dumont and Pocock (1959) had noted the auspiciousness of marriage and its contradiction of pure-impure criteria (1959, 33), and Khare (1976) had observed the same in regard to certain foods. But it was F. A. Marglin (1985) who first insisted upon and expanded the topic of auspiciousness. The volume she coedited with J. B. Carmen, *Purity and Auspiciousness in Indian Society* (1986) contains several seminal essays intended to promote further research on the issue.

16. So intimately is the married state associated with auspiciousness that the Sanskrit term *maṅgalī* and its variants (e.g., H. *sumaṅgalī*; T. *cumankali*) are used throughout India to speak of a married woman (Srinivas 1978, 19; David 1980, 96; Reynolds 1980, 36ff.).

17. Wadley (1975) and Daniel (1980), with different approaches and conclusions, discuss how villagers conceptualize *śakti*. Daniel's account of villagers' use of the word is particularly informative, showing how they interpret it in specific relations between women and men.

2. THE WOMAN WHO IS NOT A HOUSEHOLDER

1. The lack of good social science research in India is regrettable, especially given the enormity of widowhood as a social problem A notable exception is the 1988 volume *Widowhood in India* (eds. Nagesh, Nair, and Katti), which contains twenty-one papers, and a further thirteen abstracts, by a variety of professionals including demographers, sociologists, and social workers. It reprints B. Saraswati's 1985 report on Benares widows (known as the "Kashivasi survey"). The essay in the 1989 collection *Widows, Abandoned and Destitute Women in India* (eds. Dandvate, Kumari, and Verghese) deals with the approximately 1,200 Sikh women left widowed by the violence that erupted in New Delhi in November 1984, following Indira Gandhi's assassination. Three issues of *India Today* (1965 vol. 45, 1966 vol. 46, 1985 vol. 85) contain articles on the topic as do the two volumes of the *Journal of the Institute of Economic Research* (1983 vol. 18, 1984 vol. 19), and a 1986 volume (47) of the *Indian Journal of Social Work*. And two compelling essays by journalists are to be found in the 15 Feb. 1983 and 15 Nov. 1987 issues of *India Today*.

2. For a historical perspective on the reformist-orthodox debate that centered on this and other issues of relevance to widows, two works are particularly useful: *Vidhaba-vivaha*, published in English as *Two Pamphlets on the Marriage of Hindu Widows* (1855, repr. 1976 as *The Marriage of Hindu Widows*) and *Hindu Widow (an autobiography)* (1930, repr. 1986). The former consists of two controversial tracts by the Bengali reformer, Pandit Isvarachandra Vidyasagara, who, distressed by the plight of widows, especially child widows, in Bengal presented a *śāstrik* argument in favor of the remarriage of widows according to orthodox Hindu rites. The second work, by a courageous Marathi woman, Parvatibai Athavale (born in 1870 and widowed in 1890), is a moving account of the experience of widowhood and the struggle to alter the habits and attitudes of society at large.

3. Properly speaking, the Sanskrit word *satī* is a noun referring to "a good and virtuous or faithful wife" who immolates herself on her husband's funeral pyre. It is used with reference to this practice by the nineteenth century, at the latest, for example, in Regulation XVII of 1829 declaring *suttee* (the British spelling) "illegal and punishable by the Criminal Courts." According to Yule and Burnell (1989, 882), "[t]he application of this substantive to the suicidal act, instead of the person, is European" (*Ibid.*, 778). Use of the word to describe the act is thus incorrect, but it is entrenched in modern discourse on the subject, especially in the phrase "to commit sati." I follow Leslie (1991, 177) in treating the word as an item of English vocabulary, transliterated from *suttee* to sati while reserving *satī* for its proper referent, the woman who commits the act.

4. The standard objection to sati is that "it is a form of suicide, and suicide is forbidden" (Leslie 1991b, 184). Tryambaka argues that it is not

really suicide and that, given women's natural inclination toward immorality, it is a "safer" path for them to follow than that of celibate widowhood (*Ibid.*, 189). Nonetheless, he presents sati as an alternative; the woman who virtuously lives the rest of her life according to the difficult course for a widow (*vidhavadhama*) ultimately earns the same reward as the one who follows her husband onto the pyre (Leslie 1989, 304).

5. Leslie (1991b) provides an excellent account of the Roop Kanwar sati and an analysis of its religious significance in light of traditional notions of *strīdharma*. P. Courtright's work on "the dreadful practice" is to be consulted for an historical perspective (1994, 1995), and A. Harlan's (1992) for a close examination of *satī* veneration among Rajput women.

6. In discussing the fear of widowhood and its inauspiciousness, Srinivas noted (1978, 19), "I have heard many orthodox Brahmin women in south India express their desire to die as *sumaṅgalī*, while their husbands were still alive." Bhuribai, the high-caste woman whose life D. Jacobson so sensitively portrays, "often mentioned her dread of the possibility of becoming a widow." Afraid of death before her husband, she prayed to God, "Please take me first. Let him live, but take me" (1978, 129).

7. B. Saraswati says that the later *śāstras* that attribute inauspiciousness to the widow have simply yielded to social "pressures." It is inauspicious to see a widow on the occasion of a wedding or at the commencement of a journey because "on the death of her husband half of hers [*sic*] is dead [she being the *ardhaṅganī* of her husband]. . . ." One must carefully avoid "the element of death" from being "mixed up with . . . life affirming situations" (1985, 117).

8. In M. Allen's view this fear of widows is occasioned by "the magnitude of the problem that they pose for the maintenance of male control" (1982, 8). Harper (1969), Tapper (1979), David (1980), and V. Das (1979) all pursue similar structuralist analyses of Hindu society's hostility toward widows, while a few others look primarily to ideology. Thus, for example, Kondos concludes that, following the popular usage of the *guṇa* categories (of Sāṃkhya philosophy), widows, witches, and menstruating women are all "harmers," laden with the destructive force of *tamas* (1982, 254–57).

9. Cf. David, "Jaffna Tamils are quite blunt on the point that the widowed woman—particularly when family finances are not superb—is a candidate for prostitution . . . " (1980, 98); Harper notes that among the Havik Brahmins of South India, "the most commonly used term for a widow is *prāṇi*, 'animal' " (1969, 90).

10. Exceptions include some Tamil communities whose widows inherit their husband's estate and may remarry (Tambiah 1973, David 1980), the matrilineal Nayars (Gough 1956), and Bengal, which traditionally enshrined a woman's right to property in *dayabhag* law. On property rights and other aspects of women's religio-legal status, A. S. Altekar (1973) is still the most comprehensive historical guide, but also see Essays III and IV of the Government of India report on the status of women in India (1974, 37–147).

11. The Widow Remarriage Bill of 1856 appears to have had significantly little impact on traditional Hindu society (Borthwick 1982, 125–56), nor has the Hindu Women's Right to Property Acts of 1929 and 1937, originally intended to ameliorate the plight of widows, given them any "substantial rights of ownership" (Government of India 1974, 103). In this regard one of Saraswati's strongest recommendations is that the government should provide legal aid to widows and pass legislation that would "simplify or quicken the procedure involved in litigation" under the existing Act (Saraswati 1985, 120).

12. The practice of *niyoga* does, however, appear customary among a few groups such as the Raya Rajputs of U.P. (see S. Vatuk 1980, 289) and certain Sikh communities, where it is spoken of as "settling down" the widow. In fact, the *śāstras* offer other alternatives to the woman who has lost her husband. The classical jurist Nārada, for instance, makes provision for women to take another spouse and details exactly which catastrophes require a woman to do so (see Lariviere 1989). But these remedies remained unpopular, and for the strictly orthodox, unthinkable.

13. Interestingly, Saraswati asserts that a widow with a son is not inauspicious, partly because "the shadow of the husband is 'alive' in the son" (1985, 117).

14. The Age of Consent Committee estimated that in the 1920s, 40 percent of Hindu girls were married before the age of ten (Altekar 1973, 62); on Bengal, see Borthwick (1982, 106). In 1955 the legal age of marriage for girls was set at eighteen years, but as late as 1961, in almost half the districts of U.P., the average age at marriage of females was still below fifteen years (Government of India 1974, 23). The most recently available all-India data (from the Population Reference Bureau, 1981 [Ramesh Menon 1984, 6]) indicate an upward trend to seventeen years, but this is still below the legal age. Moreover, there are significant rural-urban differences, so that, for example, a recent (1987) survey of 167 widows in Karnataka reveals that the median age at first marriage for rural respondents is 15.5 years (Nagesh and Katri 1988, 68).

15. Such was particularly the case in Bengal where the Brahmo Samāj was most active; understandably, this reform movement attracted many widows as members (Borthwick 1982, 125).

16. This widow survey is part of the larger "Kashi Project" undertaken by Professor Baidyanath Saraswati and others between the late 1960s and early 1980s in affiliation with the Anthropological Survey of India and the Indian Institute of Advanced Studies; several articles and books have emerged from the project, including *Kashi: Myth and Reality* (Saraswati 1975) and *Ascetics of Kashi* (Sinha and Saraswati 1978). The Kashi widow survey was carried out under the auspices of the N. K. Bose Memorial Foundation, Varanasi, and funded by the Indian Council of Social Science Research. Detailed results of this report are not, as yet [1992], available in English. I am grateful to Professor Saraswati for taking the time, in early 1977, to discuss his research data at length with me.

174 Notes to Chapter 2

17. No one knows how many widows there are in Benares. A rough figure may be derived by combining the number of residents in various known widow *āśrams*, or attached to temples throughout the city, with a more rough estimate of those to be found on the *ghāṭs*, begging and bathing. The authors of a report on the status of women wrote, "According to the Gandhian Institute . . . there are approximately 5000 destitute or semi-destitute widows in the city of Banares" (Government of India 1974, 8). In the late 1970s Professor Saraswati told me he thought there were about three to four thousand; R. Menon, author of a 1983 article "Widows of Varanasi," states that there are more than eight thousand.

18. Borthwick's study of women in turn-of-the-century Bengal records the case of a widow who committed suicide not long after having written "nothing was as miserable as the life of a widow." According to Borthwick "the fate of many other widows was to end up as prostitutes" (1982, 126).

19. Nearly one-third of the 440 widows in the Kashivasi survey left home under duress (Saraswati 1985, 112). Furthermore, many reported that their share of the family property had been "fraudulently appropriated by their affines and sons" (ibid., 120).

20. Alaka Hejib's fascinating paper on the dilemma posed for the woman whose husband takes *sannyāsa* is summarized in D. Carmody (1979, 63). Entry into *sannyāsa* signals one's ritual death; is the wife of a world renouncer still his wife or is she his widow? Interestingly, a few classical lawgivers do provide remedies for the woman whose husband becomes a renouncer: according to Kauṭilya, she is to accept *niyoga* (Olivelle 1984, 141–42); and according to *Nāradasmṛti* (12.97) she is required to take another husband (Lariviere 1991). The nineteenth-century paṇḍit, I. Vidyasagar, mentioned earlier, was the first modern writer to bring the *Nāradasmṛti* passage to public attention. In his 1855 pamphlet he quotes also from the *Pasarasmṛti* to defend a woman's remarriage on the demise of her husband or "on his turning an ascetic" (1976, 7).

21. Inadequate dowries threaten the lives of many. Important data on "dowry deaths" are summarized in the work of Ranjana Kumari. From January to July 1987, for example, a total of 318 deaths were reported in U.P. alone (Lok Sabha Q. No. 2746, Winter Session 1987 [R. Kumari 1989, 25–26]). The most recent statistics presented in the Indian parliament and reported by Reuters News Agency (e.g., *The Globe and Mail*, Aug.1 1991) reveal that more than eleven thousand young wives "have committed suicide or been killed in the last three years (1988–90) because of illegal but ubiquitous dowry demands."

22. Because they are unmarried *Srīmatī* is also inappropriate. The most frequently used terms of address for these "lady professors"—"Miss" and "Madame"—are both borrowed from other languages.

23. [Note: The typescript revision made in 1992 stops here, followed by handwritten pages marked "not given for typing because they need reconsideration." They contain valuable material, so I have reconstructed these sections using the handwritten text and a computer file dated 1987—S.C.]

24. Saraswati describes the government homes as "inadequate and ill-managed," in striking contrast to the private charitable institutions, especially the establishments run by female ascetics (1985, 118–19). He names three female ascetics who shelter widows—Ānandamayī Mā, Gaṅgā Mā, and Śobha Mā (discussed in later chapters)—but does not clarify the status of their establishments, which are not *vidhavāśrams* at all, but rather ascetic institutions that shelter widows, all of whom are either ascetic or lay disciples of the female ascetics who head the institutions.

25. Widows are conspicuous as servant-disciples (*celī*) to female ascetics, but handicapped girls and women are also to be found, albeit fewer in number. Of the forty traditional female ascetics, thirteen live in close association with householders. These thirteen women are gurus and protectors of at least twenty-one widows and eight handicapped women and girls.

3. UNITY AND DIVERSITY I

1. Physiologically sex-specific rituals, such as the acts (*kriyās*) undertaken by some male ascetics to gain control over ejaculation, are of course an exception.

2. The verb is *pahuncna*, "to reach or arrive at"; combined with the copula to make *pahunci hui* (f) or *pahuncha hua* (m), it takes on a special meaning, refering to a woman or man who is spiritually accomplished (cf. Parry 1985a, 62). In its more common form ascetics use the verb to describe their goal, in much the same way that they speak of "crossing over" the ocean of *sansār*.

3. Thus, for example, another common phrase expressing *sansār* as a transient and repetitive state of affairs speaks of the constant "coming and going" (*ana-jana*).

4. In general, the conceptual distinction I draw between "the transient" and "the social" parallels Burghart's (1983a, 642–43), but while he cautions against identifying the social world with householdership, arguing that intersectarian debate employs more precise categories (e.g., house-houseless, caste-casteless), I opt for identification of the two, partly because ascetic women consistently do so, but also because in my view the more precise categories ultimately collapse into a householdership-asceticism dichotomy. Moreover, as developed in the following chapter, by emphasizing the ritual construction of the social world the terms of intersectarian debate are better clarified.

5. The equation of *sansār* as the cycle of rebirth with *sansār* as the social world, which appears to be typical of ascetics, is often not recognized. Dumont, for example, unjustifiably criticizes Avalon's translation of *saṃsāra* as "world" rather than "transmigration" (Dumont 1960, 54, n28). The equation occurs in the everyday discourse of ascetics as well as in their textual tradition: The *Mahānirvāṇa Tantra*, for example, admits of

only two *āśramas* (stages of life), *gṛhastha* and *saṃnyāsa* (Avalon 1972, 158, n2). To renounce *sansār* by entering *sannyāsa* is to renounce *gṛhastha*.

6. [Note: This section is incomplete, as there is no sustained discussion of *sādhanā* in the surviving materials. From scattered notes it is clear that LTD was concerned to draw a distinction, as she does briefly here in the text, between *sādhanā* as "ascetic discipline" and *dharma* as "law." *Sādhanā* is an action noun from the verbal root *sādh*, of whose many meanings one may cite "guide (to a goal), bring about"; thus the word means something like "practicing (asceticism)" and the agent noun *sādhu* "a practitioner." Since the verb also means "to succeed, accomplish," the action noun can mean "attainment (of liberation)," and the agent noun "good man, holy man"—S.C.]

7. In everyday speech it is pronounced *sādhudharm*. The textual term closest in meaning is *yatidharma*, which strictly speaking refers to only one kind of ascetic, the renouncer, one of whose ancient names is *yati*. Only well-educated ascetics are familiar with it.

8. The scholarly attempts to deal with this important and complex question have been outlined by Olivelle at several places (1975; 1977, 30; 1984, 82–83)

9. "The only general statement which one can make concerning asceticism in the religious traditions of South Asia is that all ascetics see themselves as followers of some path which releases them from the transient world . . . and that all ascetics distinguish themselves from non-ascetics who do not seek such release" (Burghart 1983a, 643).

10. I present first the masculine then the feminine form of terms, separated by a slash (/). Where the feminine is constructed by the addition of a suffix—commonly -*nī*—to the masculine form, I write the two together, for example, *sannyāsi* (m) and *sannyāsinī* (f) produce *sannyāsi/nī*. *Sevak* is one of those terms having a proper feminine, *sevikā*, but it appears to be rarely used, the masculine form doing duty for men and women alike.

11. Cf. Śaṅkara (cited in Hoens 1979, 76): "the guru is Viṣṇu, the guru is Śiva, the guru is Brahmā himself, there is no greater *deva* than the *guru*."

12. None of the terms discussed here is essentially sectarian, but it should be noted that some serve as the basis for sectarian titles. Vaiṣṇava ascetics have appropriated both *vairāgya* and *tyāg*: Vaiṣṇava ascetics as a class are called *bairāgis*, that is, "the desireless ones" (the "v" is always pronounced "b"); and one section of ascetics in the Vaiṣṇava Rāmānandi sect whose name is *Tyāgi* (or *Mahātyāgi*).

13. [Note: This penance, which LTD had intended to illustrate with a photograph, involves sitting between four fires, set at the points of the compass, with the hot sun above as the fifth—S.C.]

14. MW defines *saṃnyās* as "putting or throwing down, laying aside, resignation . . . ; renunciation of the world, profession of asceticism." See Olivelle (1984 [1993]).

15. The feminine *sādhvī*, used for Jaina nuns, is not used, in Benares at least, for Hindu female ascetics. Here, it is a term of approbation ap-

plied to the householder woman who is truly virtuous; it simply means "a good woman."

16. Use of the word "ochre" to translate *gerua* has a lengthy history in the literature. Ghurye (1964, 90) and before him Oman (1905, 154) use it, following Wilson, who more correctly translated the word as "red ochre" (1862, 193). *Gerua* is close in color to and sometimes associated with *muṅga* (coral); both come from the mountains (*gerua* in the form of clay used as a dye), and both are highly auspicious.

17. The *kurta* violates one regulation governing the renouncer's dress, that he should wear no stitched garment (Giri 1976, 56). But the Ramakrishna Svāmis' style has affected other ascetics so that today, if a *guru* wishes to cultivate a clientele in an urban center, and especially if he or she travels abroad, this modern *turban-kurta-luṅgi* outfit is invariably sported.

4. UNITY AND DIVERSITY II

1. These have been studied by Ross (1965), Miller and Wertz (1976), and Sinha and Saraswati (1978) respectively.

2. To date no good academic studies of large ascetic festivals have been published, but for interesting and useful comments see Roy and Devi (1955) and Sinha and Saraswati (1978) on the Kumbha Melā; and Wilson (1862) and T. Bhattacharyya (1976) on the Gangā Sāgār Melā.

3. Numerous elements of ascetic discourse emphasize the separation of asceticism from householdership. In his excellent account of the secret language of the Rāmānandi Tyāgis, Richard Burghart demonstrates how through their ritual speech these ascetics "delineate the boundary between themselves and the transient world [of the householder]" (Burghart 1980, 26). In this context, the work of Patrick Olivelle, a textual scholar, should also be noted. Several of his articles on renunciation (1975, 1981), and his commentary on the *Yatidharmaprakāśa* (1977), explicate and emphasize the disjunction between the *gṛhastha* and *saṃnyāsa* statuses.

4. Present typologies of sects rest on over 150 years of writing and research. The first descriptive summary was published in 1862 [1828]—H. H. Wilson's *Sketch of the Religious Sects of the Hindus*. Following Wilson a succession of authors, most notably J. N. Bhattacharya (1963), J. C. Oman (1905), Sir R. G. Bhandarkar (1913) and J. N. Farquhar (1925a, b), and Orr (1940) outlined the sects in a systematic fashion. Field research based typologies commence with G. S. Ghurye's *Indian Sadhus* (1953). Since the publication of this seminal work, three important anthropological studies have appeared: Miller and Wertz (1976), B. D. Tripathi (1978), and Sinha and Saraswati (1978). A comparison of all these works suggests that there is really only one typology which has several, not too divergent, variations.

5. This is particularly true in the cases of non-Tyāgi Rāmānandis (i.e., the "garment wearing" Bastradhāris [cf. Burghart 1983a, 647]), and

the member of the two other sections of the Daśanāmi Sampradāya (i.e.,
the Daṇḍis and Paramahaṃsas [cf. Ghurye 1964, 71ff.]). By contrast, the
dhūnī is central to Kānphaṭa identity; ideally, it should always be kept
burning. However, even among Kāphaṭa not all adhere strictly to the
dhūnī sādhanā (the order has many *panth*s or "divisions," see Briggs
1982, 62ff.).

6. By this I mean to say that Dumont is less indebted to structural-
ism (of the Levi-Straussian sort) than he is to Weber. His crypto-Weberian
vocabulary operates in his articulation of concepts such as "the world,"
"worldly," and "other-worldly."

7. Veena Das (1977) poses a major challenge to Dumont's larger
analysis; further reflections on the strengths and weaknesses of his gen-
eral approach may be found in the recent volume *Contexts and Levels*
(Barnes, de Coppet, and Parkin 1985). See also Burghart (1983a).

8. It is important to note than in addition to institutionalized renun-
ciation, *sannyāsa*, there exists a more general notion (and practice) which
we can also speak of as "renunciation" because it entails the surrender of
one's property, responsibilities, and rights. The common terms for this are
tyāg and *vairāgya*. Some Vaiṣṇava sects, such as the Svāminarāyāṇas,
consider their final ascetic vows to be a renunciation (Williams 1984, 30);
their ascetics do not enter into *sannyāsa*, but they associate their highest
initiation strongly with *sannyāsa*, and their senior ascetics wear ochre
garments, the color traditionally associated with renunciation. Renuncia-
tion in the general rather than technical sense, that is, *tyāg* rather than
sannyāsa, is prominent in mendicant ascetic ideology, even in sects such
as the Rāmānandis whose members are not initiated into *sannyāsa*
(Burghart 1983a, 647; 1983b, 367). Because "renunciation" has both gen-
eral and particular (institutionalized) expressions, it should be used with
care, its referents clearly indicated.

9. *Sampradāya* is a multivalent term, used to refer to several differ-
ent levels of socioreligious organization. A speaker's exact meaning can be
determined only by the context of conversation. Not only are divisions
within a sect called *sampradāya*s (e.g., the Rasik Sampradāya is a division
of the Vaiṣṇava Rāmānandi Sampradāya), but aggregates of several sects
may also be called *sampradāya*s. Thus, the nine traditional Vaiṣṇava ascetic
sects are grouped together into four branches, the Catur Sampradāya,
each with a different name.

10. From the terminological difficulties faced in his studies of Sikhism,
W. H. McLeod has concluded that an indigenous word should be substi-
tuted for the English "sect." His preferred term is *panth* (1978). Retention
of *panth* in Sikh studies may well be advisable, but in the larger context
of sectarianism it is inappropriate, because it is too specific. *Sampradāya*
is far more inclusive, so that while the *panth* is a type of *sampradāya* the
reverse is not true. Others, such as Sinha and Saraswati (1978), use
sampradāya, with all its various levels of meaning, but dispense with the
English "sect," translating *sampradāya* as "division."

11. To date, only Burghart has focused attention on the character of intersectarian (and, further, intrasectarian) debate. See Burghart 1983a, 645ff., for a discussion of how members of the Rāmānandi sect distinguish between and hierarchize other sects.

12. Sometimes *santapanthīs* retain a text but radically reinterpret it. For example, the Brahma Kumārīs have an idiosyncratic interpretation of the *Bhagavadgītā* (their founder is called "the Gītā Sermonizer").

13. Sinha and Saraswati attempt to summarize the differences between the orthodox and reformist schools (1978, 29). They see as significant: i. "conceding the *varṇa* order," ii. "the method adopted in ritualistic performances" (*ārādhanā*), iii. "the object of worship" (*ārādhya)*, and iv. "the philosophical concept of god."

14. The Rādhā Soāmis are usually seen as, and portray themselves as, an exclusively householder sect, but they do in fact have a strong ascetic tendency. As noted by Farquhar (1929, 170) in the Constitution of the Satsang (1902) there is a set of rules "for the enrollment and conduct of Rādhā Soāmi monks."

15. I have heard ascetics say that Nānak was different from other *sant*s and was indeed a Hindu. (This correlates with the general Hindu tendency, at least until recently, to view the Sikhs as a Hindu *sampradāya*, e.g., Sinha and Saraswati 1978, 30). Udāsīs and Nirmalas argue that though Nānak may have been a *sant*, he was nonetheless an Advaita Vedāntin, a true follower of Śaṅkara, and thus, like him, a great defender of *sanātana dharma*. As in the cases of the Svāminārāyaṇas and the Dādūpanthīs, conformity to one of the classical systems of philosophy does not automatically assure a sect membership in the *sanātanī* camp. My research suggests that there must also be an intact *paramparā* going back to an orthodox founding teacher: Thus, the Udāsīs's claim to Daśanāmi affiliation through their second guru, Bhakta Giri, does not stand because *his* guru, Śrī Canda, was a *sant*.

16. The value of Tripathi's statistics is unfortunately reduced because he gives no figures for the total population, but rather ratios within a sample of (five hundred) ascetics (Tripathi 1978, 3–5). He does not employ the *santapanthī* category as such but, based on his descriptions of sixty-six sects, I conclude that at least forty-eight are nontraditional. Of the remaining sixteen sects some are not, properly speaking, sects at all but rather divisions within other, larger sects (e.g., the Rasikas [*Ibid.*, 45] are a division or section found within more than one Vaiṣṇava sect).

17. The *santa sampradāya*s they located in Benares are, on the Śaiva side: Nāthpanthis, Udāsis, and Nirmalas; on the Vaiṣṇava side: Kabirpanthīs, Dādūpanthīs, Praṇāmīpanthīs and Svāminārāyaṇas; and of indeterminate theistic affiliation: Garibdasīs, Ghīsapanthīs, and Brahma Kumārīs. Their category "others" (1978, 51), which contains nearly one-half the female ascetic population, is not unorthodox but consists of nonsectarian *brahmacāri/ṇī*s, discussed later in the chapter.

18. This distinction is clearest among the traditional sects, but it does carry over into the *santapanthī* camp so that despite their general rejection of image worship, most can be classified as either Śaiva or Vaiṣṇava. Some, such as the Svāminārāyaṇas, are theistic. Others, though not worshiping any Hindu deity, may nonetheless practice *japa*, repetition of the name of a deity, Rām, for example, and can thus be classified as Vaiṣṇava. A sect's founder, though a reformer, may have been initiated in an orthodox lineage such as the Daśanāmis, and so claim Śaiva affiliation. Still other sects follow an orthodox philosophy and align their militant sections with that sect; on this basis the Nirmalas and Udāsīs are allocated to the Śaiva camp.

19. The important role played by the militant sections of all sects in defining the overall organizational structure cannot be overestimated. And the rivalry has not always been friendly: The Kumbha Melā itself has often been the occasion during which simmering feuds over status and access to pilgrimage routes have erupted into fierce battles. See, especially, Farquhar (1925), Ghosh (1930), Sarkar (1959), and Ghurye (1964, 100ff.).

20. This is largely because Vaiṣṇava ascetics have held periodic conferences for this purpose. The earliest such council was probably held in the fourteenth century (Ghurye 1964, 161), and there have been many others since then. See Farquhar (1929, 298), De (1942, 87–88); and Burghart (1978).

21. The specific form they worship is Viṣṇu reclining on a serpent attended by Srī, Bhū, and Līlā. Spoken of as a pair, the name of the Goddess comes first: the Rāmānujis worship Lakṣmī-Nārāyaṇa, the Rāmānandis Sītā-Rām.

22. Rādhā is viewed as wife rather than mistress. Furthermore, among the Nimbārkis there is no tendency (as in most other Rādhā-Kṛṣṇa sects) to bring one or other of these deities to the fore. Rādhā-Kṛṣṇa is a single unit. I have in my possession a copy of a deed, relating to the establishment of a trust fund for a major Nimbārki *āśram* in Benares, which treats the Rādhā and Kṛṣṇa images as a single deity under the name "Sree Sree Kalachandjew" (*jew* = *jī*, an honorific). (Indian law accepts deities as "juristic persons" entitled to rights in property.)

23. The Mādhvas are not classic *Sāṃkhya* dualists as Ghurye states (1964, 157). Wilson (1958, 83ff.) and Bhandarkar (1913, 58) both show quite clearly their Vedāntic roots, Wilson commenting on the incompatibility between Madhvācārya's *dvaita* philosophy and *Sāṃkhya-Yoga*.

24. Mādhvas also honor Rāma and Viṣṇu, but not Gopāl-Kṛṣṇa, and so the Rādha cult with its devotionalist and erotic elements is absent in their system (Bhandarkar 1913, 62; De 1942, 17, 112). The few ascetics in this sect are all southerners who claim Daśanāmi affiliation (Wilson 1958, 80; Sinha and Saraswati 1978, 133ff.); other Vaiṣṇava ascetics in Benares have told me that Mādhva ascetics usually take *sannyāsa* (cf. Wilson 1958, 82; Ghurye 1964, 157).

25. So much does their theology focus on Rādhā that they are legitimately considered Vaiṣṇava Śāktas. See Wilson (1958, 98–100) and Ghurye (1964, 194–95).

26. The Sakhīs are poorly researched and their discipline is little understood. See Wilson (1958, 100–1) and Tripathi (1978, 42–43)

27. Ghurye, partly following S. K. De (1942), attempts a reconstruction of the sequence of events which might have led to the Caitanyites's entry into the Brahma Sampradāya (Ghurye 1964, 158, 161). Despite their suspect lineage, the Caitanyites are the largest sect in the Brahma Sampradāya. They have a great many subsects that vary in their interpretation of Rādhā's relationship with Kṛṣṇa, ranging from tantric Śāktas (Wilson 1958, 97–98) to the more puritanical ISKCON (International Society for Krishna Consciousness).

28. Though these two sects are, at least in Benares, quite distinct (Sinha and Saraswati 1978, 133, 251–52), the standard typologies do not distinguish between them (Bhandarkar 1913, 76–82; Wilson 1862, 68–78; Ghurye 1964, 155–57). As I understand it, it is the worship of Vallabhācārya himself, combined with a generally antiascetic tendency (cf. Wilson, *Ibid.*) that distinguishes the Vallabhācāryas from the Viṣṇusvamis. In addition, so I was told, Viṣṇusvāmis refuse entry to non-Brahmins and take *sannyāsa* initiation (Wilson 1958, 69), while the Vallabhas are liberal in their view of caste, having many non-Brahmins among them (Bhattacharya 1968, 360; Wilson 1958, 78; and Pocock 1973).

29. [Note: Unfortunately, it seems that in neither typewritten nor handwritten form did LTD leave any extended discussion of more than the first of these four—S.C.]

30. [Note: An ancient term first used for the payment or gift given to sacrificial priests—S.C.]

5. SOCIORELIGIOUS ASPECTS OF FEMALE ASCETICISM IN VARANASI

1. Most notably, Sinha and Saraswati (1978). There are no comparative statistics for the other northern pilgrimage centers, and the only study we have of a southern center, Bhubaneshwar (Orissa), indicates that it is quite small (Miller and Wertz 1976, 11). The problem is that the accounts we do possess are rich in description but short on quantitative data. Moreover, they tend to describe pilgrimage centers popular with only one sectarian tradition (Ross 1965; Giri 1976). B. D. Tripathi's otherwise useful study of *sādhu*s in U.P. (1978) provides ratios within a sample but no figures for the total population. All ascetics say that Varanasi is the largest center, and one anthropologist, R. L. Gross, whose lengthy field research led him to nearly every major northern center, provides no statistics, but does confirm Varanasi's preeminence (1979, 169–71). Varanasi itself is a small city with a municipal population of 708,647 (1981 Government of

India). The territory of my research, which includes settlements such as Ramnagar, Kotwa, and Maruadih, is now designated Varanasi Urban Agglomeration, covering just over 103 square kilometers with an approximate population of 798,000. At the time of their research (1967–69) Sinha and Saraswati estimated that one person out of 240 in this city was an ascetic. The lower ratio I saw (perhaps one in 354) is due not so much to a decline in asceticism as to a significant increase in the population of Varanasi itself. See Census of India 1981, Series 22, Part II–A, 74.

2. Female ascetics are found in numbers at only two other centers, Mathura-Vrindavan and Haridwar; but, on the testimony of several well-travelled bairāginīs and sannyāsinīs, Varanasi contains more than these two centers combined. This is also the opinion of the ascetic researcher, Swami Sadānanda Giri (personal communication). The female ascetic population of Varanasi is quite stable; I employ the ethnographic present throughout, referring to the years 1980–81.

3. The independent ascetics treated later deny sectarian affiliation, but they are not ritually independent. Both Śāradā Mā and Anandamāyi Mā relied on sannyāsis to initiate their disciples, whether into *brahmacarya* or *sannyāsa*. On Śāradā Devī, see Gambhirananda (1955, 350); Anandamāyi Mā's ritual dependence on the renunciatory tradition was stressed in conversations with me by Śailenda Brahmachari, Secretary of the Shree Shree Anandamāyee Saṅgha, and is confirmed by Ojha (1984, 208) and various devotees, for example, Gupta 1976, 26.

4. In addition, even though the women's ritual lives are largely indistinguishable within the overall pattern of ascetic practice, they appear to appropriate ascetic ideology in their own way so that the great religio-philosophical heterogeneity, and hence ritual diversity, observed among the male ascetic community is also characteristic of the female.

5. There are exceptions to the requirement that a recognized preceptor must officiate: in *svadīkṣā*, an ascetic initiates herself or himself. When such a person is well-known, his or her right to have done so must rest on evidence of exceptional spiritual accomplishment. On the other hand, there are *svadīkshitā* ascetics who initiate themselves, take on ascetic robes, and are never challenged.

6. To date only one scholar, Catherine Ojha of the Center d'Études de l'Inde et de l'Asie du Sud, has conducted in-depth research on female asceticism, also in Varanasi. Her excellent article on female monastic communities (1984) presents a somewhat different analysis of female asceticism, which, in her view, is a marginal and essentially masculine mode of life. Discrepancies in our figures (she counted forty-five female ascetics and estimates that there are no more than one hundred in the city [Ojha 1981, 265]) reflect differences in orientation and in our definition of an ascetic. Her research focuses on large convent-like communities of celibate students, mine includes the smaller but more diverse population of *sannyāsinīs* and *avadhūtanīs*. Apart from Ojha's work, the only other account is by Ursula King (1984). This good but brief study examines the

effects of social change on the status of women, outlining the roles of highly visible female ascetics in a number of different communities. It is not so much a study of female asceticism as of select female ascetics, but it clearly confirms certain of my observations, such as the religious authority and independence of women preceptors, and should be consulted as a general introduction to the topic.

7. This is a carefully reasoned figure based on Sinha and Saraswati's statistics, estimates by the well-placed and knowledgeable ascetic, Swami Sadānanda Giri, and a general acquaintance with such variables as the number of ascetics dying each year, the number arriving to live in Varanasi (as branch establishments in other centers close), and the decline in new recruits. We have no way of determining exactly how many ascetics visit or reside temporarily in Varanasi at any given time. Sinha and Saraswati estimate this floating population at about one-quarter of the total.

8. A detailed account of one type of Nimbārki Vaiṣṇava initiation may be found in Ojha (1984, 207–8); she concludes that the female ascetic *gurus* of this order imperfectly initiate their female disciples. According to my information, those who remain ascetics for life receive a full initiation; in addition, one of these *gurus*, Gaṅgā Mā, has created a unique ritual, which she explicitly compares to the taking of *sannyāsa*, for selected female disciples.

9. Though, technically, all Vaiṣṇava ascetics are *bairāgi/nīs*, in practice the term is used almost exclusively to refer to the Rāmānandis who, of all the Vaiṣṇava *sampradāyas*, are in their social organization and mode of asceticism the most similar to *sannyāsi/nīs*.

10. The textual description of *sannyāsa dīkṣā* that most closely approximates contemporary practice can be found in Olivelle's translation of and commentary on the seventeenth-century *Yatidharmaprakāśa* (Olivelle 1977; see especially pp. 37–44).

11. By this I mean that the population at large regards them as living liberated souls (*jivanmuktās*) and that their adoration has become a cult. Two features characterize Hindu saints: (i) they enter frequently into *samādhi*, and (ii) they are believed to be divine, capable of manifesting themselves as full incarnations of one or more deities.

12. On this topic see Giri's important outline of the characteristic *siddha-sādhakṛ* relationship in the Nāga-Avadhūtani subdivision (1976, 27–28).

13. Hindus often observe with pride that Sikhs are great admirers of Hindu *gurus*. Two of the most popular accounts of holy men and women in India are by Sikhs, S. S. Uban (1977) and Khushwant Singh (1975); both describe the renowned Varanasi *mātājī*, Ānandamayī Mā.

14. The words the women use and that I translate here as "traditional" and "orthodox" are, respectively, *rūdhibādi* and *dharmik* or *prāmāṇik*.

15. Though Śāktism is permeated with tantric thought and some scholars might question this separation of the two, the fact remains that despite common philosophical underpinnings their cultic expressions diverge

greatly. Briggs writes, "If Śākta and Tantra were to be discriminated one would refer specifically to the worship of the goddess, the other to magical and sacramental ritual" (1982, 274). In the Varanasi context Śāktism is so respectable it is hardly ever associated with even the most tame forms of right-handed Tantra (dakṣiṇācār). Most Śāktas dissociate themselves from Tantra, offering what Sanderson calls an orthodox self-representation (1985, 191). Śāktism in Varanasi is Tantrism moved from the periphery to the center; the philosophical (and practical) implications of this shift toward orthodoxy are comparable to those described by Sanderson (Ibid.) for the tantric Śaivas of Kashmir.

16. Śāktism just as eloquently argues for women's special preceptorial powers. Cf. Woodroffe (1929, 505), "The Devī is Herself the Guru of all [the Tantra] Shastras and woman, as indeed all females. Her embodiments are in a peculiar sense Her representatives. For this reason all women are worshipful, and no harm should ever be done them."

17. These brief comments on the Śākta-Tantric complex hardly do justice to the topic. There are few accounts of Śākta or tantric asceticism that portray their practices and beliefs from the perspective of women. Some idea of the overall complexity and variability of this current of Hindu thought and practice may be gleaned from Woodroffe (1929), Dimock (1966), Parry (1985a), Denton (1991), Gupta (1979), and Sanderson (1985a), though the last two do not treat of its specifically ascetic expressions. The study which best explores the interface between tantric and Śākta elements in Hindu asceticism is Briggs' Gorakhnāth and the Kānphaṭa Yogis (1982 [1938], especially pp. 162–78, 274–83). See also Ray (1980) on Buddhism.

18. For a discussion of how tantric doctrine and practice can contribute to the high status of householder women, see M. Allen on the Newars of Nepal (1982, 200–01).

19. All the Government of India Census figures between 1891 and 1931 indicate large Nāthapanthi and Daśanāmi Nāga populations with approximately equal numbers of male and female members; in 1891, for example, there were 436 Jogis and 430 Joginīs in Benares. See Government in India, Census of India 1891, North-Western Provinces, Part 3, 52, and also Gross 1979, 163–66.

20. Personal communication (1977); I am indebted to Dr. Nepali for his clarification of this and other important issues in the history and sociology of the Nepali community in Varanasi. The remarks of P. Caplan are also worth noting, "Women in Nepal, like their counterparts in India, play no part in political life, are not educated, do not travel, yet unlike the mass of Indian women, they are much freer in their relationships with men, both before and after marriage" (1973, 179).

21. Privately, some ascetics cynically remark that Ānandamayī Mā's kanyā gurukul is merely a "finishing school," because she and senior members of her entourage actively negotiate marriages for some of their brahmacārinīs, who then leave the ascetic life. Gaṅgā Mā and Śobhā Mā,

however, value asceticism far above householdership, and actively discourage marriage.

22. See White's (1980) lively account of Gurumā Jñānānanda Saraswati, whose spiritual discipline and forceful personality are characteristically *sannyāsik*.

23. The most influential works on Śāradā Devī are by Gambhirananda (1955) and Nikhilananda (1962). Pashupati (1968) is an excellent introduction. The literature on Ānandamayī Mā is extensive; two works which clearly place her within a classic hagiographic tradition and which echo the life of Śāradā Devī, are the biography written by B. Mukerji (1980) and a collection of articles published by the Ānandamayī Mā society, *Mother as Seen by her Devotees* (A. K. D. Gupta 1976). The biographies of Śobhā Mā still accumulate. To date several books are available, only in Bengali.

24. This represents the postpubertal to premenopausal age span, precisely those years during which the classical Hindu woman ought to be married and reproductive.

25. Beyond this age (twenty-five years) the appellation *kanyā* (virgin) becomes conceptually problematic.

26. I did not discover whether they were of the Daṇḍi or Paramahansa divisions; the former have distinct tantric leanings. I was told that a few orthodox Vaiṣṇava renouncers are also there, but the presence of the renowned tantric scholar, Gopināth Kavirāj, as permanent resident has had a significant impact on the *āśram* and perpetuates its association with Śāktism and Tantra.

27. If anything, *sannyāsa* is for them a far more serious matter than for the Śaivas: it is seen as an almost impossible goal for the average human, because it demands such a degree of surrender. Thus most Vaiṣṇavas take *sannyāsa* late in life, by which time it is held they might have cultivated the disposition of detachment.

28. I learned of some tension in the *āśram* occasioned by the departure of an elder sister of one of the *brahmacaāriṇīs* I met. She had undergone *sannyāsa* initiation but refused to submit to the restrictions imposed by Gaṅgā Ma; specifically, she insisted on the right to attend religious functions outside the *āśram*, activities in which any typical *sannyāsinī* might and even should participate, such as religious readings. This is one of the few instances in my research where internal conflict in an authoritarian ascetic structure was admitted. It demonstrates the different understanding of *sannyāsa* in this context and the fear of pollution from external sources.

29. The status of *kayastha* as *vaiśya* or *śūdra* continues to be problematic. Āśramites seemed to imply that they are *śūdra* by birth but can be accepted as *vaiśya* in terms of lifestyle. Thus, the *kayastha* girls in one *āśram* are responsible for preparing the balls of goat dung and ash used as kindling; yet the ascetic life is still appropriate for them. Of the very few who might be of *kṣatriya varṇa* (perhaps daughters of military personnel), no special mention was made, but it was always adamantly

stated that *only* Brahmin girls might cook and act as officiants (*pūjārīs*) for deity worship.

30. Ānandamayī Mā initiated herself into *sannyāsa*. This was graphically described to me by several devotees and forms part of her enduring mythology. It is detailed in the hagiographic literature; see, for example, *L'Enseignement de Mā Ananda Moyi*, by Jean and Josette Herbert, Paris: Edition Albin Michel, 1974.

6. SAINTHOOD, SOCIETY, AND TRANSCENDENCE

1. With two exceptions, the authors quoted in the text present hagiographical accounts of women saints. Anne Feldhaus (on Bahiṇā Bāī) and A. K. Ramanujan (on Mahādēvi) have written excellent critical studies of their subjects. In my fieldwork quite a few householders, and both male and female ascetics, made references to the lives of women saints, Lāl Dad, Mīrā Bāī, Mahādevī, and Aṇṭal being the most popular.

2. The term *sant* is the formal title used in certain North Indian ascetic orders (A. Bharati 1970). The important point is that sainthood is a *social* fact. It is the recognition by a community of people that someone is a liberated soul.

3. Anandkar's presentation of Bahiṇā's life story (1955, 640–72) is full of vivid detail and action—the true stuff of legend. In his account, the agonies of her tortured life are more fully described, but it is Anne Feldhaus's translation and discussion of some of Bahiṇā's poems (1982) that reveal the intellect of this remarkable woman.

4. Whenever present day ascetics retell the story of the famous debate between Śaṅkarācārya—the alleged founder of Hindu monasticism—and Madan Miśra, they stress the fact that though she was Madan's wife, she awarded Śaṅkara victory in the debate and became a *sannyāsinī* herself and that Śaṅkara then named one of his ascetic lineages (Bhārati) after her. See Jadunath Sarkar's version of the legend (1959, 11–13).

5. Draupadī, the persecuted heroine of the Mahābhārata epic, provides a startling contrast to Avvaiyār. She remained as *wife* to an irresponsible king (and his four brothers). Nancy Falk's study (1977) explores how, within the context of myth, Draupadī mediates the conflict between "a *kṣatriya dharma* of power and the eternal *dharma* of truthfulness" (ibid., 108).

6. As discussed in chapter 5, Vaiṣṇavite devotionalism recognizes five attitudes toward the deity of which the parental (*vātsalya*) is the most presumptuous and thus the most elevated (Ghurye 1964, 174). The most respected renunciatory Vaiṣṇava ascetic I know in Varanasi is an elderly woman *bhaktā* of the god-child Rāma (Bāl Rāma).

7. Aṇṭal is a generic term used by the Tamil Śrī Vaiṣṇavas to refer to their female saints. This and its masculine counterpart, *azhvar*, refer to those "who dive deep into the ocean of love divine" (Paramatmananda

1955, 23). Hardy (1983) on Kṛṣṇa *bhakti* suggests that Aṇṭal played an exceedingly important role in the tradition of mystical poets by introducing a decidedly physical and sensuous element.

8. In my encounters with women who go into mystical trance states, the majority are what I term worldly ascetic devotionalists. The role played by their community of followers in supporting them is crucial.

9. These are, of course, Vīraśaiva (*liṅgāyat*) designations. For a full account of this form of South Indian sectarian Śaivism, see S. C. Nandimath, *A Handbook of Vīraśaivism*, Dharwar, 1942. Ramanujan (73: 29) has a note on the terms *bhaktā* (m. *bhakta*) and *bhavī* (m. *bhavi*).

10. Cf. W. McCormack (1973, 176). I have seen such lithographs as far north as Bombay.

11. Kaul, 1973. There are many books and articles written on Lalla and early translations of her poetry, for example, *The Word of Lalla the Prophetess*, by Sir Richard Temple (Cambridge, 1924). She was well-known to certain historical personages such as the fourteenth-century Badshah, King Zain-ul-Abi-din, who is reported to have met her at his court. Her ascetic lineage appears to have been authentically traced to a well-known tantric *guru*, Siddhi Srikanth.

12. Śaiva Nāgas follow the rule of complete nudity (Ghurye 1964, 100ff.) and Vaiṣṇava Tyāgis of nudity except for a requisite loincloth (Burghart 1983b). Naked ascetics smear their body with ashes both for specific symbolic reasons, and for practical reasons: they afford a measure of physical protection. The Vaiṣṇava ideology of nudity and ashes is discussed in depth by Burghart in his translation of an important Rāmānandi Tyāgi text, *Śri Guru Rāmānand Swami's Pañc Mātra*. There are two photographs of most impressive Nāga ascetics in Sinha and Saraswati (1978), plates 5 and 6.

13. A Vaiṣṇava *tyāgī* of my acquaintance could, in the company of her *guru* and certain senior *gurubhais* (brother ascetics), wear only a loincloth; on other occasions she tied only one short cloth over her body. Otherwise, for the performance of certain rituals such as fire-sacrifice, nudity is obligatory.

14. See plate 7, Sinha and Saraswati (1978) and also p. 73 of the text.

15. I would go further and suggest that these saints were *gurus* to male initiates and thus members of a tradition of female tantric lineage. There is very little written on the role of women as *tantrik gurus*. A few observations on Bengali Vaiṣṇavite tantra are contained in Dimock, 1966, 96ff.

16. For more on this topic consult Mircea Eliade (1973), *Yoga: Immortality and Freedom*, and Sir John Woodroffe (1929), *Shakti and Shākta*.

17. On the ideology and practice of internal and external *tantrik* ritual, consult Sanjukta Gupta (1979, 127 ff.) and Dimock (1966: 195ff.), "Principles of sādhanā."

18. *Geruā gamcā*—a piece of ochre-colored rag—has important ascetic significance; the fact that the word *gamcā*—which really means something

like "an all-purpose scarf"—is used rather than *kapra*—which means a proper and substantial sheet of cloth—is of interest, because it highlights her indifference to fabric and also conveys indigence: Rickshaw pullers throw a *gamcā* over their head and shoulders.

19. A thorough analysis of Mahādevī's mysticism requires careful attention to the "language of secrecy" or of "ciphers" (*sandhyābhāṣa*) employed by the Vīraśaiva poets (Ramanujan 1973: 48–49) and the esoteric "six-phase system" (*Ibid.*, 169) used to convey the stages of the human soul in the process of mystical ascent. I have chosen to emphasize the elements of Mahādevī's poetry that appear to me to demonstrate the most salient features of her behavior—as these are also conveyed by her intensely personal poetry.

20. This is in Tamilnadu, about forty miles west the city of Madras.

21. For information on this sect, consult D. N. Lorenzen (1972), *The Kāpālikas and Kalamukhas,* Berkeley; H. W. Barrow (1893), "On Aghoris and Aghoripanthis," *Journal of the Anthropological Society of Bombay,* Vol. 3: 197–251; and J. P. Parry (1984), "Sacrificial Death and the Necrophagous Ascetic."

Glossary of Hindu and Sanskrit Terms

adhikāra—right/obligation, entitlement
āśrama—stage of life
āśram—ascetics' residence
bhavuk—emotional
brahmacārin (/brahmacārinī)—student, celibate ascetic, *naiṣṭhika*
 brahmacārin (/brahmacāriṇī)—lifelong celibate
brahmin—priestly class
dharma—religious duty
dīkṣā—initiation
dvija—twice-born
ghāṭs—stone steps in Benares, used for bathing and cremation
gṛhasthin—householder
gṛhiṇ/ī—male/female householder
guru—spiritual preceptor
guru-bahan—sisters-in-the-same-*guru*
jīvanmukta—liberated soul
karma—actions
kṣatriya—warrior class
Kumbha Melā—great festival of ascetics
laukik—worldly, popular
mahantinī—abbess or prioress of a monastery
maṅgal / maṅglik—auspicious(ness)
mantra—verbal formula
mokṣa—spiritual release, liberation from *sansār*, "salvation"
mukti—see *mokṣa*
nivṛtti—resignation, quiescence
prasād—sanctified food

pravṛtti—activity
puruṣārtha—the four legitimate ends or goals of human beings
śakti—feminine principle
samādhi—meditative trance
samuccaya—"cumulation" (view of the four *āśramas*)
sanskār (saṃskāra)—life-transition ritual, initiation rite
sansār (saṃsāra)—endless cycle of birth-life-death-and-rebirth
sannyās (saṃnyāsa)—renunciation
sannyāsin/ī (saṃnyāsin/ī)—male/female renouncer
śāstra—sacred text
śāstrik—textual (opposed to *laukik*)
śūdra—fourth, servile class
tilak—sectarian marks
tīrtha—pilgrimage site
upanayana—initiation into studentship (for men), marriage (for women)
vaidik—of the Vedas
vairāgya—dispassion
vaiśya—merchant class
vanaprastha—one who sets out for the forest
varṇa—status, class
varṇāśramadharma—the ideal world order (a social and ritual construct)
vāsanā—passion
vikalpa—"option" (view of the four *āśramas*)

Bibliography

[Not all of the items in LTD's bibliography are referred to in this version of her work. It has been left unaltered as a guide to her thinking on the subject, and as a guide to the subject in general. Meena Khandelwal's additional bibliography helps make this list up-to-date. S.C.]

Abbott, J. (1984) *Indian Ritual and Belief: The Keys of Power.* New Delhi: Usha Publications.

Allen, Charles and Sharada Dwivedi (1984) *Lives of the Indian Princes.* London: Century.

Allen, Michael (1982a) Girl's Pre-puberty Rites Amongst the Newars of Katmandu Valley, in Michael Allen and S. N. Mukherjee (eds.). (1982).

——— (1982b) The Hindu View of Women, in Michael Allen and S. N. Mukherjee (eds.). (1982).

Allen, Michael and S.N. Mukherjee (eds.) (1982) *Women in India and Nepal.* Canberra: ANU. (Australian National University Monographs on South Asia No. 8.)

Altekar, A. S. (1973 [1938]) *The Position of Women in Hindu Civilization from Prehistoric Times to the Present Day.* Varanasi: Motilal Banarsidass.

Anandkar, P. (1955) Bahiṇā Bāī. In *Women Saints of East and West Sri Sarada Devi (The Holy Mother) Birth Centenary Memorial.* The Rama Krishna Vedanta Centre of London.

Ardner, Shirley (ed.) (1975) *Perceiving Women.* London: Malaby.

——— (1978) *Defining Females: The Nature of Women in Society.* London: Croom Helm.

Avalon, Arthur (1972 [1913)] *Tantra of the Great Liberation (Mahanirvana Tantra).* New York: Dover.

Avinashilingam, T. S. (1955) Avvaiyar. In *Women Saints of East and West Sri Sarada Devi (The Holy Mother) Birth Centenary Memorial.* The Rama Krishna Vedanta Centre of London.

191

Ballhatchet, Kenneth and David Taylor (eds., 1984) *Changing South Asia: Religion and Society*. London: Asian Research Service (S.O.A.S., University of London).

Barnes, R.H., Daniel de Coppet and R.J. Parkin. (1985) *Contexts and levels: anthropological essays on hierarchy*. Oxford: Journal of the Anthropological Society of Oxford (JASO Occasional papers no. 4).

Bayly, Chris (1983) *Rulers, Townsmen and Bazaars*. Cambridge: Cambridge University Press.

Beal, Samuel (trans.) (1969 [1884]) *Si-yu-ki. Buddhist Records of the Western World* (Two Vols.) From the Chinese of Hiuen-Tsiang. Delhi: Oriental Books Reprint. [First published by Trübner, London.]

Bennett, Lynn (1983) *Dangerous Wives and Sacred Sisters: Social and Symbolic Roles of High-caste Women in Nepal*. New York: Columbia University Press.

Bhagat, M. G. (1976) *Ancient Indian Asceticism*. New Delhi: Munshiram Manoharlal.

Bhandarkar, R.G. (1913) *Vaisnavism, Śaivism, and minor religious systems*. Strassburg : Karl J. Trübner

Bhattacharya, Jogendra Nath (1968 [1896]) *Hindu castes and sects; an exposition of the origin of the Hindu caste system and the bearing of the sects towards each other and towards other religious systems*. Calcutta: Editions Indian.

Bhattacharya, T. (1976) *Gangasagar mela, a pilgrim's guide*. Calcutta: Office of the District Magistrate.

Bharati, Agehananda (1970) The Hindu Renaissance and its Apologetic Patterns, *Journal of Asian Studies*, vol. 29, 2:267–87.

——— (1975) *The Tantric Tradition*. New York: Samuel Weiser.

——— (1980) *The Ochre Robe* (2nd edition). Santa Barbara: Ross-Erikson.

Borthwick, Meredith (1982) 'The Bhadramahilā and Changing Conjugal Relations in Bengal 1850–1900,' in Michael Allen and S.N. Mukherjee (eds., 1982)

——— (1984) *The Changing Role of Women in Bengal, 1849–1905*. Princeton: Princeton University Press.

Bloch, Maurice and Jonathan Parry (eds., 1982) *Death and the Regeneration of Life*. Cambridge: Cambridge University Press.

Bose, N. K. (1951) Caste in India. *Man in India* 31, no. 3 and 4:114–116.

——— (1965) Religion and Society. *Transactions of the Indian Institute of Advanced Study* I:47–56.

Bouglé, Celestin (1927 [1908]) *Essais sur le régime des castes*. Paris: Alcan (Travaux de l'Année Sociologique). English Translation with an introduction by D. F. Pocock, 1971. Cambridge: Cambridge University Press.

Briggs, George Weston (1982 [1938]) *Gorakhnāth and the Kānphaṭa Yogis*. Varanasi: Motilal Banarsidass.

Bühler, George (trans.) (1969 [1886]) *The Laws of Manu*. New York: Dover. [*The Sacred Books of the East* Vol. XXV. F. Max Müller (ed.) 1886. Oxford: The Clarendon Press.]

Burghart, Richard (1978) 'The Founding of the Ramanandi Sect.'
Ethnohistory 25, 2:121–39.

—— (1980) Secret Vocabularies of the 'Great Renouncers of the
Ramanandi Sect, in W.M. Callewaert (ed.) *Early Hindu Devotional Lit-
erature*. Leuven: Departement Orientalistik Katholieke Universiteit
Leiden (Orientalia Lovanensia Analecta 8).

—— (1983a) Renunciation in the Religious Traditions of South Asia.
Man (NS) 18:635–53.

—— (1983b) Wandering Ascetics of the Ramanandi Sect. *History of
Religions* Vol. 22, no. 4:361–80.

Burghart, Richard and Audrey Cantlie (eds., 1985) *Indian Religion*. Lon-
don: Curzon.

Butler, A. (1979) *The Myth of the Magus*. Cambridge: Cambridge Univer-
sity Press.

Caplan, Patricia (1973) Ascetics in Western Nepal. *The Eastern Anthro-
pologist* 26, 2:173–82.

Carman, John B. and Frédérique Apffel Marglin (eds.) (1986) *Purity and
Auspiciousness in Indian society*. International studies in sociology and
social anthropology no. 43. Leiden : E.J. Brill.

Carmody, Denise Lardner (1979) *Women and World Religions*. Nashville:
Abingdon.

Carrithers, Michael, Steven Collins and Steven Lukes (eds.) (1985) *The
category of the person: Anthropology, philosophy,history*. Cambridge:
Cambridge University Press.

Carstairs, G. M. (1983) *Death of a Witch*. London: Hutchinson.

Chakraborti, Haripada (1973) *Asceticism in Ancient India in Brahminical,
Buddhist, Jaina and Ajivika Societies*. Calcutta: Punthi Pustak.

Chaturvedi, Mahendra and Bhola Nath Tiwari (1975) *A Practical Hindi-
English Dictionary*. Delhi: National.

Cohn, Bernard S. (1964) 'The Role of the Gosains in the Economy of the
Eighteenth and Nineteenth Century Upper India,' *Indian Economic and
Social History Review* 17: 88–95.

Coulson, Michael (1981) *Three Sanskrit Plays*. New York: Penguin.

Courtright, Paul B. (1994) The Iconographies of Satī, in John Stratton Hawley
(ed.) *Satī: The Blessing and the Curse*. New York: Oxford University Press

—— (1995) 'Sati, sacrifice, and marriage: the modernity of tradition,' in
Lindsey Harlan and Paul B. Courtright, *From the margins of Hindu
marriage: essays on gender, religion, and culture*. New York: Oxford
University Press.

Dandvate, Pramila, Ranjana Kumari, Jamila Verghese (eds.) (1989) *Wid-
ows, abandoned and destitute women in India*. New Delhi: Radiant.

Daniel, Sheryl B. (1980) Marriage in Tamil Culture: The Problem of
Conflicting Models, in *The Powers of Tamil Women* (ed.) Susan S.Wadley.
Syracuse: University of Syracuse.

Das, R. M. (1962) *Women in Manu and His Seven Commentators*. Varanasi:
Kanchana.

Das, Veena (1975) Marriage Among the Hindus. In *Indian Women* (ed.) D. Jain. New Delhi: Government of India.

———— (1977) *Structure and Cognition: Aspects of Hindu Caste and Ritual.* Delhi: Oxford University Press.

———— (1979) Reflections on the Social Construction of Adulthood. In *Identity and Adulthood* (ed.) S. Kakar. Delhi: Oxford University Press.

David, Kenneth (1980) Hidden Powers: Cultural and Socio-Economic Accounts of Jaffna Women. In *The Powers of Tamil Women* (ed.) Susan S. Wadley. Syracuse: University of Syracuse.

Denton, Lynn Teskey (1991) 'Varieties of Hindu Female Asceticism', in Leslie, I. Julia (ed.) (1991).

Dimock, Edward C., Jr. (1966) *The Place of the Hidden Moon: Erotic Mysticism in the Vaisnava-Sahajiya Movement of Bengal.* Chicago: University of Chicago Press.

Dube, Leela (1979) The Image of Women in Traditional Religions of India. Lecture given at Queen Elizabeth House, Oxford, November 1979.

Dumont, Louis (1957) For a Sociology of India. *Contributions to Indian Sociology* I:7–22.

———— (1960) World Renunciation in Indian Religions. *Contributions to Indian Sociology* IV:33–62.

———— (1961) Marriage in India: the present state of the question; I. Marriage alliance in Southeast India and Ceylon. *Contributions to Indian Sociology* V:75–95.

———— 1965 The Functional Equivalents of the Individual in Caste Society. *Contributions to Indian Sociology* VII:85–99.

———— 1980 (1970) *Homo Hierarchicus: The Caste System and its Implications* (revised English edition). Chicago: The University of Chicago Press.

Dumont, Louis and David Pocock (1958) Commented Summary of the first part of Bouglé's *Essais. Contributions to Indian Sociology* II:31–44.

———— (1959) Pure and Impure. *Contributions to Indian Sociology* III:9–39.

Eck, Diana L. (1982) *Banaras: City of Light.* New York: Alfred A. Knopf.

Eliade, Mircea (1973) *Yoga Immortality and Freedom.* Princeton: Princeton University Press.

Erndl, Kathleen M (1993) *Victory to the Mother : the Hindu goddess of northwest India in myth, ritual, and symbol.* New York: Oxford University Press

Falk, Nancy Auer (1977) Draupadī and the Dharma. In *Beyond Androcentrism — New Essays on Women and Religion.* Missoula: Scholar's Press.

Falk, Nancy Auer and Rita M. Gross (eds.) (1980) (1980)*: Women's Religious Lives in Non-Western Cultures.* San Francisco: Harper & Row.

Farquhar, J. N. (1925a) The fighting ascetics of India, *Bulletin of the John Rylands Library*, vol.9: 431–452

———— (1925b) 'The Organization of the Sannyasis of the Vedanta,' *Journal of the Royal Asiatic Society*, pp.479–86

———— (1929) *Modern Religious Movements in India.* London: Macmillan.

Feldhaus, A. (1982) Bahiṇā Bāī: Wife and Saint. *The Journal of the American Academy of Religion*, 50, 4:591–604.

Freeman, James M. (1980) The Ladies of Lord Krishna: Rituals of Middle-Aged Women in Eastern India. In (1980) (eds.) Nancy Auer Falk and Rita M. Gross. New York: Harper Row.

Fruzzetti, Lina M. (1981) Purer than Pure: The Ritualization of Women's Domain in a Hierarchical Society. *Journal of the Indian Anthropological Society* 16:1–18.

—— (1982) *The Gift of a Virgin: Women, Marriage, and Ritual in a Bengali Society.* New Brunswick, N.J.: Rutgers University Press.

Gambhirananda, Swami (1955) *Holy Mother Shri Sarada Devi.* Mylapore: Sri Ramakrishna Math.

Gervis, Pearce (1956) *Naked They Pray.* London: Cassell.

Ghosh, Jamini Mohan (1930) *Sannyasi and fakir raiders in Bengal. Compiled mainly from official records.* Calcutta: Bengal Secretariat Book Depot.

Ghurye, G. S. (1953) *Indian Sadhus.* Bombay, Popular Book Depot.

Giri, Swami Sadānanda (1976) *Society and Sannyasin (A History of the Dasnami Sannyasins).* Rishikesh: Kriyayoga Asrama.

Goody, Jack and Stanley J. Tambiah (eds.) (1973) *Bridewealth and Dowry. Cambridge Papers in Social Anthropology 7.* Cambridge: Cambridge University Press.

Gough, E. Kathleen (1955) Female initiation rites on the Malabar Coast. *Journal of the Royal Anthropological Institute* 85:45–80.

—— (1956) Brahmin kinship in a Tamil village. *American Anthropologist* 58:826–53.

Government of India (1891) *Census of India.* North-western Provinces, Part 3. Govt. of India.

—— 1974 *Towards Equality: Report of the Committee on the Status of Women in India.* New Delhi: Ministry of Education and Social Welfare, The Department of Social Welfare, Government of India.

—— 1981 *Census of India.* Series 22, Uttar Pradesh, Part II-A. (Ravindra Gupta, Director of Census Operations.) Shimla: Govt. of India.

Gross, Rita M. (1977) *Beyond Androcentrism: New Essays on Women and Religion.* Missoula: Scholars Press (American Academy of Religion, Aids for the Study of Religion, No. 6)

Gross, Robert L. (1979) *Hindu Asceticism: A Study of the Sadhus of North India.* Unpublished Ph.D. thesis, Department of Anthropology, University of California—Berkeley. [now (1992) *The Sadhus of India: a study of Hindu asceticism.* Jaipur: Rawat Publications]

Gupta, A. K. D. (1976) God as Love. In *Mother as Seen by Her Devotees.* Shree Shree Anandamayee Charitable Society. Varanasi.

Gupta, Sanjukta (1979) Modes of Worship and Meditation, in S. Gupta, Dirk Jan Hoens and Teun Goudrian (eds.) (1979).

Gupta, Sanjukta, Dirk Jan Hoens and Teun Goudrian (eds.) (1979) *Hindu Tantrism.* Leiden: E. J. Brill.

Haddad, Yvonne Yazbeck and Ellison B. Findly (eds) (1985) *Women, Religion and Social Change*. Albany: State University of New York Press.

Handoo, C.K. (1955) Lalleswari or Lal Diddi of Kashmir. In *Women Saints of East and West Sri Sarada Devi (The Holy Mother) Birth Centenary Memorial*. The Rama Krishna Vedanta Centre of London.

Hardy, Friedhelm (1983) *Viraha Bhakti*. London: Oxford University Press.

Harlan, Lindsey (1992) *Religion and Rajput women: the ethic of protection in contemporary narratives*. Berkeley: University of California Press.

Harper, E. B. (1964) Ritual pollution as an integrator of caste and religion. *Journal of Asian Studies* 23 (supp.):151–97.

——— (1969) Fear and the status of women. *South Western Journal of Anthropology* 25:81–95.

Havell, E.B. (1905) *Benares the Sacred City: Sketches of Hindu Life and Religion*. London: Blackie and Son.

Hejib, Alaka (1977) Wife or Widow? The Ambiguity of the Status of the Renounced Wife of a Sannyasi. Paper delivered at the American Academy of Religion, San Francisco, December 1977.

——— (1980) The Concept of Sacrifice in Understanding Hindu Feminism. Paper presented to the International Association for the History of Religions, Winnipeg, Canada.

Hoens, Dirk J. (1979) 'Transmission and Fundamental Constituents of the Practice,' in Gupta, Sanjukta, Dirk Jan Hoens and Teun Goudrian (eds.) (1979).

Holden, Pat (ed.) (1983) *Women's Religious Experience*. London: Croom Helm.

Iltis, Linda Louise (1985) *The Swasthani Vrata: Newar Women and Ritual in Nepal*. Unpublished Ph.D. thesis, Department of South Asian Languages and Literature, University of Wisconsin.

Jacobson, Doranne (1977) The Women of North and Central India: Goddesses and Wives, in Doranne Jacobson and Susan S. Wadley (1977)

——— (1978) The Chaste Wife: Cultural Norm and Individual Experience, in Sylvia Vatuk (ed.) *American Studies in the Anthropology of India*. New Delhi: American Institute of Indian Studies and Manohar Publications, pp. 95–138.

——— (1980) Golden Handprints and Red-Painted Feet: Hindu Childbirth Rituals in Central India. In Nancy Auer Falk and Rita M. Gross (eds.) (1980).

Jacobson, Doranne and Susan S. Wadley (1977) *Women in India: Two Perspectives*. Delhi: Manohar Book Service.

Jain, Devaki (ed.) (1975) *Indian Women*. New Delhi: Publications Division, Ministry of Information and Broadcasting, Government of India.

Jha, Makhan (1972) Aspects of Hindu Tradition in Nepal. *Research Journal of Ranchi University* 8:137–42.

Kakar, Sudhir (ed.) (1979) *Identity and Adulthood*. Delhi: Oxford University Press.

Kamaliah, K. C. (1977) Women Saints of Tamil Nadu. *Indian Literature* 20, 2: 46–65.

Kane, P. V. (1941a) *History of Dharmaśāstra (Ancient and Medieval Religious and Civil Law)*, Vol. II, Part 1. Poona: Bhandarkar Oriental Research Institute.

—— (1941b) *History of Dharmaśāstra (Ancient and Medieval Religious and Civil Law)* Vol. II, Part 2. Poona: Bhandarkar Oriental Research Institute.

—— (1968) *History of Dharmaśāstra*, Vol. I, Part 1 (Second edition). Poona: Bhandarkar Oriental Research Institute.

Kaul, Jai Lal (1973) *Lal Ded*. New Delhi: Sahitya Akademi.

Khare, R. S (1976) *Culture and reality: essays on the Hindu system of managing foods*. Simla: Indian Institute of Advanced Study.

King, Ursula (1984) The Effect of Social Change on Religious Self-Understanding: Women Ascetics in Modern Hinduism. In *Changing South Asia: Religion and Society* (eds.) K. Ballhatchet and David Taylor. London: Asian Research Service.

Kondos, Vivienne (1982) The Triple Goddess and the Processual Approach to the World: the Parbatya Case, in Michael Allen and S.N. Mukherjee (eds., 1982).

Krygier, Jocelyn (1982) Caste and Female Pollution, in Michael Allen and S.N. Mukerjee (eds.) (1982).

Kumari, Ranjana (1989) *Brides are not for burning: dowry victims in India*. New Delhi: Radiant Publishers, 1989.

Lang, Karen Christina (1986) Lord Death's Snare: Gender-Related Imagery in the Theragāthā and the Therīgāthā. *Journal of Feminist Studies in Religion*, II, 2: 63–79.

Lariviere, Richard W. (1989) *The Nāradasmṛti* (critically edited with an introduction, annotated translation, and appendices.) Philadelphia: Dept. of South Asia Regional Studies, University of Pennsylvania.

Leslie, I.Julia (1989) *The Perfect Wife: The Orthodox Hindu Woman according to Strīdharmapaddhati of Tryambakayajvan*. Delhi: Oxford University Press.

—— (ed.) (1991) *Roles and Rituals for Hindu Women*. London: Pinter.

—— (1991b) 'Suttee or Satī: Victim or Victor?,' in Leslie (ed.) (1991)

Lockwood, Michael and A. Vishnu Bhat (trans. and eds.) (1981) *Mattavilasa Prahasana ('The Farce of Drunken Sport')* by King Mahendravikramavarma Pallava. Madras: The Christian Literature Society.

Logan, Penelope (1980) Domestic Worship and the Festival Cycle in the South Indian City of Madurai. Ph. D. Thesis, University of Manchester, Faculty of Economic and Social Studies.

McCormack, W. (1973) On Lingayat Culture, in A. K. Ramanujan, *Speaking of Siva*. London: Penguin.

McGee, Mary (1987) *Feasting and fasting: the Vrata tradition and its significance for Hindu women*. Ph D Thesis, Harvard University.

—— (1991) 'Desired Fruits: Motive and Intention in the Votive Rights of Hindu women,' in I. Julia Leslie (ed.) (1991a)

McLeod, W. H. (1978) 'On the word *panth*: a problem of terminology and definition,' *Contributions to Indian Sociology* 12, 2: 287–95.

Madan, L. (1955) Mīrā Bāī. In *Women Saints of East and West Sri Sarada Devi (The Holy Mother) Birth Centenary Memorial*. The Rama Krishna Vedanta Centre of London.

Madan, T. N. (1965) *Family and Kinship: a study of the Pandits of rural Kashmir*. Bombay: Asia Publishing House.

———— (1981) The ideology of the householder among the Kashmiri Pandits. *Contributions to Indian Sociology* Vol.15, 1&2: 224–49.

Marglin, Frédérique Apffel (1978) Types of Sexual Union and their Implicit Meanings. Paper presented at the Conference on Radha and the Divine Consort, Harvard University.

———— (1980) Purity and Auspiciousness: The Case of the Devadasi-s. Paper presented at the Conference on Religion in South India, Washington, D.C.

———— (1985) *Wives of the God-King: the Rituals of the Devadasis of Puri*. Delhi: Oxford University Press.

Mehta, Rama (1970) *The Western Educated Hindu Woman*. Bombay: Asia Publishing House.

———— (1975) *The Divorced Hindu Woman*. Delhi: Vikas Publishing House.

Mehta, S. (1955) Gauribāī. In *Women Saints of East and West Sri Sarada Devi (The Holy Mother) Birth Centenary Memorial*. The Rama Krishna Vedanta Centre of London.

Miller, David M. and Dorothy C. Wertz (1976) *Hindu Monastic Life: The Monks and Monasteries of Bhubaneswar*. Montreal: McGill-Queens University Press.

Mookerjee, Ajit (1967) *Tantra art; its philosophy & physics*. New Delhi: Ravi Kumar.

Mukherji, Bithika (1980) *From the Life of Sri Ānandamayī Ma*, Vol. One. Calcutta: Shree Shree Anandamayee Charitable Society.

Mukherji, Prabhati (1978) *Hindu Women: Normative Models*. Orient Longman.

Nagesh, H. V., P. S. Nair, A. P. Katti, *Widowhood in India*. Ujire: Sri Dharmasthala Manjunatheshwara Educational Trust.

Nandy, P. (trans.) (1975) *The Songs of Mīrābāī*. New Delhi: Arnold-Heineman.

Nikhilananda, Swami (1962) *Holy Mother: Being the Life of Sri Sarada Devi Wife of Sri Ramakrishna and Helpmate in his Mission*. London: George Allen & Unwin.

Ojha, Catherine (1981) Féminine Asceticism in Hinduism: Its Tradition and Present Condition. *Man in India* Vol. 61, no. 3:254–85.

———— (1984) Condition feminine et renoncement au monde dans l'Hindouisme. *Bulletin de l'Ecole Française d'Extrème-Orient* Vol. 73:197–222.

Olivelle, Patrick (1975) A Definition of World Renunciation. *Wiener Zeitschrift fur die Kunde Sudasiens*, XIX: 75–83.

———— (1977) *Vasudevāśrama Yatidharmaprakāśa: A Treatise on World Renunciation Part Two*. Vienna: the Nobili Research Library.

—— (1981) 'Contributions to the Semantic History of Saṃnyāsa,' *Journal of the American Oriental Society* 101: 265–74

Oman, John Campbell (1905) *The Mystics, Ascetics, and Saints of India.* London: T. Fisher Unwin.

Orenstein, H. (1968) Toward a Grammar of Defilement in Hindu Sacred Law, in Milton Singer and Bernard S. Cohn (eds.) *Structure and Change in Indian Society.* New York: Wenner-Gren Foundation for Anthropological Research.

Orr, W. G. (1940) 'Armed Religious Ascetics in Northern India, *Bulletin of the John Rylands Library*, vol. 24: 81–100

Paramatmananda, Swami (1955) Andal. In *Women Saints of East and West Sri Sarada Devi (The Holy Mother) Birth Centenary Memorial.* The Rama Krishna Vedanta Centre of London.

Parry, Jonathan (1980) Ghosts, greed and sin: the occupational identity of the Benares funeral priests. *Man* (NS) 15: 88–111.

—— (1981) Death and cosmogony in Kashi. *Contributions to Indian Sociology* (NS) 15: 337–65.

—— (1982) Sacrificial Death and the Necrophagus Ascetic, in Maurice Bloch and Jonathan Parry (eds., 1982)

—— (1985a) The Aghori Ascetics of Benares, in Richard Burghart and Audrey Cantlie (eds., 1985)

—— (1985b) The Brahmanical tradition and the technology of the intellect. In *Reason and Morality* (ed.) J. Overing. London: Tavistock.

Pashupati (1968) *On the Mother Divine.* Kalyangarh, West Bengal: Sri Phanibhusan Nath.

Pearson, Anne (1986) Women's Vratas in North India: Worldly Asceticism. Paper delivered at the American Academy of Religion, Atlanta, GA, November 1986.

Pillai, S. (1955) Karaikkal Ammaiyar. In *Women Saints of East and West Sri Sarada Devi (The Holy Mother) Birth Centenary Memorial.* The Rama Krishna Vedanta Centre of London.

Pocock, David (1973) *Mind, Body and Wealth.* Oxford: Oxford University Press.

Radhakrishnan (1971 [1927]) *The Hindu View of Life.* London: Unwin.

Ramanujan, A. K. (1973) *Speaking of Siva.* Penguin.

Ray, Reginald A. (1980) Accomplished Women in Tantric Buddhism of Medieval India and Tibet. In Nancy Auer Falk and Rita M. Gross (eds., 1980).

Reynolds, Holly Baker (1980) The Auspicious Married Woman. In Susan S. Wadley (ed.) *The Powers of Tamil Women.* Syracuse: University of Syracuse.

Ross, A. N. (1965) *The Place of the Sannyasi between Tradition and Change in India with Particular Reference to Rishikesh.* B. Litt. Thesis, Taylor Library of Social Anthropology, University of Oxford.

Roy, D.K. and I. Devi (1955) *Kumbha: India's ageless festival.* Chaupatty, Bombay, Bharatiya Vidya Bhavan.

Ruether, Rosemary (ed.) (1974) *Religion and Sexism: Images of Women in the Jewish and Christian Tradition*. New York: Simon and Schuster.

Salholz, Eloise et al. (1986) Too Late for Prince Charming? (A summary of Marriage Patterns in the the United States. By Patricia H. Craig and David E. Bloom, Yale University). In *Newsweek* June 2, 1986.

Sanderson, Alexis (1985) Purity and Power among the Brahmans of Kashmir. Michael Carrithers, Steven Collins and Steven Lukes (eds., 1985)

Saraswati, Baidyanath (1975) *Kashi: Myth and Reality of a Classical Cultural Tradition*. Simla: Indian Institute of Advanced Study.

——— (1985) 'The Kashivasi widows.' *Man in India* 65, 2: 107–120.

Sarkar, J. (1959) *A History of the Dasanami Naga Sannyasins*. Allahabad: Sri Panchayati Akhada Mahanirvani.

Sharma, H. D. (1939) *Contributions to the History of Brahmanical Asceticism*. Poona: Oriental Book Agency.

Shree Shree Anandamayee Charitable Society (1976) *Mother as Seen by her Devotees*. Calcutta.

Singer, Milton B. and Bernard S. Cohn (eds.) (1968) *Structure and Change in Indian Society*. New York: Wenner-Gren Foundation for Anthropological Research.

Singh, Khushwant (1975) *Gurus, Godmen and Good People*. Bombay: Orient Longman.

Sinha, Surajit and Baidyanath Saraswati (1978) *Ascetics of Kashi: an anthropological exploration*. Varanasi: N.K. Bose Memorial Foundation.

Smith, Frederick M. (1991) 'Indra's Curse, Varuna's Noose, and the Suppression of the Woman in the Vedic *Śrauta* Ritual,' in I. Julia Leslie (ed.) (1991a)

de Souza, Alfred (ed.) (1980) *Women in Contemporary India and South Asia*. New Delhi: Manohar Publications.

Srinivas, M. N. (1952) *Religion and Society among the Coorgs of South India*. Oxford: Oxford University Press.

——— (1978) *The Changing Position of Indian Women*. Delhi: Oxford University Press.

Stevenson, M. S. (1971) *The Rites of the Twice-Born* (2nd edition). New Delhi: Oriental Books Reprint.Corporation. (1st edition, 1920, Oxford University Press).

Tambiah, Stanley J. (1973) Dowry and Bridewealth and the Property Rights of Women in South Asia. In *Bridewealth and Dowry* (eds.) Jack Goody and Stanley J. Tambiah. Cambridge: Cambridge University Press.

Tapper, Bruce Elliot (1979) Widows and Goddesses: female roles in deity symbolism in a south Indian village. *Contributions to Indian Sociology* (NS) 13, 1:1–31.

Tewari, Laxmi G. (1982) Women's Fasts and Festivals from Uttar Pradesh: their Art, Rituals and Stories. *Journal of South Asian Studies* V, 1:42–50.

Thiel-Horstmann, Monika (1991) Treatises on Dadupanthi Monastic Discipline, in Chandramani Singh and Neelima Vashishtha (eds.), *Pathways to Literature, Art and Archaeology: Pt. Gopal Narayan Bahura Felicitation Volume*, vol. 1: 95–113. Jaipur, 1991.

Thompson, Catherine (1983) Women, Fertility and the Worship of Gods in a Hindu Village. P. Holden (ed., 1983).

Tiwari, Kapil N. (1974) Renunciation: a Hindu-Buddhist Approach. *Indian Philosophy and Culture* XIX, 1:30–39.

Tripathi, B. D. (1978) *Sadhus of India: The Sociological View*. Bombay: Popular Prakashan.

Uban, Sujan Singh (1977) *The Gurus of India*. London: Fine Books (Oriental).

Vandana (1978) *Gurus, Ashrams and Christians*. London: Darton, Longman & Todd.

Vatuk, Sylvia (1980) The Aging Woman in India: Self-Perceptions and Changing Roles, in A. de Souza (ed.) *Women in Contemporary India and South Asia*. New Delhi: Manohar Publications.

Vidyarthi, L. P., Saraswati, B. N. and Makan Jha (1979) *The Sacred Complex of Kashi*. Delhi: Concept Publishing Company.

Vidyasagara, Isvarachandra (1976) *Marriage of Hindu widows*. Calcutta: K. P. Bagchi.

Wadley, Susan Snow (1975) *Shakti Power in the Conceptual Structure of Karimpur Religion*. Unpublished Ph.D thesis, Chicago: Department of Anthropology, The University of Chicago.

——— (1977a) Women and the Hindu Tradition. In Doranne Jacobson and Susan S. Wadley (eds.) *Women in India*.

——— (1977b) Women and the Hindu Tradition. *Signs Journal of Women in Culture and Society* 3:113–125.

——— (1980a) Hindu Women's Family and Household Rites in a North Indian Village. In Nancy Auer Falk and Rita M. Gross. (eds.) (1980).

——— (1980b) (ed.) *The Powers of Tamil Women*. Syracuse: Foreign and Comparative Studies/South Asian Series, No.6 Maxwell School of Citizenship and Public Affairs, Syracuse University.

Weber, Max (1960) *The Religion of India: The Sociology of Hinduism and Buddhism* (Translated and edited by Hans H. Gerth and Don Martindale). Glencoe, Illinois: The Free Press.

White, Charles S. J. (1980) Mother Guru: Jñānānanda of Madras, India. In Nancy Auer Falk and Rita M. Gross. (eds.) (1980).

Williams, Raymond Brady (1984) *A new face of Hinduism: the Swaminarayan religion*. New York: Cambridge University Press.

Wilson, H. H. (1862) *Essays and lectures chiefly on the religion of the Hindus, Vol. I, A sketch of the religious sects of the Hindus*. London: Trübner.

Woodroffe, Sir John (1929) *Shakti and Shakta: Essays and Addresses on the Shakta Tantrashastra*. London: Luzac.

Wulff, Donna Marie (1985) Images and Roles of Woman in Bengali Vaisnava padavali kirtan. In Yvonne Yazbeck Haddad and Ellison Banks Findly (eds.) (1985).

Yalman, Nur (1963) On the Purity of Women in the Castes of Ceylon and Malabar. *Journal of the Royal Anthropological Institute* 93:25–58.

Yule, H. and A. C. Burnell (1985) *Hobson-Jobson: a glossary of colloquial Anglo-Indian words and phrases, and of kindred terms, etymological, historical, geographical and discursive*. London: Routledge & Kegan Paul.

 Supplemental Bibliography
Meena Khandelwal

Selected recent publications on *saṃnyāsa*, on female Hindu asceticism in general, and on the issue of gender and Hindu asceticism, by Meena Khandelwal.

Alter, Joseph S. (1992) "The Sannyasi and the Indian Wrestler: The Anatomy of a Relationship." *American Ethnologist* 19, 2: 317–36.
——— (1997) "Seminal Truth: A Modern Science of Male Celibacy in North India." *Medical Anthropological Quarterly* 11, 3: 275–98.
Babb, Lawrence A. (1984) "Indigenous Feminism in a Modern Hindu Sect." *Signs* 9, 3: 399–416.
Bacchetta, Paola (2002) "Hindu Nationalist Women: On the Use of the Feminine Symbolic to (Temporarily) Displace Male Authority," in Laurie L. Patton (ed.) *Jewels of Authority: Women and Textual Tradition in Hindu India.* New York: Oxford University Press.
Basu, Amrita (1995) "Feminism Inverted: The Gendered Imagery of Real Women in Hindu Nationalism," in Tanika Sarkar and Urvashi Butalia (eds.) *Women and Right-Wing Movements.* London: Zed Books.
Bedi, Rajesh (1991)) *Sadhus: The Holy Men of India.* New Delhi: Brijbhasi Printers Private.
Caplan, Pat (1987) "Celibacy as a Solution? Mahatma Gandhi and *Brahmacharya*," in Pat Caplan (ed.) *The Cultural Construction of Sexuality.* New York: Tavistock Publications.
Cenkner, William (1983) *A Tradition of Teachers: Sankara and the Jagadgurus Today.* Delhi: Motilal Banarsidass.
Chatterjee, Partha (1992) "A Religion of Urban Domesticity: Sri Ramakrishna and the Calcutta Middle Class,: in Partha Chatterjee and Gyanendra Pandey (eds.) *Subaltern Studies VII.* Delhi: Oxford University Press.

Dazey, Wade H. (1990) "Tradition and Modernization in the Organization of the Dasanami Samnyasins," in Austin B. Creel and Vasudha Narayanan (eds.) *Monastic Life in the Christian and Hindu Traditions: A Comparative Study.* Lewiston, New York: The Edwin Mellen Press.

—— (1993) "The Role of Bhakti in the Dasanami Order," in Karel Werner (ed.) *Love Divine: Studies in Bhakti and Devotional Mysticisim.* Surrey: Curzon Press.

Falk, Nancy Auer (1995) "*Shakti* Ascending: Hindu Women, Politics, and Religious Leadership During the Nineteenth and Twentieth Centuries," in Robert D. Baird (ed.) *Religion in Modern India.* New Delhi: Manohar.

Findly, Ellison Banks (1985) "Gargi at the King's Court: Women and Philosophical Innovation in Ancient India," in Yvonne Yazbeck Haddad and Ellison Banks Findly (eds.) *Women, Religion, and Social Change.* Albany: State University of New York Press.

Gold, Ann Grodzins (1989)"The Once and Future Yogi: Sentiments and Signs in the Tale of a Renouncer-King." *Journal of Asian Studies* 48, 4: 770–86.

—— (1992) *A Carnival of Parting.* Berkeley: University of California Press.

Hallstrom, Lisa Lassell (1999) *Mother of Bliss: Anandamayi Ma, 1896–1982.* New York: Oxford University Press,.

Hancock, Mary E. (1995) "The Dilemmas of Domesticity," in Lindsay Harlan and Paul B. Courtright (eds.) *From the Margins of Hindu Marriage.* New York: Oxford University Press,.

Hannsen, Kristen (2002) Seeds in Motion: Thoughts, Feelings and the Significance of Social Ties as Invoked by a Family of Vaishnava Mendicant Renouncers in Bengal. Dissertation for Department of Social Anthropology, University of Oslo.

Hartsuiker, Dolf (1993) *Sadhus: Holy Men of India.* London: Thames and Hudson.

Hatley, Shaman and Sohail Inayatullah((1999) "Karma Saṃnyāsa: Sarkar's Reconceptualization of Indian Asceticism." *Journal of Asian and African Studies* 34, 1:139–51.

Hausner, Sondra Leslie (2002) Wandering in place: body, space and time for Hindu renouncers (Nepal, India). Dissertaion for Department of Anthropology, Cornell University.

Hawley, John Stratton (1986) "Images of Gender in the Poetry of Krishna," in Caroline Walker Bynum, Stevan Harrel and Paula Richman (eds.) *Gender and Religion.* Boston: Beacon Press.

—— (1987) "Morality Beyond Morality in the Lives of Three Hindu Saints," in John Stratton Hawley (ed.) *Saints and Virtues.* Berkeley: University of California Press.

Hiltebeitel, Alf, and Kathleen M. Erndl, eds. (2000) *Is the Hindu Goddess a Feminist? The Politics of South Asian Goddesses.* New York: New York University Press.

Hirst, Jacqueline (1993) "The Place of Bhakti in Sankara's Vedanta," in Karel Werner (ed.) *Love Divine: Studies in Bhakti and Devotional Mysticism*. Surrey: Curzon Press.

Kakar, Sudhir (1982) *Shamans, Mystics and Doctors*. Boston: Beacon Press.

—— (1991) "Ramakrishna and the Mystical Experience," in Sudhir Kakar, *The Analyst and the Mystic*. New Delhi: Viking.

Khandelwal, Meena (1996) "Walking a Tightrope: Saintliness, Gender, and Power in an Ethnocentric Encounter." *Anthropology and Humanism* 21, 2: 111–34.

—— (1997) "The Ungendered Atma, Masculine Virility and Feminine Compassion: Ambiguities in Renunciant Discourses on Gender." *Contributions to Indian Sociology* 31, 1: 79–107.

—— (2001) "Sexual Fluids, Emotions, Morality: Notes on the Gendering of Brahmacharya," in Elisa J. Sobo and Sandra Bell (eds.) *Celibacy, Culture, and Society: The Anthropology of Sexual Abstinence*. Madison: University of Wisconsin Press.

—— (2004) *Women in Ochre Robes: Gendering Hindu Renunciation*. Albany: State University of New York Press.

King, Ursula (1980) "Who is the Ideal Karmayogin?" *Religion* 10: 41–59.

Kripal, Jeffery (1995) *Kali's Child*. Chicago: University of Chicago Press.

Leslie, I. Julia (1983) "Essence and Existence: Women and Religion in Ancient Indian Texts," in Pat Holden (ed.) *Women's Religious Experience*. New Jersey: Barnes and Noble.

Llewellyn, J.E. (1995) "The Autobiography of a Female Renouncer," in Donald S. Lopez Jr. (ed.) *Religions of India in Practice*. Princeton, N.J.: Princeton University Press.

Madan, T.N. (1987) *Non-Renunciation*. Delhi: Oxford University Press.

Madhavananda, Swami, and Ramesh Chandra Majumdar (1982) *Great Women of India*. Mayavati, Almora, Himalayas: Advaita Ashrama.

Marglin, Frederique Apffel (1985). "Female Sexuality in the Hindu World," in C.W. Atkinson, C.H. Buchanan, and M.R. Miles (eds.) *Immaculate and Powerful: The Female in Sacred Image and Social Reality*. Boston: Beacon.

Masson, J. Moussaieff (1976) "The Psychology of the Ascetic." *Journal of Asian Studies* 35, 4: 611–25.

McDaniel, June (1989) *The Madness of the Saints*. Chicago: University of Chicago Press.

—— (1995) "A Holy Woman of Calcutta," in Donald S. Lopez, Jr (ed.) *Religions of India in Practice*. Princeton, N.J.: Princeton University Press.

McGee, Mary (2002) "Ritual Rights: The Gender Implications of Adhikāra," in Laurie L. Patton *Jewels of Authority: Women and Textual Tradition in Hindu India*. New York: Oxford University Press.

McKean, Lise (1996) *Divine Enterprise: Gurus and the Hindu Nationalist Movement*. Chicago: University of Chicago.

Mukta, Parita (1994) *Upholding the Common Life: The Community of Mīrābāī*. Delhi: Oxford University Press,.

Narayan, Kirin (1989) *Storytellers, Saints, and Scoundrels*. Philadelphia; University of Pennsylvania Press.

—— (1993)"Refractions of the Field at Home: American Representations of Hindu Holy Men in the 19th and 20th Centuries." *Cultural Anthropology* 8, 4: 476–509.

Narayanan, Vasudha. (1993)"Renunciation and Law in India." In *Religion and Law in Independent India*, edited by Robert D. Baird, 279–91. New Delhi: Manohar.

Obeyesekere, Gannanath (1981) *Medusa's Hair*. Chicago: University of Chicago Press.

Ojha, Catherine (1985) "The Tradition of Female Gurus." *Manushi* 31, 1: 2–8.

—— (1988) "Outside the Norms: Women Ascetics in Hindu Society." *Economic and Political Weekly* April 30.

Olivelle, Patrick (1984) "Renouncer and Renunciation in the Dharmasastras," in Richard W. Lariviere (ed.) *Studies in Dharmaśāstra*. Calcutta: Firma KLM Private Ltd.

—— (1992) *Saṃnyāsa Upanishads*. New York: Oxford University Press.

—— (1993) *The Āśrama System*. New York: Oxford University Press.

—— (1995) "Ascetic Withdrawal or Social Engagement," in Donald S. Lopez, Jr. (ed.) *Religions of India in Practice*. Princeton, N.J.: Princeton University Press.

Parry, Jonathan (1994) *Death in Benaras*. New York: Cambridge University Press.

Pearson, Anne Mackenzie (1996) *Because It Gives Me Peace of Mind*. Albany: State University of New York Press,.

Phillimore, Peter (2001) "Private Lives and Public Identities: An Example of Female Celibacy in Northwest India," in Elisa J. Sobo and Sandra Bell (eds.) *Celibacy, Culture, and Society*. Madison, Wisconsin: The University of Wisconsin Press.

Ramanujan, A.K. (1982) "On Women Saints," in John Stratton Hawley and Donna M. Wulff (eds.) *The Divine Consort*. Boston: Beacon Press.

Ramaswamy, Vijaya ((1992)) "Rebels-Conformists? Women Saints in Medieval South India." *Anthropos* 87: 133–46.

—— (1996) *Divinity and Deviance: Women in Virasaivism*. Delhi: Oxford University Press.

—— (1997) *Walking Naked: Women, Society, Spirituality in South India*. Shimla: Indian Institute of Advanced Study.

Robinson, Catherine A. (1999) *Tradition and Liberation: The Hindu Tradition in the Indian Women's Movement*. Surrey: Curzon.

Roy, Parama (1998) *Indian Traffic*. Berkeley: University of California Press.

Sangari, Kumkum (1993) "Consent, Agency and Rhetorics of Incitement." *Economic and Political Weekly* May 1: 867–82.

Sinclair-Brull, Wendy (1997) *Female Ascetics: hierarchy and purity in an Indian religious movement*. Surrey: Curzon.

Sunder Rajan, Rajeswari (1998) "Is the Hindu Goddess a Feminist?" *Economic and Political Weekly* 33, 44 (October 31): WS 34–WS 38.

—— (1999) "The Story of Draupadi's Disrobing: Meanings for Our Times," in Rajeswari Sunder Rajan, *Signposts: Gender Issues in Post-Independence India.* New Delhi: Kali for Women Press.

Thapar, Romila (1984) *Ancient Indian Social History.* 2nd ed. Hyderabad, India: Orient Longman.

Van der Veer, Peter (1989) "The Power of Detachment: Disciplines of Body and Mind in the Ramanandi Order." *American Ethnologist* 16, 3: 458–70.

—— (1987) "Taming of the Ascetic: Devotionalism in a Hindu Monastic Order." *Man* 2, 2: 680–95.

Yogananda, Paramahansa (1985) *Autobiography of a Yogi.* 6th ed. Bombay: Jaico Publishing House,.

Young, Katherine (1987) "Hinduism," in Arvind Sharma *Women in World Religions* Albany: State University of New York Press.

—— (2002) *"Om,* The Vedas, and the Status of Women With Special Reference to Srivaisnavism," in Laurie L. Patton (ed.) *Jewels of Authority: Women and Textual Tradition in Hindu India.* New York: Oxford University Press.

Young, Serenity (1994) "Gendered Politics in Ancient Indian Asceticism." *Union Seminary Quarterly Review,* 48, 3–4: 73–92.

Index

Abstention: acts of, 1
Adiguru, 81
Advaita Vendanta, 87
Age of Consent Committee,
173n14
Allen, Charles, 44
Altekar, A. S., 27, 29, 46, 48, 130
Ammaiyār, 142
Ananda Devī Mātṛ Kanyāpīṭha,
131–134
Ānandamayī Mā, 11, 37, 74, 113,
114tab, 120, 126, 135, 137,
175n24
Ānandamayi Mā Kanyapitha, 129–
131
Andal, 37
Annadā Devī Kanyāpiṭha, 115
Antal, 148–152
Asceticism: Advaitin, 60; antiso-
cial, 70, 92; breathing/posture
exercises, 92; celibacy and, 94,
95–97, 100, 166; celibate
studentship, 4; classes in, 70–
73; clothing, 95, 96; commonali-
ties in practice, 79; construction
of social world in, 60; defining,
19–21; degrees of, 141; devalua-
tion of householdership in, 59,
60; devotional, 79, 91; dietary

requirements in, 19; different
sects pursuing same disciplines,
79; difficult-to-classify sects in,
83; distinct communities in, 103;
diversity of, 68–75, 77–102, 104;
early, 2; easing economic
hardship through, 52–53; entry
into, 19, 20; erotic, 91; forbid-
ding, 23; formal, 37, 53–55;
freedom from rebirth in, 59;
gnosis in, 91; guidelines for
behavior in, 61–62; guru/disciple
relationship in, 112–115; hair
styles, 109; for householders, 93;
individualistic lifestyle of, 12;
initiation into, 19; inner dimen-
sion of, 69; institutionalized, 1,
2, 8, 41, 43, 48, 95, 103, 104;
nonsectarian, 79; orders in, 7;
orthodox, 82–84, 108tab, 109;
parental, 91; preceptor/disciple
relationship in, 62–68; presence
of women in, 4; proliferation of,
2; proper relationship to larger
society, 7; protection/enhance-
ment of femal purity through,
53–55; rasa theory in, 91;
religio-philosophical orientation,
81; religious meanings of every